Theo Fabergé

and the

St Petersburg Collection

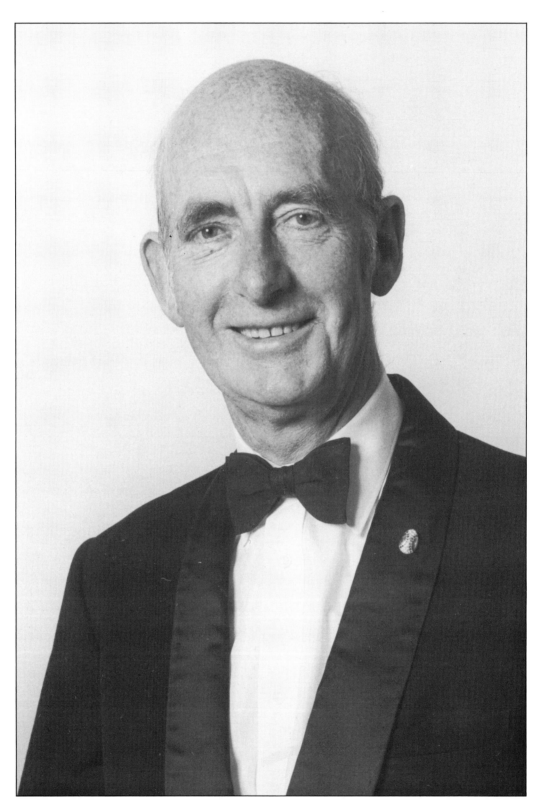

Theo Fabergé

THEO FABERGÉ
AND THE

ANDREW MOORE

DAUPHIN PUBLISHING LIMITED AND THE ST. PETERSBURG COLLECTION

British Library Cataloguing in
Publication Data

THEO FABERGÉ AND THE
ST. PETERSBURG COLLECTION
Arts/Antique/General
Moore, Andrew
Theo Fabergé and The St. Petersburg Collection
1. Europe. Fabergé, (Family)
1. Title. 2. St. Petersburg Collection
929′2′094

ISBN 1 872357 00 8
ISBN 1 872357 01 6 Leather edition

**Published by Dauphin Publishing Limited and
The St. Petersburg Collection.**

First published in October 1989.

Theo Fabergé and The St. Petersburg Collection.
marketing and distribution
Dauphin Publishing Limited, 118 Holland Park Avenue,
London W11 4PA.

**Theo Fabergé and The St. Petersburg Collection
was designed and printed by Dauphin Publishing Limited.**

Photography: Patrick Llwellyn-Davis,
Edward Allwright, John Gotts.
Manuscript: Jackie Shelford.

Typeset in ITC Times by The Right Type Limited, London.
Printed and Bound in Great Britain.

*Jacket photographs
(Front) The St. Vladimir Egg
(Back) The 'surprise' within The St. Vladimir Egg
The Cathedral of St. Vladimir in sterling silver.*

CONTENTS

FOREWORD

When this volume was first proposed I had grave doubts regarding the venture, 'Who', I asked myself, 'would want to read such a book'. Eventually I was persuaded that events should be recorded so as to complete, as far as is possible, the story of the family I never knew.'

I am pleased to have been involved at every stage of the preparation of this volume. As the work progressed, I became more enthusiastic and awaited its publication so that my story, which apparently fascinates so many, would receive a wider audience. I hope it gives you, the reader, as much pleasure as it has given me.

The St. Petersburg Collection by Theo Fabergé would not have been possible had it not been for Philip Birkenstein and our North American agent Keith Lipert. I wish to record my sincere appreciation particularly to Philip who established The St. Petersburg Collection. I also wish to thank Sarah, my daughter, for her continual support and encouragement.

Whilst I am in my workshop, my thoughts do dwell from time to time on the family I never knew – my grandfather Carl, my uncles, Agathon, Eugene and Alexander and of course my own father, Nicholas. This book is as much theirs as it is mine.

In due course, as more historical information regarding the Fabergé family emerge, this volume will be updated not only to include the new knowledge, but to up-date the information about The St. Petersburg Collection.

Theo Fabergé

Theo Fabergé.

PREFACE

It gives me pleasure to write the preface to this book about the life of my 'new found' cousin, Theo Faberge. Not only does it give his biography, but it also contains previously unpublished historic information about our family. Theo has started with great enthusiasm The St. Petersburg Collection and in his own special way he has created an original collection. His story has all the ingredients of a good novel, but it is a true account as opposed to fiction.

T. Fabergé

Tatiana Fabergé Geneva, Switzerland 1989

ACKNOWLEDGEMENTS

I wish to thank the following for their kind assistance during the preparation of this volume.

Theo Fabergé

Tatiana Fabergé

Oleg Fabergé

The Office of Her Majesty's Private Secretary, Chitralada, Bangkok, Thailand.

Barbara German, great niece of Nicholas Fabergé's wife, Marion.

The Worshipful Company of Turners of London.

The Curators of the Forbes Magazine Collection, USA.

Mrs. Pornsri Luphaiboon, The Oriental, Bangkok.

Graham Roberts, Sussex University, England.

The Private Collectors who have kindly loaned objects for photography.

TO MAY

Chapter 1

INTRODUCTION

Theo's life story never failed to fascinate those to whom it is unfolded. Until 20 years ago not even Theo was a party to its secret. This is the first time that his extraordinary story has ever appeared in a book. It has all the ingredients of a fairy tale, but nevertheless is a true account and not fiction. In 1969, one of Theo's aunts decided that her nephew's true surname should no longer be kept from him.

At the age of 47, Theo discovered he was the son of Nicholas Fabergé, the youngest son of Carl Fabergé, the goldsmith and jeweller to the Imperial Russian Court. In other words, he was grandson of the man who made the eggs for the Tsars of Russia. A certain amount of intrigue within his family, which was more akin to the plot of an intricate novel than a real life situation, was also revealed. Not surprisingly, Theo was left deep in thought.

For as long has he can remember, Theo always had a penchant for making objects. This was a natural instinct even before commencing school. He recalls attempting to make a model boat at the tender age of four and later, under the guidance of his teachers, excelled at handicrafts. However, it was not in the field of the arts that Theo was to base his career. Instead he entered the world of precision engineering and completed a rigorous apprenticeship at General Aircraft. For over 30 years he followed a technical career.

The discovery of his true identity had a profound affect on Theo. Apart from the revealed family intrigue which resulted in a tangled web of emotions, the truth also acted as a catalyst to wake his dormant artistic skills. For some years he had felt that his work was not giving him satisfaction. However, life continued and he had neither the time nor the inclination to analyse what was lacking. During the period of contemplation which followed the discovery of his family's deception, he realised that the root cause of his dissatisfaction was that his work gave him no aesthetic fulfilment. He was tired of the uninteresting shapes generally required by industry and wanted to create objects which were pleasing to the eye.

In order to release supressed artistic creativity, an individual must have a medium of expression. Theo had none, but he was adamant that for his own satisfaction, he must find an outlet. He undertook a course in silversmithing and experimented with enamelling. By chance the reluctant engineer was introduced to the art of ornamental turning. Theo, a great devotee to the lathe, had at last found his niche. He began to earn his daily bread as a general craftsman restoring antique furniture and clocks. During his spare moments he experiemented with ornamental turning. Every craftsman strives for perfection and Theo is no

exception. He wanted to be recognised for his own skills and not because his grandfather happened to be Carl Fabergé.

Within six years of being introduced to ornamental turning, Theo received the ultimate honour for his work. The Worshipful Company of Turners elected him a Freeman Prizeman of the Company. More than twenty years had passed since anyone had satisfied the peers of this craft that their work was of the superlative standard. It is only after this event that Theo, having satisfied himself that his work was recognised on its own merit used the shape of an egg as an art form.

In the second half of the 1970's, Theo was selling his creations at craft fairs and working on commissions. His favourite medium was wood. Although the business was now becoming international, Theo's work was nevertheless reaching a relatively small audience. In 1986, The St. Petersburg Collection by Theo Fabergé was launched to improve the availability of Theo's work.

The title of this book, **Theo Fabergé and The St. Petersburg Collection**, implies that it is solely devoted to Theo and his work. Even the most casual of glances will reveal that this is not the case. Theo's story is extraordinary, but it is also an integral part of the Fabergé family history. Those who meet Theo often want to know why eggs were so significant to the people of Imperial Russia; how a French family came to reside at St. Petersburg and details of the history of the House of Fabergé. As jewelled eggs are generally synonymous with Carl Fabergé, questions are inevitably asked as to why they were made; what inspired the designs; how many were made and where those surviving may be seen today. Naturally questions are asked about Theo's life, his father and decendants of Carl Fabergé surviving today.

One of the objects of this book is to answer the questions that are frequently asked. Much has been written about the House of Fabergè in the past and some may wonder why the story is repeated here. Apart from the neatness of having all in one volume, there is also another reason. Thanks to the generosity of Tatiana Fabergé, previously unpublished material has been made available. For the first time the name of the family's native village in France is revealed. Readers may be surprised that the name Fabergé was only adopted last century.

The final chapter is devoted to the life and work of Theo Fabergé, and includes many early family photographs. There is also a detailed postscript about his father, Nicholas Fabergé, and for the first time a complete family tree is published recording all known descendants of Carl Fabergé.

I have known Theo since the early 1980s and I was delighted to be asked to write this volume. My researches have taken me to the Armoury of the Kremlin in Moscow, to the Gold Vaults at the Hermitage in Leningrad and to Bangkok. I have spoken to Oleg Fabergé in Finland and to Tatiana Fabergé in Switzerland. Many hours have naturally been spent in conversation with Theo at his home.

Theo does not possess any of his grandfather's creations. On occasions when we have looked at objects produced by the House of Fabergé, it has proved to be a remarkable experience, for Theo looks at the pieces with a craftsman's eyes. It may be the engine turning under translucent enamel, the way in which a diamond is set in a miniature jewelled egg, or the neatness of a hinge that attracts Theo's immediate attention. He notices perfection and like his grandfather strives to achieve the ultimate in design and craftsmanship.

Chapter 2

EASTER IN OLD RUSSIA – AN ORGY OF EGGS

Eggs have been symbolic to mankind since the dawn of time. The Phoenicians and from them the Egyptians, Hindus, Japanese and many other ancient civilisations, maintained that the world was hatched from an egg made by the Creator. In the classical world, both the Greeks and the Romans renewed their faith in life by eating eggs and the Chinese presented newborn babies with eggs painted red. Throughout time, the humble egg has signified life and hope in many cultures. Christians have long regarded the egg as symbolic of rebirth and hence of the Resurrection of Christ.

In the days of Imperial Russia, eggs played a significant part in the Easter celebrations. No other society has endowed the common egg with such importance in the celebration of this Christian festival, as did the pre-Revolution Russians. Anthony Jenkinson, an English mariner, experienced one such celebration in the 16th century: 'They (the Russians) have an order at Easter which they always observe: to dye or colour red a number of eggs of which every man and woman giveth one to the priest of their parish upon Easter morning. And moreover, the common people used to carry in their hands one of these red eggs, not only upon Easter day but also three or four days after; and gentlemen and gentlewomen have their eggs gilded. They use it as they say, for a great love, and in token of the Resurrection, whereof they rejoice'.

Winters in Russia are long and the climate can be cruel. In days of old, Easter was a festival that was eagerly awaited as it was synonymous with Spring as well as the celebration of the Resurrection. Preparation began early, and almost a sixth of every year was devoted in some way to the celebration of the Resurrection and the start of Spring. Eight days before the beginning of Lent saw the start of the *Maslenitsa* or 'Butter Week'. This was a festive occasion of feasting, carnivals and general entertainment.

Immediately the *Maslenitsa* was over, Lent began. In old Russia Lent was taken very seriously. No meat, dairy produce, eggs or sugar were consumed. Public entertainment became less exuberant with concerts replacing operas and a more subdued form of attirement was adopted with fine brilliant jewels being replaced by more simple items. The only popular relief during the 'Great Fast' was the celebration of Palm Sunday. In the cities, a Fast Market was held on the Thursday before the religious festival. The Palm Market at St. Petersburg was perhaps the most elaborate. Branches were sold for children to carry through the streets; these 'palms' were adorned with leaves and flowers made from paper. Wax fruit and angels were bought and added to the branches by those who could afford the expenditure.

The old Russian Easter was an orgy of eggs. The Imperial Glass Works produced enormous quantities in every hue. Some were plain, while others were painted and gilded with religious subjects or flowers. Alternatively, the glassworkers etched the decoration onto the body of an egg. The designs may have been left plain or enhanced by skilled painters. The porcelain factories also satisfied the public's demand for decorated Easter eggs. Some specimens were undecorated like the specimen in the Hermitage Collection with an 'ox-blood', mauve and green glaze. Others were painted with flowers or geometric designs. Religious subjects such as saints also abounded. Many eggs were inscribed with the words *Christ is risen* in Cryllic script. The wealthy may have commissioned personalised examples as gifts for friends or relatives. Porcelain Easter eggs bearing the Imperial cypher of Alexandra Feodorovna appear at auction from time to time. Glass and porcelain eggs were intended to be suspended from ribbons so that the recipients could decorate their homes.

Eggs were also made of less permanent materials such as wax and sugar. They varied in size, from the minute wren's egg to that the size of an ostrich's. Transparent eggs often contained some delight. This may have been a group of angels, a single cherub, a saint or a bouquet of wax flowers as a reminder that Spring was rapidly approaching. The confectioners sold cardboard eggs covered in foil and filled with bonbons or chocolates.

However, it was the humble hen's eggs that played the most significant rôle in the old Russian Easters. During Eastertide they were consumed in enormous quantities. Johann George Kohl, a German who had lived in Russia for six years during the second quarter of the 19th century, described the demand for eggs as 'incredible' and estimates that in 1842 the 500,000 citizens of St. Petersburg ate their way through 10 million eggs. They were used partly in the making of the traditional Easter bread and dessert while others were hard boiled, stained red and decorated with shadings of white in a host of different patterns. Many were inscribed with, for example, such words as *Christ is risen, Take eat and think of me*, or, *This present I give to him I love*.

Towards midnight the day before Easter Sunday, the churches began to fill for the Easter service. The priests would begin to slowly read Mass. Then, as midnight neared, the congregation would light candles until the building was ablaze with light and Easter Day burst forth in full glory. The golden doors of the iconostasis would be thrown open, a procession would be led outside the church and upon the return to the Lord's House, the choir would sing heavenly anthems. The Easter service would last up to three hours. Towards the end, most people, but especially the peasants, would bring their breakfast to be blessed by the priests.

Whereas the more affluent members of society may have began their Easter Day with a banquet, many foods were egg-shaped or served in egg shells. The traditional old Russian breakfast for Easter morning comprised kulich, an Easter bread, which was generally of a rounded cylindrical shape bearing the letters *XB* signifying *Christ has Risen*; this was eaten with a spread called paskha, and was followed by hard boiled eggs and vodka.

It was customary for everyone to greet each other with the words, 'Christ is risen! Indeed he is risen.' There was general merrymaking and the exchange of gifts. However, the ultimate Easter gifts were those presented by the Tsars to their Tsarina and other members of the Imperial family. These were the work of a company run and controlled by Carl Fabergé. The work of this company, which ceased trading in 1917, has become legendary throughout the world. However, before proceeding to describing the Imperial Easter Eggs which the firm of Fabergé created, it is first necessary to relate why a French Huguenot family settled in Russia and became the leading jewellers of Europe and far, far, beyond.

Chapter 3

THE HOUSE OF FABERGÉ

At the middle of a large case entirely devoted to pieces by Fabergé in the Armoury Museum of the Kremlin, is a stylised model of the Kremlin featuring the cupola of the Cathedral of the Assumption (*Uspenskii Sobor*) at its centre. The 1976 catalogue of the Armoury Museum starkly states, 'This is a musical box'. It does indeed contain a musical mechanism which is wound by a gold key 63.5mm in length. However, the piece is in fact, the *Uspenskii Cathedral Egg*, which was presented to Alexandra Feodorovna by Nicholas II on Easter morning in 1904. This is one of the most ambitious of the Imperial Eggs.

The catalogue reveals that, 'The largest jewellery firm in Russia was the world-famous Fabergé. It was founded in St. Petersburg in 1842 by Gustav Fabergé, whose ancestors had left France and settled in what is now Estonia as long ago as 1685.' There is only one flaw in this statement—it is most unlikely that the Fabergé family had settled in Estonia (the smallest of the three Soviet Baltic republics) as early as the 17th century. However, one can forgive this slight inaccuracy as there is little documentary material relating to the family and much that is know today has been passed down by word of mouth from one generation to the next. Matters are not helped by the family's surname changing. This was not, as previous publications have indicated, a method of concealing their identity, but was instead a natural evolvement of a name over time. In 17th century France the family was known as Favri. Papers held in the Fabergé Family Archives reveal its progressive change over the years through Favry, Fabri, Fabrier and finally to Fabergé. Gustav had adopted the name Faberge by 1825, but did not add the accent until 1842.

The early Favris were indeed fugitives as they were the subject of religious persecution. The family was of Huguenot descent and living at La Bouteille in the Picardy region of northern France, when in 1685, Louis XIV revoked the Edict of Nantes. The Huguenot movement of French Protestants developed during the 16th century and experienced persecution from an early stage. Their first martyr was burnt at the stake in 1523. However, in 1598, Henry IV promulgated a law at Nantes which gave his Protestant subjects a large amount of religious freedom. Known as the Edict of Nantes, it also gave Huguenots full civil rights and established a special court to deal with disputes arising from the Edict. Although the Catholics tended to interpret the law very strictly it at least gave the Huguenots a certain degree of protection.

When the Edict was revoked, it deprived the French Protestants not only of religious liberty, but also of all their civil freedom. Clearly such a situation was intolerable and over a period of a few years from 1685, France lost around a quarter of a million of its Protestant citizens. Primarily, they fled to England, the Netherlands, Prussia or America.

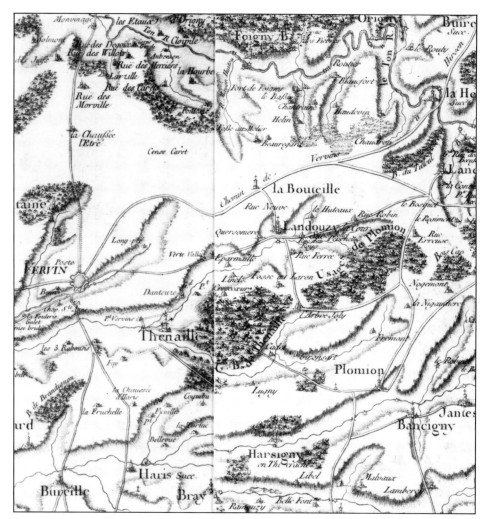

La Bouteille, the Fabergé's native village in the Picardy region of northern France — approximately 90km north of Reims. Circa 1750. (By Permission of The British Library).

Little is known of the family at this time. Whether they were silversmiths, merchants or farmers is, and will remain, a complete mystery, until more detailed research is undertaken. Escaping from the persecution in France they sought refuge in eastern Germany at Schwedt-on-Oder (north east of Berlin), though their exact date of arrival is undocumented. However, it is known that one Jean Favry was employed as a tobacco planter there during the last quarter of the 18th century. It has not been established as to how long they resided at Schwedt-on-Oder, but, by 1800, a Peter Favry had settled at Pernau in the Baltic province of Livonia (now part of modern Estonia). Around this period the family took out Russian citizenship, thus securing freedom from regligious persecution.

From the reign of Catherine the Great (1762-1796), religious freedom had been enshrined in Russian law. Moreover, since the early 18th century, Peter the Great's reforms had made the country attractive to craftsmen, artists and scientists as their services were in great demand. Many prospered and some amassed considerable fortunes. The situation continued during the first half of the 18th century and even improved during the second half. Catherine was an enthusiastic patron of the arts: as soon as she had ascended the throne, she instructed her envoys overseas to scour auction sales for objects to adorn her new Winter Palace at St. Petersburg. This is now The State Hermitage, regarded by many today as containing the world's finest collection of art treasures.

The Hermitage is generally recognised as having started as a museum in 1764, when Catherine instructed her architect to build a pavilion adjacent to the Winter Palace to house her art collection. This was expanding so rapidly that, seven years later, work started on a second adjacent building, this time of three stories, to take the overflow. The Empress was such a compulsive collector that processions of carts wove their way to Russia loaded high with works of art.

It was not unknown for sailing ships to dock at the quays of the Neva (the palace complex is built on the banks of this river) to discharge their cargoes of priceless paintings and objets d'art. However, the collection was not open to the public. As the Empress wrote to a correspondent in Paris, 'Only the mice and I admire all this. . .' Indeed, the first ever account of the Imperial collection at the Winter Palace states, 'Her Imperial Majesty's Hermitage is thus named from its designation to serve for the private amusements and exercises of Catherine II.' It was not until after her death that the Hermitage was referred to as a museum and then only individuals 'of certified worth' were admitted. As Boris Piotrovsky writes in the foreword of *The Hermitage, Its History and Collections*, it was, 'The first museum born of the art market as we know it today. . .'

Many Huguenots were fine craftsmen. For example, Paul de Lamerie, one of Britain's most celebrated silversmiths, was a Huguenot. His family escaped from France after the Edict of Nantes. It is reasonable to assume that had Peter Favry been an exceptional artist or craftsman, he would not have chosen Pernau as a place to settle. Instead he would have decided to reside at fashionable St. Petersburg. Old Russia was very keen on the French. Under Catherine the Great, the aristocracy adopted not only the French language, but also its culture. Therefore any talented individual with Gallic origins was more than likely to thrive in the 'aristocratic' St.Petersburg.

It was Peter Favry's son, Gustav, born in 1814, who travelled to St. Petersburg to make his fortune. Interestingly, in the latter half of the 18th century, a goldsmith named Fabergér or Farbiger originally from Wurtemberg, is said to have resided in the city and practised his craft under the patronage of Catherine the Great. It is not possible to confirm or refute that this gentleman was any relative to the Favris of Picardy. However, we do know that the young Gustav was not apprenticed to anyone named Farberger or Farbiger, although his chosen career was that of a goldsmith. Instead he learnt the craft from Master Andreas Ferdinand Spiegel. Afterwards he joined the celebrated firm of Keibel, which had reworked the Russian Crown Jewels in 1826.

In 1841, Gustav Faberge earned the title of Master Goldsmith, and one year later he was in a position to open his first basement shop in Bolshaya Morkskaya Street, St. Petersburg. From there he made and sold jewellery with the assistance of Johann Alexander Gunst and Johann Eckhard. It was a busy year for Gustav, for, in addition to opening his own business, he married Charlotte Jungstedt, the daughter of Carl Jungstedt, a painter of Danish origin. Four years later an event occurred which was not only joyous to both Gustav and his wife, but also was to be significant to the development of the business and beneficial to the world at large. This was the birth of their first son, Peter Carl Fabergé, who was also called Carl Gustavovitch in accordance with Russian tradition, but later better known internationally as Carl Fabergé. He was born on 30 May 1846.

Little is known of Gustav Fabergé's business. It appears to have been a typical quality jewellers that produced little out of the ordinary. However, it must have prospered, for young Carl attended the fashionable Gymnasium of St. Anne's, a school for the sons of affluent professionals and business people, as well as for the sons of lesser nobles. The institution was run on German principles; Fabergé senior appeared to favour the Germanic approach to life. It was apparent that he intended his son to enter the family business. It was therefore essential for the young Fabergé to receive a thorough grounding in the art of goldsmithing and also in business matters. The combination of artistic/technical and commercial skills showed foresight, for a business does not thrive on artistic achievement alone — one only has to note how many geniuses in the field of art who died penniless in their own lifetimes to realise this point. However, artistic training and commercial ability are not the sole ingredients

for success. In the artistic world one has to possess an intuitive gift for a chosen field of art. Gustav was more than blessed with the fact, whether he recognised it or not, that his son was extremely gifted. Regardless of this recognition, Gustav gave Carl Fabergé the opportunity to develop any latent skills, to travel and view what others did elsewhere in the then readily accessible Western world.

All that has been previously written on the House of Fabergé has somewhat ignored the rôle played by Carl Fabergé's father. However, it has to be recognised that he established the foundations upon which the business was based and did everything in his power to ensure its future success. Initially, the young Carl was trained 'in-house' by Peter Hiskias Pendin, a gentleman of Finnish origin who had originally trained as an optician and then as a goldsmith jeweller. Not only was he Gustav Fabergé's great friend, but also his partner. Pendin imparted all the knowledge that he had acquired during his second career to his young charge. Together they explored the techniques of the goldsmith and jeweller as well as the retailing side of the business. Apparently, Pendin excelled as a salesman. One family story is told by A. Kenneth Snowman in his book *The Art of Carl Fabergé*, which highlights his retailing skills. Pendin had sold a pair of pendant ear-rings to the wife of a prosperous merchant. A few days later she returned the pieces emphasising that while she liked them very much indeed, she felt that she was too old for such baubles. Pendin's remark, 'But my dear lady, just imagine what you would look like without ear-rings—like a cow without a bell!', persuaded her to retain the jewels.

In 1857, or shortly afterwards, the firm of Fabergé made an important association. August Wilhelm Holmström was a Swedish Finn who was born at Helsinki in 1829. He was apprenticed to the St. Petersburg jeweller Herold, became a journeyman in 1850 and a master in 1857. In that year, he purchased the workshop of Frederick Johan Hammarström and soon became Fabergé's principal jeweller. He and his family's association with the House of Fabergé was a long one. As Holmström was a superb craftsman, it was a very fruitful relationship.

In 1860, Gustav retired to Dresden. His affairs were watched over by Pendin and the day-to-day running of the business was left in the hands of V.A. Zaianchovski, his manager. Not only was the House of Fabergé financially successful at this time, but its 46-year-old founder must have been satisfied that it would not flounder during his absence. Gustav did not retire because of his own or his wife's ill health for, in 1862, the couple were blessed with another son who was christened Agathon.

Around the time of his parents' move to Dresden, the young Carl started a more extensive programme of education. His first port of call was Dresden, chosen no doubt so that Gustav could keep a paternal eye on his son. Carl undertook a business course at the Dresden Handelsschule and graduated in 1861 at the age of 15. He then became apprenticed to Josef Friedman, a renowned Frankfurt jeweller. As to how long he received tuition from Friedman is unknown. We are not even sure of the order of his European Grand Tour that followed.

It is believed that he was accompanied to Italy by Julius Butz, a friend whose father was Alexander Franz Butz, the St. Petersburg jeweller. No doubt the work of the Florentine enamellers and goldsmiths left a lasting impression on Carl's mind. Later in life he drew upon the memory of his visit to the *Opificio delle Pietre Dure*, the hardstone-carving workshops in Florence. London was not missed out of the itinerary, though the purpose of his visit appears to have been language as opposed to artistic training.

The young Carl's last port of call was Paris. He undertook a course at Schloss's Commercial College. This may have been his formal education, but it was not the only studying he undertook in France. Paris is a city that breathes

art. The Louvre of course immediately springs to mind as featuring at the top of Carl's list of 'places to visit'. He could not have failed to have been impressed with the fine collections upon display and either consciously or sub-consciously he would possibly have been burying designs in the depths of his mind to develop at a later stage. Paris is not just the Louvre, there are other smaller collections to view and café society to explore. Intellectuals, artists, writers and connoisseurs of art were always eager to exchange their views with anyone who cared to join the conversation. We shall never know what inspiration the young Russian found in this quarter. Then of course there was the Palace of Versailles with its sumptuous Baroque interior. Undoubtedly the greatest influence upon Carl Fabergé was French taste and art. The time he spent in France was therefore a critical period for his artistic development.

Nine years after his travels began, Carl Fabergé returned to St. Petersburg to take over the running of the family business founded by his father. Once Carl had returned in 1870, aged 24, to take control of the House of Fabergé, Pendin remained for a while to oversee the transition in the change of management. The mainstay of the business in Carl's early years of control was still traditional jewellery, but with the assistance of the master jeweller August Holmström, new styles were formulated. Pendin died in 1881, the year in which a move was made to larger premises across the street, to 16/18 Bolshaya Morskaya Street. Not only would this allow for expansion, but the shop at the new location was at ground as opposed to basement level.

In 1882 Carl's younger brother, Agathon, joined the company. Born during the early years of his parents' retirement at Dresden, he did not embark upon a European tour. He was only 20, 16 years Carl's junior, when he entered the business, and his education appears to have been centred at Dresden. According to Marvin Ross in *The Art of Carl Fabergé*, he developed, in that city and in later experience, a talent for designing so remarkable that many have considered him a finer artist than was his brother. He greatly influenced Carl, particularly in the design of 'objects of fantasy.'

During Carl's early years of control, the mainstay of the House of Fabergé was traditional jewellery although the House also produced jewels that radically differed from any made by Russian contemporaries. However with the lack of hallmarks and the general problem of dating pre-20th century Russian jewellery with any accuracy, it has not been possible for any meaningful academic study of the development of the Fabergé style in the 1870s to be undertaken. Also, it must be kept in mind that with Carl's commercial training, he would have realised that a business cannot be radical and be sure of survival, unless it has a solid foundation. His caution may have been greater as a family man. In 1872, he married Augusta Jacobs, the daughter of a manager at the Imperial Furniture Workshops. The marriage was blessed with the birth of five sons — Eugene (1874), Agathon (1876), Alexander (1877), Nikolai (1881) and Nikolai, later known as Nicholas (1884). The first Nikolai died in 1883, but the surviving four sons all later worked in the business.

His brother Agathon's arrival in St. Petersburg coincided with the necessary evidence in Carl's mind that his business was firmly established. The presence of his brother, combined with a desire to experiment with ideas he had formulated over a 20-year period, resulted in a turning point for the House of Fabergé. In 1882, the company exhibited to a wider public for the first time at the Pan-Russian Exhibition held in Moscow under the patronage of Tsar Alexander III. It is known that Fabergé exhibited copies of the magnificent gold treasures of the Scythians, the tribes which inhabited the steppes adjacent to the northern shores of the Black Sea from the 7th to the 3rd centuries B.C., as well as examples of his own jewellery designs. It was Count Sergei Stroganov, President of the Imperial Archaeological Commission which was based at the

Hermitage, that suggested Fabergé make imitations of the splendid objects excavated from barrows in the Ukraine and North Caucasus. These can still be viewed at the Treasury of the Hermitage, as can some of the Fabergé replicas.

The workmanship of some of these jewels is so fine that the guides tell visitors today that not even Fabergé was prepared to attempt to make copies of certain pieces. One item from the Scythian Treasure of which a replica was made, is a 4th century B.C. gold 'lion head' bangle found at Kerch in 1867. It is the work of Erik Kollin, Fabergé's head goldsmith from 1879 until 1886. Although not an exact replica of the original, it being hinged for easy wearing, the workmanship is superb. It was exhibited at the Pan-Russian Exhibition and one is now in The Forbes Magazine Collection at New York. Although we do not know the identity of any of the other objects shown by Fabergé, two things are certain; the company was awarded a gold medal and was subsequently brought to the attention of the Imperial family. When Tsar Alexander III was shown original items from the Scythian Treasure alongside copies made by Fabergé, it is said that he could not distinguish the originals from the replicas. He was so impressed that he ordered that Fabergé's work should be displayed in the Hermitage as examples of superb craftsmanship. By 1885, Fabergé was 'goldsmith by special appointment to the Imperial Crown'. In that year the company started to look in earnest for a market outside Russia. Exhibiting at the Nuremburg Exhibition, Germany, Fabergé was awarded a gold medal.

Fabergé's fame spread and it was clear that the company could not operate solely from premises in St. Petersburg. Although St. Petersburg was then the capital of Russia, Moscow, the country's second city, could not be overlooked by any businessman, so in 1887 the company opened the doors of its Moscow branch at 4 Bolshoi Kiselni Street. It is not generally appreciated that there was a significant English connection with the House of Fabergé in the 19th century. The Moscow branch was managed by three Englishmen — the brothers Allan, Arthur and Charles Bowe. Allan Bowe was Carl Fabergé's partner. He was, according to Henry Bainbridge, an astute businessman who ran the branch so as to commercially exploit Fabergé's reputation to the full. A letter from Allan Bowe is preserved at the Shrewsbury Museum in the UK. It is dated December 1901 and is addressed to J. Oswald Jones, an English jewellery designer. It relates to the terms and conditions of employment at the Fabergé workshops in Moscow and offers a unique insight behind the scenes at the House of Fabergé:

'Your letter of the 21st inst and two panels of designs and sketches have arrived. To judge by both the letter and the sketches, I think that you would suit us. At first you will find a certain difficulty in working to order, that is, making designs to meet the many requirements of customers. I also notice that you show me no jewellery work, where diamonds and other stones are used. This would have to be learnt. However, as you are young, you will, after 6 months' work (if you go at it seriously), find yourself a full-fledged jeweller's artist — and that is what I want.

Now to business, I offer you 160 roubles a month salary — which makes exactly £17 - The hours of work are: Winter, from 9 till 7, with one interval of an hour for lunch. Summer from 10 till 6, with one hour for lunch. These are the hours of my establishment and no exception can be made.

You would work in a large, light and warm room above the shop, where all my designers are. You are under nobody but myself — so that there is no possibility of being bullied by any overseer and C.

You would work only for the jewellery department – silver having its own men.

Living: I have made enquiries, and find that you can be boarded and lodged in a decent and comfortable way, in an English family, for 60 roubles (£6-8) a month, which would leave you 110 roubles a month to spend. We have a colony of 300-350 English men and women in Moscow, and among them you are sure to make some friends. I have four Englishmen (more or less so) in the shop.'

The Moscow shop concentrated on traditional Russian objects. Although Allan Bowe gives the impression in his letter that he was totally in charge (which is quite reasonable as he is writing to a prospective employee), Carl Fabergé's influence was very much present. Apart from being managed by Englishmen, the Moscow branch differed totally in clientele from the St. Petersburg establishment. The city of St. Petersburg was built as a 'window on Europe' and it was the home of the Court. Fabergé's aristocratic clients in St. Petersburg were very Western-influenced and responded to the objects that are now regarded as 'typical Fabergé'. On the other hand, the clients of his Moscow branch were a class of nouveau rich bourgeoisie who wanted traditional Russian wares. This does not imply that the merchandise on display at Fabergé's in Moscow was the ordinary stock-in-trade to be found at any Russian jewellers. The quality of Fabergé's Moscow silver is superb and his traditional Russian cloisonné enamel was of a more delicate colouring than those of his rivals. The Moscow workshops employed some 100 craftsmen.

In 1888, Fabergé turned his attention to Scandinavia, displaying a selection of his creations at the Nordic Exhibition in Copenhagen and was awarded a special diploma as the company exhibited *hors concours* (i.e. not competing for a prize). The 1890s were a period of further expansion and increased fame. In 1890, the St. Petersburg premises doubled in size and a branch was opened at Odessa. Only about 25 craftsmen were employed at the Odessa workshop, where small items of jewellery were produced.

Gustav Fabergé, the founder of the business, passed away at Dresden in 1893. An even greater blow to Carl Fabergé was dealt two years later when Agathon, his younger brother died at the age of 33. Agathon had devoted much of his time not only to designing, but to diverting the energies of the workshops away from making traditional jewellery to concentrate upon the 'objects of fantasy' which made the House of Fabergé internationally famous.

Agathon's departure did not halt the company's progress. In 1896, the House displayed a selection of its creations at the Pan-Russian Exhibition, Nijny-Novgorod and was awarded the State Emblem. The following year Fabergé exhibited *hors concours* at the Nordic Exhibition, Stockholm. It may appear strange that the company displayed at foreign exhibitions without competing for a prize. The reason at Stockholm, was that Eugene Fabergé, Carl's oldest son who joined the company in 1896, was a member of the jury. As to why generally the House of Fabergé did not like to compete at such events is a mystery; certainly it did not need gold medals or other prizes for enhancing its reputation.

At the Stockholm Exhibition the company made its first sale to a museum. The city's National Museum acquired a reddish-brown banded agate *kovsh* (a traditional Russian boat-shaped drinking vessel with a single handle) by the workmaster Michael Perchin. The gold handle takes the form of a pair of entwined dolphins in green enamel. They have diamond eyes and the anchor which flanks the dolphins is set with a cabochon ruby. The piece can still be viewed at the Museum. However, Fabergé's biggest triumph at Stockholm was to be granted the Royal Warrant of the Court of Sweden and Norway.

In 1898, it was decided that the enlarged premises at St. Petersburg were no longer adequate. Carl purchased 24 Bolshaya Morskaya street for 422,592 roubles, then about £45,000 or US$220,000 (on the basis that the exchange rate was then £1 = $4.86). Fabergé commissioned his nephew, the architect Carl Schmidt, to reconstruct the site and in 1900 the new building was complete. In addition to retail showrooms, the new premises contained most, but not all, of the workshops, the administrative offices and a private apartment for Carl Fabergé. It is interesting to compare contemporary photographs of the St. Petersburg establishment with those of the Moscow branch. The former, which is in the Gothic style, is discreet, albeit large, whereas the latter is emblazoned with Fabergé's name and is surmounted by a large version of the Imperial Warrant. They characterise the differences between the two establishments referred to above.

The year 1900 was probably one of the greatest for the House of Fabergé, for not only did the head establishment move into an imposing purpose-built edifice, but the House also exhibited in Paris and attained an international recognition of the highest esteem at the World Exhibition. Among the 'objects of fantasy' which Fabergé showed to the world, was a selection of items he had made for the Imperial Family. As well as miniature diamond-set replicas of the Russian Imperial Insignia, three Imperial Easter Eggs (see Chapter 5) were shown at the express wish of the Dowager Empress Marie Feodorovna and Tsarina Alexandra Feodorovna. This was the first time these objects, which still capture the imagination of the world, were publicly displayed. Fabergé must have been astounded by the reaction of the public and the jury, and although no prize was forthcoming, Carl Fabergé received a far more precious award that a gold medal. Unanimously the jury elected him a Master of the Paris Guild of Goldsmiths and additionally he was presented with the Cross of the Legion of Honour.

It is interesting to note in the *Rapports du Jury International (Joaillerie)*, published in 1902. the high regard with which the House of Fabergé was held:

'One has to express one's satisfaction when examining one by one and in detail the jewels exhibited hors concours *by the House of Fabergé, who is a member of the Jury. The work reaches the extreme limits of perfection, it means the transformation of a jewel into a real* objet d'art. *It is the perfect execution, completed with precise setting, which distinguishes all the objects exhibited by Fabergé. This may be seen on the miniature imperial crown set with 4,000 stones, or the enamel flowers which are so perfectly imitated that they would be regarded as perfect plants − or all the many* articles de fantaisie *which have been examined by the Jury at length.'*

Not everyone praised Fabergé. Monsieur Chanteclair, writing of the Paris World Exhibition, has this to say regarding the Azova Egg which was displayed (see Chapter 5):

'This small object, made by Holmströem (a Fabergé workmaster) represents one year's work: we did not very much appreciate the patina, the external ornaments of the egg, which are slightly exaggerated in the combination of colours, and the rose-cut diamonds in the centres of the rococo scrolls. As Monsieur Fabergé remains a true admirer of the French styles, we think he could easily have chosen among each of these some ornamentations which are less known, but equally decorative.'

But Monsieur Chanteclair was very much a lone voice in a sea of praise. The Imperial family were delighted at the reception Carl Fabergé received from an international audience in Paris. The Grand Duke Vladimir Alexandrovich arranged an exhibition of Fabergé's objects, including the Imperial Easter Eggs, at his palace in 1902. Also exhibited were miniature replicas of the Russian Imperial regalia which were also shown at the 1900 World Fair. Made in platinum and encrusted with diamonds, the Tsar's and Tsarina's crowns are 7mm and 35mm respectively in height, while the sceptre is 145mm high. After the exhibition at the Grand Duke's, the Tsar gave permission for them to be placed on display at the Hermitage, where they can be seen today.

Commercially, artistically and technically, the House of Fabergé was highly successful. Among its clientele were not only the Russian Imperial family and the country's aristocrats and bourgeoisie, but also the royalty, nobility and wealthy of foreign lands. Following the success of the World Fair, Carl Fabergé must have given considerable thought to opening a branch overseas. With his great love of French style, it would appear to have been logical to have opened retail premises in Paris. The House of Fabergé only operated permanently from one city on foreign soil and the chosen location was the capital of England – London. There were various reasons why this was not a surprise move. Allan Bowe, the Englishman who managed the Moscow branch with his two brothers, was a partner in the business. Edwardian London was a refined and wealthy city with scores of potential customers. In 1901/2, The Duchess of Marlborough (née Consuelo Vanderbilt) had visited the St. Petersburg showroom and had purchased substantial quantities of Fabergé's objects, including a magnificent egg. The Duke and Duchess of Marlborough were received by the Dowager Empress Maria Feodorovna and quite possibly were shown the Imperial Easter Eggs. The example commissioned by the Duchess is similar to the Serpent Clock Egg presented to Marie Feodorovna by Tsar Alexander III. The Dowager Empress was the sister of England's Queen Alexandra and the British Royal Family would have heard of Fabergé's ingenuity and craftsmanship well before the House of Fabergé began exhibiting outside Russia.

Whatever the combination of events, Arthur Bowe was despatched to London in 1903 and given the task of establishing a branch in England's capital. Initially he operated from the Berners Hotel, but later temporarily opened an office at Portland House, Duke Street, Grosvenor Square. Later the branch operated from 32 Old Burlington Street. The first public display of the company's objects took place in 1904, at the imposing Royal Albert Hall during a charity bazaar organised by Lady Arthur Paget. Most of the items initially offered in London were drawn from the stock at the Moscow branch.

In 1906, Fabergé dissolved the partnership with Allan Bowe and opened a branch of his St. Petersburg establishment at 48 Dover Street in London's West End under the joint management of Henry Bainbridge and his youngest son, Nicholas. Bainbridge was an Englishman. How he became associated with the House of Fabergé is briefly mentioned in his book *Peter Carl Fabergé Goldsmith and Jeweller to the Russian Imperial Court*, first published in 1949. In a footnote he states, '... while recovering from lead poisoning (contracted when working out the Bischof white lead process for Dr. Ludwig Mond) at Bushey Heath in 1904, I met a girl, Violet Powell by name. She sent me to her uncle, Arthur Bowe, and it was in consequence of this chance introduction that I became associated with the House of Fabergé.'

We are indebted to Bainbridge for a description of the London branch. Being a first floor establishment there were no window displays at ground level, and apart from the word FABERGÉ appearing in small letters on each side of the street entrance, there was no indication of the company's presence and there was certainly no hint of the type of business conducted. Those who passed through

the door would enter an entrance hall, where the commissionaire would greet the visitors, escort them to the lift and send them gliding upwards to the first floor. So as to forewarn those above, a small button would be pressed so that the staff could hastily prepare for the reception of customers. However, Bainbridge soon learnt that royalty rarely used lifts outside their palaces and the regal visitors would trundle up the stairs under their own steam to knock at the door with their bare knuckles. From Bainbridge's account the establishment was modest. He wrote in his book:

> *'To call these rooms "showrooms" or "galleries" would not be fair to them; they were far too modest for such glorification. A "backwater" is a better term, for it was here, quite unknown to the passing crowd in Piccadilly that kings put aside their crowns, that ambassadors, maharajahs and magnates of all kinds, gay lords, grave lords, law-lords, and the lords of the Daily Press, together with the throng of Edwardian society, cast off their chains of office, and leaving the main-stream of their activities for a while, spent a cool and refreshing half-hour.'*

Bainbridge recalls on one afternoon, Queen Alexandra accompanied the King and Queen of Norway, the King of Greece and the King of Denmark to the House of Fabergé in Dover Street. 'May we open the drawers?', the Queen asked.

Recently the sales ledgers for the London branch were discovered. Alexander von Solodkoff, a London dealer and Fabergé scholar, first wrote of them in *The Connoisseur* of February 1982 and elaborated further about them in *Masterpieces from the House of Fabergé* published two years later. The two leatherbound folio volumes record the date of the sale, the purchaser's name, a description of the object sold, its inventory number, the sale price in pounds sterling and its cost price in roubles. The column of purchasers' names reads like a *Who's Who* of Edwardian society. What a fascinating insight they also give to the shopping habits of the upper classes of the day. The ledgers reveal that while King Edward VII and Queen Alexandra visited Dover Street infrequently, more often than not they purchased a substantial number of objects which remain in the Royal Collection. So too do objects bought by others as gifts for the British monarchy. For example, on 28 November, 1910, the Hon. Mrs. Ronald Greville bought, "Dog 'Caesar', white onyx, brown enamelled collar with inscription, 'I belong to the King', Nr. 18521, £35 (cost price 157 roubles)." This is in fact a model of King Edward's Norfolk terrier. It is carved from white chalcedony and the eyes are cabochon rubies. A small gold bell hangs from the collar. It is still in the British Royal Collection and was exhibited at the Fabergé Exhibition staged at The Queen's Gallery, Buckingham Palace in 1985. Caesar was Edward's favourite dog and accompanied his master nearly everywhere. At the King's funeral, Caesar was carried immediately behind the coffin, ahead of the Royal Family and the foreign monarchs.

The ledgers also give an interesting insight into prices. Simple enamel Easter eggs sold in the range of 10 shillings (£½) to £1., and more elaborate gold mounted examples retailed at various sums from £3 to £10. The average price for a hardstone animal figure was £25, though as indicated above, commissioned examples could sell for over £35. Cigarette cases, a popular gift in Edwardian England, would sell from £7 to £120 according to the material used (silver examples were in the lower range, with gold cases decorated with gems and enamel selling at the higher figures). The enchanting flower studies, of which only 35 examples are recorded in the ledgers, sold at various sums from £20 to £117. Enamelled silver frames would cost their purchaser anything

from £20 to £30, while gold or silver mounted wooden examples could have been obtained in the £4-£7 range. The highest prices were for jewellery; £1,400 was paid for a diamond tiara in December 1909. In 1911, the London branch moved to 173 New Bond Street.

Fabergé's business expanded far beyond London in the first decade of the 20th century. Although the House of Fabergé did not have trade premises in France, the company made at least two visits a year. Annually, before Christmas, a selection of objects was taken to Paris, while to meet the demand at Easter, visits were made each Spring to Nice, Cannes and Monte Carlo. It is believed that the French trade was conducted from London, for in his book Bainbridge makes reference to submitting articles to the assay office in Paris for hallmarking. Carl Fabergé also incorporated visits to Paris in his trips to London. Fabergé objects were keenly sought by the French following the impact that the House made at the 1900 World Fair in Paris. Such was the popularity of Fabergé's objects in Siam (modern Thailand), that Carl was invited by His Majesty King Chulalongkorn to Bangkok in 1904. In March 1890, Nicholas, later Tsar Nicholas II, called at Siam during a naval cruise and was entertained by the King of Siam. They appeared to have formed a firm friendship. King Chulalongkorn presented his visitor with two elephants and a white monkey as presents for Tsar Alexander III. The Tsar was particularly fond of the monkey and as an act of gratitude, and for the hospitality extended to the Tsarevitch, he bestowed Russia's highest order, the Order of St. Andrew, upon the King of Siam. Seven years later, King Chulalongkorn visited St. Petersburg and was entertained by Tsar Nicholas II. It is believed that the underlying reason for the journey was political, for two days after the arrival of the Siamese party, it was announced that talks had taken place regarding France's aggressive adventures into Siam and that the Tsar was going to intercede. However, regardless of the reason for King Chulalongkorn's visit, all that concerns us is the strong links between the two countries in the early years of the 20th century.

The House of Fabergé was 'Goldsmith and Jeweller to the Imperial Court' and such were frequently commissioned to produce 'specials' that were then given as gifts to visiting dignitaries by the Tsar. An extensive stock of Fabergé's creations were permanently housed at the Winter Palace at St. Petersburg for such occasions. Items typically given were signed photographs of the Tsar, in a Fabergé frame of course, boxes or cigarette cases, possibly bearing the Imperial cypher, tie pins or brooches. This treasure house would be replenished by the House of Fabergé once a month. The King of Siam was presented with at least one Fabergé object during his visit.

King Chulalongkorn was accompanied to Russia by his son, His Royal Highness Prince Chakrabongse. The 15-year-old Prince remained at St. Petersburg after his father's departure and lived as a member of the Imperial Family. He attended the *Corps des Pages* and rose to the rank of captain in the Hussars. In 1906, he married Catherine Denitski, an 18-year-old Russian. After the King of Siam's departure, the Tsar, and possibly even the Prince, sent gifts of Fabergé objects to Siam. These clearly were well received in Bangkok, hence the King's invitation to Carl Fabergé. Whether Carl Fabergé himself ventured to the East is unknown, but we do know that at least one member of the Fabergé family made the long journey to Bangkok. The Thai Royal Collection of Fabergé objects is still cherished by the present Royal family. In addition to typical Fabergé items, it also contains specimens that are typically Eastern such as the 380mm high Buddha carved from nephite which is still kept in the King's private chapel. Other objects combine Western and Eastern styles, such as the nephite gold mounted and diamond encrusted box, the lid of which is decorated in sepia enamel with a view of The Temple of Dawn. A few items from the Thai Royal Collection are on public display at the Teak Mansion, Bangkok.

In 1905, a further branch of the House of Fabergé was opened in Kiev. Only about 10 craftsmen were employed in the production of small jewels. However, the venture appears not to have been a success, for the branch was closed in 1910. This is not an indication that Fabergé's acumen was waning, but merely that Kiev was not a suitable location for the sale of the company's objects. The output of the House of Fabergé reached a peak in 1913 with the Tercentenary of the Russian House of Romanov. The event was celebrated with great splendour. Fabergé's creations were in great demand as they were considered the most suitable gifts to mark such an occasion. The Tsarina Alexandra Feodorovna prepared sketches for brooches which the Imperial Family wished to present to the Grand Duchess and ladies of the Court. The House of Fabergé prepared designs for the approval of the Tsarina before making the brooches, all of which incorporated the Imperial crown and emblems. Various combinations of coloured stones and pearls ensured that each piece was unique.

However, clouds of gloom were already beginning to form; World War I brought austerity. Many of Fabergé's clients became impoverished while those that did not, had other things on their minds than 'objects of fantasy'. As its contribution to the war effort, the House of Fabergé started to produce hand grenades. In 1915, the Tsar ordered that all Russians repatriate their capital held abroad. The branch in London closed its doors and until recently it was considered that no business was transacted after that event. However, the discovery of the sales ledgers of the London branch reveals that Henry Bainbridge continued dealing privately on behalf of the House of Fabergé until 9 January 1917. In 1917 the entire stock of almost 200 objects was sold *en bloc* to Lacloche Frères, the Paris jewellers, as it had been importing French *objets d'art* into Russia since the turn of the 20th century. Lacloche remarked all the Fabergé boxes with its own label.

It was not World War I that proved fatal to the House of Fabergé. In 1916, the business was changed from a partnership into a joint stock company with a capital of 600 shares issued at 5,000 roubles each. The new legal entity was thus valued at three million roubles. In 1917, the year of the Russian Revolution, the company was taken over by the 'Committee of the Employees of the Company K. (Carl) Fabergé'. Carl Fabergé, realising all he had worked for was no more, left Russia.

With the assistance of the British Embassy, Carl Fabergé began his escape. His journey was to be hazardous. During a brief pause at Riga, the Bolsheviks attacked the town. He fled to Berlin and again encountered problems. By 1920, having journeyed via Frankfurt-on-Main and Hamburg he was in Wiesbaden, and here, in May, he spent his 74th birthday with 15 of his old St. Petersburg friends. It is usual to refer to birthday celebrations, but Carl Fabergé could not have felt that festivities were in order. He was not surrounded by his family and everything he had worked for was his no more. He was a broken man and often repeated the words, 'This is life no more'.

Madame Fabergé, his wife, appears not to have left St. Petersburg until December 1918, when she left secretly with Eugene, her eldest son. They journeyed through Russia by train, sledge and on foot. In Denmark the two parted and Madame Fabergé travelled to Lausanne, Switzerland, via London. Shortly after his birthday, Carl fell ill. It was not long before Madame Fabergé was at his side with other members of the family also gathered at Wiesbaden. In June 1920, when Carl was well enough to travel, he and his wife settled at the Bellevue Hotel, Lausanne. Initially Carl's health improved and he even enjoyed excursions into the surrounding district. However, in July he fell in his room and was put to bed. He never recovered, he died on 24 September 1920. Augusta Fabergé, his wife, died five years later.

In 1929, Eugene, their eldest son, removed his father's remains from Lausanne Crematorium and took them to Cannes to be buried in his mother's grave. The black Swedish porphyry tombstone reads:

CHARLES FABERGÉ
joaillier de la Cour de Russie
né 18 mai 1846 à St. Petersburg
décédée 24 Septembre 1920 à Lausanne

AUGUSTA FABERGÉ
née Jacobs
née 25 decembre 1851 (vieux style) à Tsarskoe Selo
décédée 27 janvier 1925 (nouveau style) à Cannes

Carl Fabergé and his eldest son Eugene, photographed shortly before Carl's death in 1920. (Courtesy of The Fabergé Family Archives).

Chapter 4

CARL FABERGÉ –
THE MAN AND HIS WORK

There are only a few people alive today who knew Carl Fabergé. But he was captured on celluloid and from the photographs which have survived we can view the man whose work enchants so many. It seems odd that in two groups taken as far apart as 1895 and 1918 he is photographed seated in a wheelchair. But it would be unsound to conclude that Carl Fabergé was an invalid. He was in fact an active person, until his last years, for Henry Bainbridge who visited him in St. Petersburg and who was also the manager of the London branch, recalls long walks with his employer in the then Russian capital. He also makes reference to the head of House visiting London and Paris in his book *Peter Carl Fabergé Goldsmith and Jeweller to the Russian Imperial Court* published in 1949. One can only conclude that the earlier picture was taken during a period of convalescence – the later one was taken at Wiesbaden after the Revolution when Fabergé was a broken man and mourning the loss of his lifetime's endeavours.

It is a profile portrait of about 1918 that gives us the most detailed record of this jeweller extraordinaire: Fabergé is facing to the left staring into the distance as if recalling time past and contemplating the present as well as the future. There is possibly a slight trace of melancholy in the eyes, but one can also believe that they were capable of being far more penetrating with regard to detail than the average man's outlook on the world. The most striking feature of his visage is not the classical nose, or the finely groomed beard, but his large, gently sloping forehead.

By their very nature, character assessments from photographs are subjective. A more positive approach to gain an insight into the man would be to examine something he wrote about the House of Fabergé. Although no history, as far as we know, was penned, the company did produce catalogues. These were published for the benefit of clients who, 'Because they live in the provinces, have no opportunity of visiting our premises personally and of seeing for themselves our rich selection of goods'. Although it is doubted whether Carl Fabergé was responsible for writing their contents, it goes without saying that he would have made alterations to the text until he was entirely satisfied that what was presented to the public was correct in every way. This is how he worked. Consequently, we know that everything emanating from the House of Fabergé bears his touch, even if it was not the product of his own labours.

The following is a translation from the French of the introduction from a Fabergé catalogue published in Moscow during 1899:

1. *The products of our firm are frequently renewed due to the bizarre demands of fashion: new objects are offered for sale every day.*

2. *Some of our best objects cannot be published because we fear they will be imitated by our competitors.*

The products of our firm are executed in our own workshops with materials of highest quality. The best artists, working exclusively for us, give us a variety of remarkably elegant designs which are as good as the best works of our foreign competitors. With regard to the Selection, we would like to mention the high quality of all sorts of articles in silver, gold, or brilliants in all kinds of designs including those of the latest fashion. With regard to the quality of our products, it will suffice to give our esteemed customers the four principles to which our production has rigorously submitted throughout the many years of our activity.

1. *We only offer objects which are in perfect condition; this means, each item – even if the value is not higher than one Rouble – is fabricated with precision in all details.*

2. *We always try – and our customers can always rest assured of it – to offer a large quantity of newly designed articles. Old items which are out of fashion are not kept in stock; once a year they are collected and destroyed.*

3. *We always try to produce our articles in such a way that the value of an object corresponds to the sum of money spent on it; in other words, we are selling our objects as cheaply as the precise execution and workmanship permits.*

4. *Due to our considerable capital we are able to have a stock of a large quantity of articles both in variety and value which are offered to our esteemed customers.*

What does this passage reveal about Carl Fabergé? Clearly he strove to be at the forefront of fashion. It is interesting to note that the stock was added to daily. Presumably, by the term 'new objects', he meant items that were unique for it was not Fabergé's policy to make two identical items (other than pairs). It is no mean achievement to add new designs to stock each day, for even if the additions were a variant of an existing line, a considerable amount of creativity would be required. Emulation, it is said, is the highest form of flattery, but in a competitive commercial environment, copying is a deadly enemy. Not to publish details of 'our best objects' shows a degree of modesty coupled with good business acumen. It also reveals an excellent form of marketing. To throw the veil of secrecy over some of the activities of the House of Fabergé creates a mystique which could only but increase the public's desire to learn more. Certain sectors of society would yearn to be allowed into the 'inner-sanctum' to at least see, and hopefully to buy, the treasured creations. Possibly unwittingly, but it is doubted, Fabergé was generating what the economist calls 'conspicuous consumption', or the buying of objects to impress others. This is an essential ingredient to a successful luxury trade.

In the previous chapter, it will be recalled that Carl Fabergé undertook a business course at the Dresden Handelsschule in his teens and, while on his Grand Tour, a period of study at Schloss's Commercial College, Paris. Whether or not he learnt selling techniques at these establishments is not known. However, as marketing is a relatively new tool of management, and one which has only become an academic subject in recent years, it is doubted whether he received a formal education in this area. Fabergé's subtle promotional style was therefore no doubt formulated in his rôle as a business man. It is unusual for a man of artistic temperament to be gifted also in the practical commercial field. Clearly, Carl Fabergé managed to combine the two rôles without his business skills being detrimental to his jeweller's art. The fine balance between art and commercial success is rarely achieved by creative geniuses.

The passage, *'We always try to produce our articles in such a way that the value of an object corresponds to the sum of money spent on it'*, is interesting. What follows, the reference to *'selling our objects as cheaply'* as permitted, is undoubtedly an illustration of Fabergé's salesmanship. However, the passage reveals, if it is not just a selling technique, that the House of Fabergé possibly used a reasonably advanced accounting technique. Cost accounting was formally developed this century when the running of a business became a management science rather than something that just happened. The passage implies that the House of Fabergé had given more than a passing thought to costings. It is relatively easy to do this when the business is a normal manufacturing concern — a factory which is producing thousands of identical 'widgets'. However, it is another matter when the business is like Carl Fabergé's — producing thousands of 'one-off' items. It means that not only does the cost of the raw materials and direct labour have to be calculated for each object, but a proportion of overheads also has to be allocated to each creation. Clearly, considerable thought had been given to the whole complex matter of costings. It is reasonable to assume that lesser objects would have been subjected to some quick rule of thumb with only the more expensive items being the subject of a detailed cost analysis. However, whatever technique was used, the success of the House infers that the administration was smooth and did not interfere with creativity generally. The implication is that Carl Fabergé had a balanced view of life and always trod the course where neither his artistic rôle interfered with his business acumen and vice versa. This is a characteristic of an unusual exceptional man: the practical genius.

The policy of destroying all stock that remained unsold after a period of one year could have been a marketing ploy. It was fashionable to shop at Fabergé's and the statement would certainly appeal to those who wished to restrict their purchases to the very latest style. It also reveals that Carl was not a stubborn man. The final test as to whether an artist, craftsman or manufacturer has made objects which appeal to the public, is to see the items selected from the display cabinets and to hear the cash register ring. If an object lies gathering dust, it is either not considered to be value for money or it does not appeal. In other words, the design, standard of finish or general appearance does not conform to contemporary acceptability. There is no doubting that quality control was strict at the House of Fabergé. Indeed, there is an old story that Carl Fabergé carried a small hammer in his pocket. If any object he saw in his workshops was not of the standard set by the House, he would attack it with this destructive weapon. This treatment would not only serve to drive home the standards required by the House to the workman whose object had offended, but was also a salutary warning to others.

Above all, the introduction reveals a perfectionist. Such individuals are not always easy to deal with. Their exacting demands upon others can lead to friction based upon 'unreasonable expectations'. However, there is no contemporary evidence to suggest that Carl Fabergé's quest for the ulimate standards of craftsmanship ever bordered upon the over-fastidious. He had a workforce of up to 700 employees. To maintain consistently high standards over a period of nearly 50 years means one thing: he was highly respected by those he employed. From this one can speculate that he himself could achieve the quality of work he expected from others. In other words, it was not a question of, 'Not good enough', but he would be able to state why the quality had not been achieved and no doubt give guidance to prevent the same situation occuring. But, respect alone does not result in the smooth running of an artistically creative business. The man at the top, in order to attain his goal, must have outstanding qualities of leadership. Remember that Carl Fabergé built up his business during a period when there were under-currents of revolution in his country. There is every indication that he was revered by those he employed, with the reverence being

weighed heavily towards affection.

Through photographs and the introduction to a catalogue, an attempt has been made to give some indication of Carl Fabergé, the man. The only way in which it is possible to obtain a greater insight into Carl Fabergé is to refer to Henry Bainbridge's book and become enveloped in his reminiscences. Apart from knowing Carl Fabergé personally, he also benefited in 1937 and afterwards, from long conversations with Carl's son Agathon and was able to add considerably to his own knowledge. The result is a book rich in material. No wonder Mr Bainbridge sub-titled the opus 'His Life and Work'. It says more about Carl Fabergé than does any subsequent work.

We learnt in the previous chapter how Henry Bainbridge was introduced in 1904 to Arthur Bowe, who had been despatched from Moscow to London to establish a branch of the House in England's capital. Bainbridge had had an interest in Russia from his schooldays. He recalls a day in 1884 at Teesdale in the north east of England, when, at the age of 10, he developed an intense desire to visit that vast country. As to why, he remains silent. Possibly it was just a boyhood whim. He appears to have launched into a career as a 'coalminer and research chemist'. It was while recovering from lead poisoning contracted as he developed the Bischof white lead process for Dr. Ludwig Mond, that his introduction to Mr Bowe was effected. Bowe recommended him to Carl Fabergé. In 1906, the 32-year-old Henry Bainbridge found himself in St. Petersburg to meet Mr. Fabergé, then 60 years old. Carl Fabergé appears to have been a man who followed his intuition and consequently his decisions were more or less instant. Bainbridge refers to his accepting individuals who, 'came his way' and making the best of them. However, this statement says as much for Mr Bainbridge's modesty as it does about Carl Fabergé. Fabergé would have quickly assessed Henry Bainbridge's potential and decided that he was the man to represent the House in London. Clearly any choice of personnel was an important one, but the appointment to the observer appears to have been casual.

During the six weeks Henry Bainbridge was in St. Petersburg, Fabergé and his future employee explored the city and its environs. They visited The Hermitage, the historical buildings, walked in the countryside and sampled the best food and wine. Conversation was minimal on these excursions and the only time business was mentioned was when Bainbridge, 'grasped a *bonbonnière* like a piece of coal'. Fabergé apparently shivered and no doubt gave his future representative a lesson in handling objets d'art. It may be surprising that Fabergé was generally silent when showing Bainbridge Russia's capital. The fact is that he was conversationally economical on the task of the moment, whether it was working or eating and never used two words when one would suffice. Bainbridge recalled that feeling out of the conversation at a dinner party, he decided to engage in some 'small talk' with Carl Fabergé. He opened with, 'I see Lord Swaythling is dead'. 'And who may Lord Swaythling be?' came the response. 'A banker', replied Bainbridge. Fabergé's question, 'And what can I do with a dead banker?' drew the attempt for a *tête-à-tête* on society matters to a swift conclusion.

This may appear to be the characteristic of a severe man. It is not. Quite simply Carl Fabergé did not like to waste his time on matters that were not productive. This does not mean that he was unkind or lacked a sense of humour. Indeed, he was of a generous disposition and enjoyed a joke. Bainbridge recalled that at one dinner party at which Fabergé was the host, he had been partnered with a German lady. Conversation between the couple did not flow easily. Noticing the situation, Fabergé broke the ice by placing a Hindustani dictionary between Bainbridge and the German lady, with the words, 'Perhaps that will help you'. St. Petersburg was a city where the practical joke thrived and Fabergé was on the receiving end of some quite lavish ones. For example, there was his friend John, who lived at Saratov. Carl once jokingly remarked to him, 'John for 20

years you have sent me caviar at Christmas, but there are other things in Russia, camels for example.' A little time elapsed before a brightly dressed Kalmuck arrived at 24 Bolshaya Morskaya Street with a letter addressed to the head of the House. It read, 'My dear Carl, you asked me for a camel. I have sent you one.' Much to Fabergé's amusement, a camel was tethered outside his fashionable premises.

One would imagine that Carl Fabergé, with his frequent contacts with royalty, the aristocracy and senior officials, would always have been donned in dark suits of the very best cut. However, he did not pander to conventional attire. Bainbridge makes reference to Fabergé's dress being, 'punctilious in his own particular way'. He did not favour black as a colour, but had a preference for tweeds. Bainbridge continued: 'There was an air of the country gentleman about him; at times he reminded one of an immaculate gamekeeper with large pockets.'

This sentence may have completely destroyed the picture that was being built in one's mind. Fabergé was not a stereotype of jeweller. Most of us have preconceived ideas of how certain individuals who follow a trade or profession should look. Perhaps we think of the artist wearing a smock, a banker donned in a pin-stripe suit and of a butcher wearing a blue and white striped apron, his head crowned with a straw boater. However, few of us have any notion of how an 'artist jeweller', as opposed to a 'retail jeweller' in his showroom should look like. It therefore should not be too much of a shock that Carl Fabergé resembled a gamekeeper. One can learn a considerable amount about a person from their dress. In my opinion, Fabergé's preference for tweeds shows two things. First, despite his fame, he did not adopt airs of pretentiousness, but continued to be modest. Second, it reflects a human approach to life.

Fabergé was not so eccentric that he presented himself at the royal palaces of Europe donned in tweeds — he knew when and how to follow convention. The following conversation recorded by Bainbridge reveals this, and also another aspect of his character. Queen Alexandra, the wife of England's Edward VII, was an ardent fan of the great man and also a very good customer. She desperately wanted to meet the man whose creations gave her such pleasure. The message to Henry Bainbridge was very clear, 'If Mr.Fabergé ever comes to London you must bring him to see me.' When Carl visited England's capital, Henry Bainbridge broached the subject of the Queen's wishes at the earliest appropriate moment.

Fabergé: *'The Queen wants to see me. What for?'*

Bainbridge: *'Well, you know what an admirer she is of all your things. She wants to see you, that's all.'*

Fabergé: *'Nonsense! Besides, she will have forgotten all about it by now and won't want to be troubled.'*

Bainbridge: *'But really Mr. Fabergé, she did give me that message. If she should hear you have been in London and have not informed her, it will be very awkward to explain.'*

Fabergé: *'But I am en voyage and have no clothes. Look at me. I cannot go like this! There is my son Nicholas and yourself.'*

Bainbridge: *'Yes, I know, but we are not you. Come, do let me write to Miss Knollys to tell her you are here, or I could telephone straight away.'*

Bainbridge's pleas were to no avail. Carl Fabergé was adamant that he was not

going to the Palace, even if the Queen of England was one of his greatest fans and a very good customer. Within half an hour of declining the royal 'command', he was on a train bound for Paris. At least Bainbridge would have had the excuse that his employer had only made a 'flying visit', should Her Majesty ever had learnt that the head of the House had been in town. Suitable clothes to one side, the conversation confirms Bainbridge's view that despite all his travels, Fabergé was only really at home in St. Petersburg. Take him away from that elegant capital on a business trip, as opposed to a vacation, and he, 'would wilt'.

In his book, Bainbridge paints a picture of a man with idiosyncracies. All individuals with character could normally be so described and many people with artistic talents have their little ways that distinguish them from the humdrum of humanity. Bainbridge writes, '(He was the) most unbusinesslike of men and his methods (were) the most topsy-turvy, judged by ordinary standards, yet Fabergé was one of the most successful.' The fact is that Carl Fabergé was no ordinary person. As for his business methods being 'topsy turvy', they may appeared to have been so, but they were nevertheless based on sound principles. In my opinion, Fabergé was a natural at commerce, he had a thorough grounding in business and although he appeared not to give such matters thought, acted like the experienced motorist who drives intuitively when over-taking another vehicle and does not need to resort to complex calculations.

An astute businessman can be a cold calculating creature. It is apparent that Fabergé was not of this ilk. The phrase, 'Live and let live', was the one he most frequently used. Bainbridge wrote that Fabergé had, 'As near to a complete understanding of human nature as it is possible for a man to come'. Given one word to describe his character, 'tolerance' would be the most appropriate in Bainbridge's opinion. When Fabergé accompanied the newly appointed manager of the London branch of the House to St. Petersburg station for his return journey to England, all the advice he gave was the two words, 'Be noble', before he vanished quickly back to his work.

At the height of his fame, Fabergé's visiting card was a passport to palaces and embassies throughout the world. However, Fabergé the individual was almost unknown outside St. Petersburg and Moscow. His name had spread, but he did not crave publicity. His work spoke for itself. There was no need in Fabergé's view to promote the House himself as the firm's reputation was second to none. Although advertising was undertaken, Carl Fabergé's objects generally sold themselves.

Well over 100,000 items emanated from the House of Fabergé, when Carl was at the helm. By the turn of the century 500 workmen were employed by the House and the figure possibly reached 700 at the peak of the company's success in 1913. Matters are put into a more manageable perspective with the information that at least 20 workers were engaged soley in the manufacture of the silk and velvet lined wooden cases that were used to house the objects the firm sold. Needless to say, the cases, like their contents, were of the finest craftsmanship.

In an interview he gave late in 1913, Carl stressed to the interviewer that he was not a merchant, but, an 'artist-jeweller'. The resultant feature appeared in the 15 January, 1914 edition of *The Capital and Countryside*. Entitled *A Little Something About Jewels*, the piece is not entirely devoted to Fabergé:

'The Russian jewellery master Fabergé is one of the premier in the world. At his branches in St. Petersburg and Moscow, over 500 workers and craftsmen are employed. The firm has already produced a mass of artistic creations which are already dispersed throughout the whole world. It is

understood that Fabergé is a constant supplier to the sovereigns of almost every country. He exibits to American millionaires and the English gentry. At present, he is fulfilling an order for the King of Siam...

Clearly, comparing my own business with such fims as Tiffany, Boucheron and Cartier, they probably have greater jewels than us. At their establishments it is possibly to find a ready-made necklace for 1½ million roubles. But you see, they are traders, not artist-jewellers. An expensive piece interests me little if its worth is only because it is set with many brilliants or gems', the old man Fabergé told me.'

The writer then looked around one of Fabergé's workshops and came across a 'little leaf', presumably a jewel of some description, which cost 2,000 roubles. He remarked, 'If one dropped it on the floor, no one would notice it.' The interviewer then asks Fabergé, 'Who will buy such things? Are they not a waste of money?' Fabergé diplomatically avoided replying to the pointed question about value for money, but merely said, 'There are people who became bored with jewels and gems long ago … They are attracted to such trinkets'.

The interviewer stresses that Fabergé was not impressed by stones purely because of the quality of the gem. It was the overall effect that concerned him, not the fact that every diamond was perfect. Indeed, he was not adverse to using diamonds that had imperfections visible to the naked eye in minor pieces. One thing was never allowed to lapse − the quality of the workmanship of the House.

When people are first introduced to the works of Carl Fabergé, they are sometimes surprised that he was not personally responsible for every item that is a 'piece of Fabergé'. There should be no looks of astonishment, for not every piece of silver marked Paul Storr, or item of furniture that is 'Chippendale', is the personal work of these particular craftsmen. Even certain artists are not always responsible for an entire canvas that bears their signature, for the less important areas could be by the hand of an assistant. However, the final work would have the approval of the master, whether he or she, was a 'craftsman', designer or artist. The same applies to Carl Fabergé.

Although during his apprenticeship he would have learnt the craft of the goldsmith, all of his adult life he was a designer who followed his creation through the various stages to the final product. No item is known to exist from his apprenticeship days, or indeed later in his life, that is solely of his making. The fact has cause confusion. For example, there is a passage in *Fabergé in the Royal Collection*, published in 1984, which details the pieces in the Thai Royal Collection, and declares, 'Fabergé's main job was not so much on the actual manufacturing side as in organisation and management. This perhaps explains why no piece can be proved to have come from Fabergé's own hand. It could be said that Fabergé saw himself not as an artist in his own right, but as the leader and co-ordinator of a body of outstanding artists and craftsmen'. Alas this entirely misses the point of Carl Fabergé's rôle.

Throw a stone into the centre of a pond and its ripples spread to the edge. Carl Fabergé's effect on his organisation was a little like this situation. He was at the centre, but his presence and influence were felt and seen throughout the House, whether in London, Moscow, Kiev, Odessa or St. Petersburg. The nucleus of his empire was his office, for it was here that Carl's ideas, or those developed in collaboration with his designers, began their passage through the House. After possibly discussing proposals with their Head Workmaster, the draughtsmen would translate the rough sketches into detailed technical drawings. It would also be their responsibility to plan the various stages of production. A meeting would be held in Fabergé's office. All those involved with the manufacture of the piece in hand would be seated at the round table. The shape

of the conference table is significant as it indicates that those concerned worked together as a team, even though there was a hierarchy.

The most important man below Carl was his Head Workmaster. The first was Erik August Kollin, a Swedish Finn from Pohja. Born in 1836, he was apprenticed at Tammisaari, but moved to St. Petersburg in 1858, where he worked for August Holmström, who had become Gustav Fabergé's principal jeweller in the previous year. Kollin qualified as a master in 1868, left Holmström's employ and established his own business. In 1870, Carl Fabergé, who took control of his father's business in the same year, appointed Erik Kollin as his Head Workmaster responsible for the management of all of the House's workshops. Kollin's work is not often encountered today. His most famous creations were copies of the Scythian Treasures described in the previous chapter and which were exhibited at the 1882 Pan-Russian Exhibition. It is Kollin's work that brought The House of Fabergé to the attention of the Imperial Family. In 1885, the firm was granted the Imperial Warrant. Whether Kollin felt that he could fare better upon his own is unknown, but in 1886 he left and established his own business. However, he retained links with the House, for items bearing his marks, but in specially-fitted Fabergé boxes, do exist, though generally his work is now relatively scarce.

All those involved with the House appear to have lived in a closely knit community, for Kollin's successor was Michael Evamplevitch Perchin. He was quite a remarkable man for, born of peasant stock at Petrozavodsk in 1860, he was basically self-taught, learning skills from local craftsmen. He journeyed to St. Petersburg and became apprenticed to Erik Kollin. Perchin qualified as a master in 1884 and upon Kollin's departure from the House became Fabergé's Head Workmaster. The objects bearing his mark are diverse. They range from hardstone animal figures to fine jewels, from exquisite gold and enamel objects to the ultimate pieces that emanated from the House — the Imperial Easter Eggs. Perchin remained with the firm until his death in 1903.

Possibly Michael Perchin was grooming the man to replace him after his demise, for Hendrik Emanual Wigström secured the position. He was a Finn from Tamminsaarie and was Perchin's junior by two years. Wigström arrived in St. Petersburg around 1878. Having completed his apprenticeship he became a journeyman — i.e. was hired to work by the day — in Michael Perchin's workshop and later became his assistant. When Perchin died, he was appointed Fabergé's Head Workmaster. He remained with the firm until after the Revolution when the House was no more. As this included the firm's most productive period, it is not surprising that Wigström's mark is one of the most frequently encountered on Fabergé's objects. Like his predecessor, he was responsible for crafting the Imperial Easter Eggs. He also specialised in photograph frames and cigarette-cases and enamelled objects generally.

Under the Head Workmaster there were workmasters who were either goldsmiths, silversmiths or jewellers, and their employees. Some of the workmasters ran their own businesses and worked under contract for Fabergé, while others worked exclusively for the House. After the firm's initial success at the Pan-Russian Exhibition, it became necessary to move the main workshops away from the retail premises. Additionally, with the structure of the business, manufacturing was not concentrated in one place. However, in 1900, when the specially-constructed premises at 24 Bolshaya Morskaya Street became operational, virtually all of the St. Petersburg workshops, Fabergé's living accommodation and the main retail outlet came under one roof. The only workshops elsewhere in the capital were those devoted to gem carving and silversmithing.

When the Head Workmaster received instructions for the manufacture

of objects, he would allocate the work to a particular workshop or workshops. For example, a carved stone bird with gold legs and a gold beak would have to pass through the gem-carving and a goldsmith's workshop. The actual allocation of the work would depend upon the object in question and the particular aspect of the workshop, together with the existing workload. Regardless of which particular workmaster to which the manufacture of the object was entrusted, the Head Workmaster was responsible for supervising every aspect of its production. Naturally, this did not mean that he was present during the manufacturing process, but that he would inspect items at various stages to ensure that the work was a faithful interpretation of the design and that the quality of the workmanship met with the House's high standards of quality.

On occasions where the design had to be altered for technical reasons, the matter would be discussed with the Head Workmaster who in turn would consult Carl Fabergé. If no solution could be found to the technical problems, a compromise would be reached. Where special and important commissions were concerned, Fabergé would have a considerable involvement with the actual production of the piece. The Head Workmaster would seek his approval at the completion of a particular process and at every major stage in the crafting of the object. Matters would not proceed until Fabergé was entirely satisfied. In the normal course of events, the Head Workmaster had complete control while the objects were in the workshops. However, he did not have general sanction of approval. Before each object could be retailed, or passed on to the customer who had commissioned it, Carl Fabergé had to give his approval.

Where appropriate, objects emanating from the House were generally marked both with the workmaster's stamp and with Fabergé's surname or initials. However, items made by a workmaster who did not work exclusively for the House, only carried that workmaster's mark. Only objects produced in a workshop exclusively under Fabergé's control, bore the workmaster's mark together with Fabergé's surname or initials in Cyrillic (Russian) characters. Where more than one workshop was involved, the piece would bear the mark of the Head Workmaster, who would also mark items produced exclusively in his own workshop. Items produced at Moscow do not bear the workmaster's stamp, but do feature the double-headed eagle as proof of the firm's Imperial Warrant. Where appropriate, items bore Russian State hallmarks and the firm's inventory number, the latter being scratched, as opposed to stamped, on the surface of the precious metal. Items not approved by Carl Fabergé were either destroyed or sold without Fabergé's mark.

The firm guaranteed the sale of the objects that it approved. In other words, the House reimbursed the workmaster for making the object immediately upon completion. Those workmasters who had workshops within the Fabergé headquarters, or who operated from premises owned by the House, had to pay rent to Fabergé and to pay their own craftsmen. However, the raw materials of the workmaster's trade – gold, silver, precious stones and the like – were all supplied by the House. In his book, *Peter Carl Fabergé*, Henry Bainbridge mentions this arrangement and concludes, 'By this arrangement the workmaster was relieved of the heavy expenses of materials and had constant work. He was paid regularly and Fabergé was in immediate touch with each article in the process of its making.'

What are these articles and what makes them so special? There is no easy answer. However, Fabergé's photograph frames, bell pushes, cigarette cases, powder compacts, parasol handles, clocks, seals, boxes, thermometers and magnifying glasses do all have two things in common. He combined functional objects and objets d'art, the French term for small objects of artistic value, into what he called *objets de fantaisie*. The delicacy of his creations was in total contrast to the applied arts that had developed in Europe since the mid-19th century. After

the 1860s, the style became both heavy and elaborate. Ladies appeared ladened with precious stones, in contrast to the previous fashion for objects that were noteworthy because of their exquisite nature. Snuff boxes, favourite gifts to gentlemen in court and diplomatic circles, were encrusted with stones in an ostentatious manner. Not only personal items were subjected to a 'heavy hand', but furnishings in general. It was a period when overstatement resulted in an ugly pompous display of wealth. Taste is ever changing, though, and by the mid-1880s the *style pompier*, as it was dubbed, was no longer fashionable. Individuals favoured a more discreet approach and ornamentation became more refined.

Europe's designers had begun to look to the past for inspiration. They now developed their own refined gothic, renaissance, baroque and rococo styles as opposed to directly copying what had gone before. Historicism, or drawing on the past, became the vogue. Fabergé's Grand Tour of Europe then came into its own. He had studied the collections in Dresden, Paris and Florence, as well as the fine array in the Treasury at the Hermitage. In brief, he had seen an excellent cross-section of European objets d'art and of course still had the Hermitage a stone's throw away. All that he had seen in the past fused in his mind to supply an almost constant supply of new designs. He did not copy what had gone before, but adapted various styles to his own requirements. Above all, he had examined the very best craftsmanship of past ages. He not only drew upon what he considered to be the best aspects of past design, but also strove, and succeeded, in adopting and even improving upon the standards of the best craftsmanship from previous ages. However, he did not just regurgitate, adapt or improve upon the work of previous craftsmen. In Fabergé's work there is a refreshing, undefinable difference that gives it a unique aspect. Competitors attempted to copy the style, but failed to find the magic ingredient that was the Fabergé style. Possibly the key to Carl Fabergé's success was excellence in all things.

One of the many areas in which the House excelled was the art of enamelling. The Oxford English Dictionary defines enamel as, 'To inlay or encrust enamel with a vitreous (i.e. glass) composition applied to the surface by fusion.' It is a very techncial process and the finest translucent enamel requires a heat of about 600 degrees centigrade. Fabergé's workmasters used temperatures varying from 700 degrees to 800 degrees so as to achieve the superb quality for which the firm is renowned. Working at such levels of heat meant that the slightest error, or wrong constituency of the enamel, would result in a ruined object. Enamellers today work at about half the temperature used by Fabergé's workshops. Although the House's enamel work was considered the ultimate of perfection, Carl Fabergé still felt that there would be room for improvement. In *The Art of Carl Fabergé* by A. Kenneth Snowman, the author relates an anecdote by Alexander Fabergé, Carl's third son and an accomplished enameller. In 1906, presumably upon his father's request, he journeyed to Paris to meet Jouillon, France's most celebrated enameller. Alexander's request was straightforward − he wished to become apprenticed to Jouillon so as to improve his, and subsequently the House's, enamelling technique. The great artist kindly replied, 'Are you crazy? We in Paris are quite unable to do the things you appear to do so easily in St. Petersburg.'

A passing mention has already been made to the functional but decorative objects that emanated from the House. Purely decorative items were also made. Naturally there was jewellery, but there was far more besides. If all the stone animal carvings produced by the firm were brought together, many large menageries could be formed. The variety of animals is as diverse as the materials used. There are elephants carved from brown-black obsidian, pink adventurine quartz, bowenite, grey kalgan jasper, lupis lazuli, rock crystal, smoky quartz and chalcedony. There are kangaroos, baboons, bears, pigs, cats, rabbits, mice,

shire horses, squirrels and apes. Fish include salmon, sturgeon and puffer fish. Elegant flamingoes vie with pigeons, bats, ducks, kiwi and Japanese sparrows for attention. Frogs, toads and snails are also included in the Fabergé menagerie.

The variety of objects produced by the House of Fabergé is almost endless. The hardstone figures of military personnel and Russian peasants are a specialised category of their own. So too are the flowers made from precious metal, enamels and semi-precious stones. There are examples of miniature furniture made from enamelled precious metals and endless objects carved from dark green nephrite - boxes, bowls, paper knives, and even crochet hooks. Fabergé managed to make the most mundane of household objects extraordinarily exquisite.

There is one group of Fabergé creations that even individuals who have no interest in objets d'art immediately associate with Carl Fabergé, jeweller to the Tsars of Russia. These are the Imperial Easter Eggs that became legend in Fabergé's own lifetime. The next chapter is devoted to this fascinating subject.

A family photograph taken circa 1918 showing Carl Fabergé seated second from the left with young Alexander, Augusta and Eugene. The other two individuals are unknown. (Courtesy of The Fabergé Family Archives).

Chapter 5

THE FABERGÉ IMPERIAL EASTER EGGS

Carl Fabergé was not the first to use the simple egg shape as the basis of an art form. But, his series of Imperial Easter Eggs made for the Tsars became a legend in his own lifetime and will undoubtedly be regarded as one of the great pinnacles of the jeweller's art for generations to come. People who have no interest in objets d'art are fascinated by the Imperial Eggs. Even if they do not appreciate the fine craftsmanship, the novelty of the pieces appeal. Their connection with the massacred Romanov family also has a certain fascination. In the foreword to the first catalogue of the Forbes Magazine Collection − which now contains 14 major Easter Eggs[1], which is three more than at The Armoury in the Moscow Kremlin − Malcolm S. Forbes relates his first encounter with one of Carl Fabergé's creations. The young Forbes was fascinated by an illustrated history of the First Great War and particularly the chapter devoted to the Russian Revolution. The pre-war extravagance of the Tsars was illustrated by a photograph of an Imperial Easter Egg. In the 1960s he began collecting Fabergé objets d'art in earnest. Mr. Forbes's introduction to the wonders of Fabergé stems from his reading of the massacre of the Russian Imperial Family. Unlike many who first encountered Fabergé in this way, Mr. Forbes became a true connoisseur collector.

Others are fascinated by the sheer extravagance of the gifts given by the Tsars at Easter. Fabergé was most fortunate in having such wealthy clients. Until the outbreak of war took its toll on the Imperial coffers, Fabergé does not appear to have been restricted by financial considerations, other than his financing the work in progress. Certain of the Imperial Eggs took over a year to make and Fabergé was not paid until after any of the Imperial commissions had been delivered. Fortunately Fabergé, through being an astute businessman, was a wealthy individual. In 1912, when presumably he needed a considerable amount of working capital to finance the increased volume of business envisaged in the following year by the celebrations of the Tercentenary of Romanov sovereignty, he was able to mortgage his St. Petersburg property to Baron Krauzkopf for 600,000 roubles. But above all, none of the Imperial Eggs would have been made if the Tsars were not prepared to commission these special gifts without apparent regard to cost. Not only are the Imperial Easter Eggs masterpieces in their own right, but they are also probably the last great series of objets d'art to have been commissioned.

Before relating the story of Fabergé and the Imperial Eggs, it is interesting to briefly examine the use of egg shapes as an art form. The craftsmen of India were making delicate filigree gold and silver goa-stone holders in the form of acorns or eggs during the 17th and 18th centuries. Goa-stones were valuable cures for all ills invented by a Florentine lay-brother in the Portugese colony of Goa, India, during the 17th century. They were made from bezoar stones (the

[1] *Note: The Forbes Magazine Collection contains 14 Eggs, 11 of which are Imperial Eggs.*

accretions from the stomach or intestines of cud chewing animals), ambergris, musk, precious stones and pearls ground into a powder. The resultant stone was then covered with gold leaf. Scrapings from it were dissolved in liquid and were either drunk or applied externally to the body. Generally the Islamic world favoured the egg shape for its goa-stone holders. There is a superb late 17th century gold filigree example in The Topkapi Saray Museum in Istanbul. Its relief scrollwork is encrusted with small rubies and emeralds. European goa-stones of the late 17th and 18th centuries were more spherical in form. There is a particularly fine silver gilt late 17th century specimen at Burghley House, Lincolnshire. It is most unlikely that Fabergé saw any goa-stone holder.

However, during his Grand Tour, Fabergé is likely to have seen an example of a 'surprise egg' at Versailles. In France during the 17th and 18th centuries it became customary for courtiers to present the King with decorated hen eggs on Easter morning. What possibly started as the simple giving of an appropriate seasonal gift, progressed into an elaborate ceremony. Indeed, some of the country's finest artists, including Watteau and Boucher, were even persuaded to abandon their canvasses and to turn their artistic talents to painting egg shells. Louis XV presented Madame du Barry, the last of his mistresses, with a gilded egg which concealed a model cupid.

A pair of ivory 'surprise' eggs can be viewed today at Versailles' Musée Lambinet. Mounted on metal stands, they have every appearance of being simple duck eggs with a chain attached at their apex. When this is lifted the scene on the first egg represents the happy conclusion of a real-life drama in which an elderly man single-handedly rescues a young girl from two unscrupulous ruffians. The wax carving in the second egg shows a cottage and four figures all in wax: the elderly man returning the daughter to her grateful parents. This pair of eggs was presented by Louis XVI to Madame Victoire de France, the daughter of Louis XV. However, none of the eggs mentioned so far, with the exception of goa-stone holder at Istanbul, even slightly resembles a Fabergé creation.

Fabergé family tradition, as related by Eugene and Agathon Fabergé to Henry Bainbridge, is that Carl Fabergé suggested to Alexander III, in about 1883, that he give the Tsarina Maria Feodorvona an egg the following Easter that contained some form of special surprise. When the Tsar wanted to know more, Fabergé would not reveal what the piece would contain. As Alexander was anxious to raise his wife's spirits, he went along with Fabergé's suggestion and commissioned the jeweller to make what he had in mind, in total ignorance of what he would be eventually presenting to the Tsarina. The situation is quite possible, for Alexander was anxious to do anything to alleviate his wife's melancholy, caused, perhaps, by a recent horrifying experience. Alexander II, the Tsar's father, had been assassinated by a terrorist's bomb in 1881. The new Tsar and his wife had both been witnesses to this gruesome event and to the subsequent death bed scene in the Winter Palace, which is so vividly related by the Grand Duke Alexander Michailovitch in *Once a Grand Duke*:

> '*The Emperor lay down on the couch near the desk. He was unconscious. Three doctors were fussing around, but science was obviously helpless. It was a question of minutes. He presented a terrific sight, his right leg torn off, his left leg shattered, innumerable wounds all over his head and face. One eye shut, the other expressionless … The agony lasted forty-five minutes.*'

One can imagine the state of the Tsarina. Undoubtedly forefront in her mind would be, 'Will my husband be next?' One can also appreciate that the Tsar would have been anxious to give her anything that would divert her mind from gruesome past events and pondering the future. However, it is possible that this

story, though feasible, is not accurate. Papers in the Central State Historical Archives at Leningrad (formerly St. Petersburg) reveal that Fabergé's name first appeared in the accounts of His Majesty's Cabinet (the office in charge of the Imperial Family's property) only in 1883. It is believed that Julius Agathon Butz, who accompanied Carl on part of his Grand Tour and who was one of the State Imperial Jewellers, proposed his candidature to the Cabinet. This was an opportune time to start receiving commissions from the Imperial Family, as the Court was preparing for the coronation of Alexander II and the Tsarina Marie Feodorovna.

By the middle of 1883, Fabergé had supplied commissions to the Cabinet amounting to 6,367 roubles and 95 copecks. Over the same period Butz's commissions had totalled 48,694 roubles. The Russian historian Marina Lopato, who undertook much valuable research in the Central State Historical Archives, states in *Fresh Light on Carl Fabergé* (Apollo, January, 1984) that most of the commissions received by the House of Fabergé were in fact suggested to the Cabinet by Carl Fabergé. The most highly priced objects were recorded in the Allocation Register on 27 May 1883: '4,000 roubles for three diamond rings with the inscription of Her Majesty's coronation day'. The other work undertaken by the House of Fabergé were bracelets, brooches and baptismal crosses. Fabergé was nevertheless very much the new man at Court and one should ask whether he was in a position to suggest an undefined gift for the Tsar to present to the Tsarina. It has now been firmly established that the first Imperial Egg was made in 1885, the year that the House of Fabergé received the Imperial Warrant. The brief description of the piece in the official record reads, 'Easter egg of white enamel, the crown is set with rubies, diamonds and rose diamonds'.

This Egg is now in the Forbes Magazine Collection, New York. It measures 63mm in length and at first inspection it appears to be a normal white hen's egg. The shell effect has been achieved by matt white enamel. The 'shell', when gently pulled, parts at the centre to reveal the egg's yolk, which is made in gold. In turn this opens to reveal a gold hen with ruby eyes on a nest of gold straw. The final surprise in the design is that inside the hen there is a miniature replica of the Imperial crown from which was suspended a tiny ruby egg. Unfortunately the crown and its jewelled egg have long been lost. One can imagine the delight of Tsarina Maria Feodorvona as she opened the box containing her gift on the Easter morning of 1885.

In the Danish Royal Collection at Rosenborg Castle, Copenhagen, there is a jewelled and enamelled gold Easter egg. The 'shell' of the egg is made of ivory, which opens to reveal a gold egg with a white and yellow enamel so as to resemble the white and yolk of a hen's egg. In turn this may be opened to reveal a gold enamelled chick with rose-cut diamond eyes. Inside the chick there is a gold diamond and pearl set crown containing a diamond ring bearing the crowned monogram 'CC'. The unmarked piece is likely to have been made during the first half of the 18th century in France. According to the Danish Royal Family, it was presented to Queen Caroline of England, the wife of George II, by Duchess Charlotte of Orleans. Queen Caroline married the English monarch in 1705 and died in 1737. She gave the egg to her daughter Mary, who married Landgrave Frederick of Hesse who was the grandfather of Queen Marie of Denmark (1767-1852) and hence the piece passed into the possession of the Danish Royal Family.

The Tsarina, Maria Feodorvona, was the daughter of King Christian IX of Denmark. Although he did not inherit the egg until 1891, there is no doubting that she would have known of its existence. During her childhood it belonged to the Tsarina's aunt, Princess Wilhelmine Marie. What better object to amuse a niece than a jewelled surprise egg? One can imagine Maria Feodorvona's delight at being shown this object and being allowed to 'discover' the chick which

contained the crown that housed a small ring. It would be reasonable to speculate that she spoke of this 'magical' object when relating childhood memories to her husband.

Was the subject of First Imperial Egg Carl Fabergé's idea or the Tsar's? As the first of the series is so much like the one in the Danish Royal Collection, which as far as is known, Fabergé had not seen, it is too much of a coincidence that his idea was so similar to the piece then owned by the Tsarina's aunt. Of course, Fabergé may have heard of this egg, for it was exhibited at Copenhagen's Industrial Exhibition in 1879. Possibly the Tsarina had spoken to Fabergé about the piece and he seized the opportunity of persuading the Tsar to commission an object, details of which remained a mystery — save that it was an Easter Egg. I doubt whether events followed these lines. When the documentary evidence regarding the commission of the Second Imperial Easter Egg is examined, it is quite apparent that Fabergé was taking orders rather than being given *carte blanche* to do as he pleased. If this was the case with his second commission, it it reasonable to propose that it was the same for the first.

The relevant papers in the Central State Historical Archives begin on 15 February 1886 and end on 24 April of the same year. The first page of the dossier is devoted to Fabergé's queries, which are shown below in normal type. The replies of the Court Minister, made in pencil on the document by N. Petrov, the Cabinet's Assistant Manager, are shown in italics.

'To manufacture a hen taking an egg out of a wicker basket it is necessary to know:

1. When the piece must be ready.
 It is preferable to have it finished by Easter, but not if this will be detrimental to the quality.

2. Whether the hen must be made of silver only or set with roses (i.e. rose diamonds).
 It must be made of gold without rose diamonds.

3. Whether the egg should be loose or fastened to the beak.
 It must be loose.

15 February 1886'

Clearly, Fabergé was concerned at the reply to his second question, for page two of the dossier reads:

'*By order of the Minister, the commission for a hen taking an egg out of a wicker basket, so that the hen could be made without rose diamonds. Meanwhile the jeweller Fabergé carrying out this commission stated that the hen should be set with rose diamonds otherwise it would not be beautiful and would look like a bronze one. Reported to the Minister. Agreed to set the hen with rose diamonds.*'

The third page of the dossier relates to the delivery of the egg to the Tsar and the settlement of Fabergé's invoice:

'The hen brought by the jeweller Fabergé is being sent to His Majesty with a courier. If there are no remarks concerning this object, asking your excellency to send back the account for payment. Saturday 5 April 1886.

N. Petrov. Repayment on 20 April 1886.'

Fabergé's account is found on the following page of the dossier:

'C. Fabergé, a goldsmith, St. Petersburg, Bolshaya Morskaya 18 − C. Fabergé. Joailler St. Petersburg, rue grande Morskaya N. 18. Account to the Cabinet of His Imperial Majesty.

The Hen

1 sapphire-egg	*1,800*
50 rose diamonds 8/32	*1,004 - 25*
60 rose diamonds 14/32	*80 - 35*
400 rose diamonds 51/4	*65 - 341. 25*
gold and workmanship	*- 750*
2 cases	*- 35*
	2986 roubles, 25 copecks
2 April 1886	*C. Fabergé*

Should be paid 2,986 roubles 25 copecks

<div align="right">

20 April 1886
N. Petrov'

</div>

The Eggs were sent by courier to Tsarskoe Selo, where the Imperial Family was then staying. Apparently there were no 'no remarks', for the final page of the dossier reads:

'Assignation check N.428 of 24 April 1886. His Majesty's Cabinet. Jeweller Fabergé is to receive 2986 roubles 25 copecks from the Court Ministry's savings bank for the egg with a wicker basket made with precious stones. Assistant Manager Petrov, chief of the department Jundolov. Chief of the accountant's branch Kaptelkin. Junior accountant Grigoriev.'

Why the invoice for the Second Imperial Egg makes reference to '2 cases', is a mystery. Reference to '1 sapphire egg' requires some clarification. The entire egg did cost 2,986 roubles 25 copecks as the records state. In a document dated 9 February 1889, it is made clear that this includes 1,800 roubles for a sapphire stone. The Second Imperial Egg is now lost.

Only the first two Imperial Easter Eggs feature a chicken, the bird which is now normally associated with Eastertide. As will be seen from the brief descriptions of the eggs at the end of this chapter, they have little in common. From two quite initial simple themes, the pieces become more elaborate as time progresses. One could speculate that after the first two commissions, Carl Fabergé was given freedom with regard to the designs.

The first two Imperial Easter Eggs are quite mundane when compared to the later creations. If an individual who is not an artist-jeweller (eg. the Tsar)

specifies an Easter gift, the 'chicken and egg' theme would be at the forefront of his mind. It is a mighty step forward to a 'Serpent Clock Egg' or eggs featuring angels or family portraits. It is reasonable to conclude that Carl Fabergé was given complete freedom of design after the initial commissions were finished and therefore Eugene and Agathon Fabergé's information given to Henry Bainbridge is correct with regard to their father's free hand. The only stipulation made by the Tsar was that the Eggs must contain a surprise. The other side of the bargain was that His Majesty was never to question the theme of any Egg, nor ask what surprise it would contain. This counter-stipulation conforms to Carl Fabergé's sense of salesmanship. As was stated in the previous chapter, the veil of secrecy is an essential ingredient to a successful luxury trade. The Tsar was probably excited about the form the annual Easter gift to his wife would take as the recipient herself. Apparently, on one occasion when the Tsar could contain his curiosity no longer, Fabergé merely replied, 'Your Majesty will be content'. This reply was far more reserved than that given in response to a Grand Duchess's enquiry, 'And what new eggs have you this year, Mr. Fabergé?' Apparently he replied, 'This year, Your Highness, we have square ones.'

From the archive material relating to the Second Imperial Egg, we learn that it was despatched to the Tsar by courier. In those days, Fabergé was a relative newcomer to the Court. At some point, most likely Fabergé was given *carte blanche* commissions for the Imperial Eggs, the delivery of the masterpieces became a personal affair between the patron and craftsman. Until more material is made available from the Central State Historical Archives at Leningrad, the exact date will remain unknown. However, one can speculate that this could have been as early as 1887. During the reign of Alexander III, Carl Fabergé would have made the deliveries personally. However, from 1895, this was not always possible. After Alexander's death on 1 November 1894, Nicholas II announced that he intended to follow his father in all things. Although he was generally considered to be an inept and autocratic ruler, he more than excelled with regard to his father's tradition of Easter gifts. Not only did his Tsarina, Alexandra Feodorovna, receive one of Fabergé's creations, but he also presented an Egg to his mother, the Dowager Empress each year. It was not always possible for Carl Fabergé to make both presentations. Consequently on occasions the Head of the house would present the Tsarina's Egg to the Tsar, while his Head Workmaster would deliver the Dowager' Empress's on behalf of the Tsar. When Carl's sons were of a suitable age, they assisted their father with the presentation.

Eugene Fabergé related his rôle at the Easter of 1912 to Henry Bainbridge. In this particular year Carl Fabergé presented the Egg to the Dowager Empress while his son attended the Tsar. The probable reason for the Head of the House abandoning his Emperor was the Tsar was in residence at Livadia Palace near faraway Yalta, while his mother was residing at the Winter Palace in St. Petersburg. It made far more sense for Eugene to make the tiring journey across Russia in place of his 66-year-old father. So, Eugune travelled to Sebastopol where he was met by Prince Vladimir Orloff who drove him the four hour journey to Yalta. With him he had the Tsarevitch Egg which is carved from a solid block of lapis lazuli and enclosed in an elaborately carved and chased gold cagework in the Louis XV style. Inside the egg there is a frame in the form of a double-headed Imperial encrusted with rose-cut diamonds containing a miniature of Tsarevitch Alexis. The piece, which is signed Henrick Wigström is now in the Lillian Thomas Pratt Collection which may be viewed at the Virginia Museum of Fine Arts, Richmond, USA.

After a change of clothes, Eugene was driven to the Lavidia Palace to hand the Egg to the Tsar. Unfortunately very few of the reactions of the Imperial Family to Fabergé's special creations have survived the passage of time. However, what transpired on this occasion was recorded by Henry Bainbridge in *Peter*

Carl Fabergé. The Tsar said he was delighted with the piece he was to present to the Tsarina on Easter morning. Generally he would indicate the ending of an audience by walking to the window. He started this procedure when he stopped and lead Eugene by the elbow to the window. After the Emperor had indicated the magnificent view over Yalta to the Black Sea, he turned to Eugene and asked him to convey his 'sincere compliments', and 'best thanks', to Carl Fabergé.

Until recently, it was believed this was the only specific reaction to a particular Egg that had survived. However, in the early 1980s, a letter from the Dowager Empress to her sister, Queen Alexandra of England, came to light. It was written on 8 April 1914, and translates from the Danish as follows:

> '... He (ie. Nicholas II) wrote me a most charming letter and presented me with a most beautiful Easter egg. Fabergé brought it to me himself. It is a true* chef-d'oeuvre, *in pink enamel and inside a* porte-chaise *(sedan chair) carried by two blackamoors with Empress Catherine in it wearing a little crown on her head. You wind it, and then the blackamoors walk: it is an unbelievably beautiful and superbly fine piece of work. Fabergé is the greatest genius of our time, I also told him: "Vous êtes un génie incomparable".'

Until the discovery of this letter, the *Grisaille Egg*, as it is called, was not known to have originally housed a mechanical sedan chair as its surprise. The Egg, which would now be more appropriately named *The Catherine the Great Egg*, was given to Mrs. Majorie Merriweather Post by her daughter who acquired it in 1931 and can now be viewed at The Hillwood Museum, Washington D.C, Mrs. Post's former residence. The museum is the only one in the USA entirely devoted to Russian art. When the late Sir Charles Clore's Collection of Works of Art by Carl Fabergé was offered by Christie's in Geneva on 13 November 1985, Lot 30 comprised, 'A jewelled, guilloché, enamel, two-colour gold automation sedan chair with figure of Catherine the Great borne by two liveried blackamoors.' The catalogue entry fully describes the piece and also reveals the attention to detail which is one of the hallmarks of the House of Fabergé:

> 'The frame of the sedan chair worked in red-gold with green-gold acanthus design, the side panels enamelled in transculucent bright yellow over a ground engraved with the Romanov double-headed eagle within laurel leaf borders, the front and back of the chair designed with ribbon-tied floral festoons, amphora and basket of blossoms, the windows and roof set with bevelled rock-crystal panels, encasing a miniature replica of Catherine the Great, seated, holding a fan and wearing a rose-cut diamond crown and a crimson cloak designed with gilt Imperial eagles and trimmed with ermine, over a transculucent pale pink enamel ceremonial gown with the blue sash and diamond-set star of the Order of Saint Andrew, the chair is carried by two blackamoors wearing court livery of scarlet coats, yellow waistcoats and lime-green knee breeches over white stocking, black patent leather shoes and lime-green turbans surmounted by white ostrich feathers. When wound, with gold key, the articulated legs are set in motion.'

As Christie's stated in a footnote, 'There is some controversy as to whether this sedan chair originally formed the surprise in the Imperial Grisaille Egg of 1914...' Although the sedan chair from the Clore Collection has been illustrated in the literature as being the missing surprise from the *Grisaille Egg*, there is a slight problem. This is revealed by Katrina V.H. Taylor, Curator of the Hillwood Museum in her book *Russian Art at Hillwood*.

'An existing automation answering this description (in the Dowager Empresss's letter to Queen Alexandra) could not possibly be the actual "surprise" as this egg because it is too big to fit inside.'

The *Grisaille Egg* and its missing 'surprise' remains a mystery. A great deal of detective work has already been undertaken in connection with the Imperial Eggs, but there is still much work yet to be done. One area which has occupied scholars, and which has yielded results, is searching for past objects which possibly inspired Fabergé when designing the Imperial Easter Eggs. As was stated in the previous chapter, Fabergé was not adverse to drawing on past styles. However, he did not merely copy what had gone before, but adapted or improved upon the work of previous designers or craftsmen. The Winter Palace complex at St. Petersburg with its fine and large collection of treasures was his nearest source of inspiration. Visitors to the State Hermitage, as it is now known, cannot but marvel when they enter the Pavilion Room in the building known as the Small Hermitage. It is a remarkably elegant, spacious, light and airy place with windows on all four sides. From here one can look out in one direction towards the Peter and Paul Fortress with its golden spire pointing towards the heavens with the River Neva many feet below. Turn 180° and the formal garden is at eye-level. The Pavilion Room is on the first floor − the 'Hanging Garden' is too as it is constructed upon what was the Imperial stables. The pavilion's slender rows of marble columns first lead the eyes upwards to the 28 crystal chandeliers that throw a 'rainbow' of light. The mosaic floor which imitates the one from the baths of the Roman Emperor Titus and mosaic tables complement the floor. Each time I visit the State Hermitage, I return to this incredible room.

The main object in the Pavilion is an 18th century English clock, the likes of which cannot be seen in the British Isles. Known as the *Peacock Clock*, it was made by James Cox. It is no ordinary timepiece, for it is housed in a large glass case the size of a cage at an old-fashioned zoo. Its man made contents even resemble a typical display in a menagerie. There is an oak tree, several birds, including an owl and a squirrel. At the centre there is a peacock. When the clock chimes this elegant creature revolves and fans its tail. Its neighbours also come to life − the owl turns its head and a cock opens its beak and crows. The time is told by looking at a mushroom that shows the hours and minutes in separate windows. The *Peacock Clock* could well have been the inspiration for the *Peacock Egg* given to the Dowager Empress by Nicholas II in 1908. This rock crystal egg contains a gold enamelled peacock perched in the branches of a tree. When removed and wound and placed on a table it struts about, moves its head and fans its colourful tail.

The connection between the *Peacock Egg* and the *Peacock Clock* is the most obvious of all the inspirations for the series of Imperial Easter Eggs. Another object on display at the Treasury at the State Hermitage is an oviform bonbonnière or sweetmeat box, made in England during the mid-18th century. It is made from a bloodstone and is applied with rococo motifs and flower swags in gold. It is quite possible that this small egg-shape article, or one very similar, was the inspiration for the 'shell' of the *Azova* Imperial Egg which Alexander III possibly presented to his Tsarina in 1891. Its jasper 'shell' is applied with gold rococo motifs set with rose-diamonds. Its similarity with the previously described bonbonnière is uncanny. The surprise it contains is a small gold and platinum model of the cruiser 'Pamiat Azova' in which the Tsarevitch (later Nicholas II) made his voyage round the world.

Also to be found in The Treasury of the State Hermitage is a set of four egg-shaped vodka beakers hallmarked at St. Petersburg in 1780. The green glass body of each beaker is mounted in gold on an ivory base. Their lids are mounted with spheres. The openwork decoration of the body takes the form

of fluted pilasters, laurel leaves and lilies-of-the-valley. These beakers are believed to have been the inspiration for the *Blue Enamel Ribbed* Imperial Egg. Its 'shell' is enamelled transclucent royal blue, while its three coloured gold decoration is very similar to that found on the beakers. However, instead of spherical terminal, the Imperial Egg is surmounted by a jewelled crown and it stands on a spirally fluted base.

Carl Fabergé's inspiration was not just derived from objects now to be found in the State Hermitage. For example, the *Renaissance* Imperial Egg of 1894 is quite definitely based upon Le Roy's early 18th century oviform chalcedony necessaire now in the State Art Collection Albertinum at Grünes Gewölbe in Dresden. Fabergé would have viewed Le Roy's creation while on his Grand Tour. The *Blue Serpent Clock Imperial Egg* of 1887 and the *Modonna Lily Imperial Egg* of 1899, which also takes the form of a timepiece, reflect the general style of Louis XIV clocks which Carl would have seen during the part of his Grand Tour that he spent in Paris. It must be stressed, however, that when the inspiration for a particular Imperial Egg is found, it is just that − a catalyst that resulted in a creation in the style *Fabergé*.

The Imperial Eggs were cherished possessions of the Russian Imperial Family. They were the personal gifts of Tsar Alexander III to his wife Tsarina Marie Feodorovna and possibly his son the Tsarevitch Nicholas; possibly from Tsarina Marie to her husband and from Tsar Nicholas II to his mother, the Dowager Empress Marie Feodorovna and his wife Tsarina Alexandra Feodorovna. The fate of the Imperial Family after the Revolution has been the subject of numerous articles, book and film, so there is little need for repetition. On the other hand, as to what happened to the Imperial Eggs has not been subjected to such wide coverage. At least 56 Imperial Eggs were made from 1885 through to 1917, of which 45 are known to have survived:

Location	Number of Eggs
Armoury Museum of the Kremlin, Moscow	11
Forbes Magazine Collection, New York [I]	11
Other American Collections	15
European Collections	7
Whereabouts Unknown	1
	45

From those that have survived, the Central State Archives at Leningrad and from other sources, 52 Imperial Eggs can be identified and these are listed in Appendix I. No attempt has been made to give the date that they were presented to their recipients, or even to identify the recipient. Until further documents are released from the Central State Archives, there is a degree of speculation in any attempt to be specific, as very few are dated and fewer carry initials indicating their recipient. But, if glasnost continues in the Soviet Union, more information could be available. Certainly The Soviets are showing a greater interest in their Imperial history than ever before. Scholars of Fabergé await further releases of archive material with considerable interest.

Only one Imperial Egg left Russia with the person to whom it was presented. This was the *Cross of St. George Egg* which was the gift of Tsar Nicholas II to his mother, the Dowager Empress Marie, on the Easter morning of 1916. In 1919 the Dowager Empress left the Crimea for England and later took up residence at her villa just outside Copenhagen. In addition to the Egg, she also managed to take a large number of jewels from Russia. Following her death and various legal wranglings, the jewels and other items were sold to Hennel and Sons Ltd, the London jewellers, for over a third of a million pounds. However,

[I]*Note: The Forbes Magazine Collection contains 14 Eggs, 11 of which are Imperial Eggs.*

the Dowager Empress's children did retain the *Cross of St. George Egg* for sentimental reasons. It remained in the family until 1961, when it was sold on behalf of Prince Vassily Romanov, her grandson. This Egg is now in the Forbes Magazine Collection in New York.

After the Revolution all the possessions of the Imperial Family became the property of the people. The valuables from the various Imperial palaces were packed into crates and taken to the Winter Palace and later shipped to Moscow. It was Lenin's wish that all historical monuments, pictures and objets d'art should be preserved as examples of the country's Imperial past. Inevitably, during the Revolution a certain amount of damage was caused, but visitors to the Soviet Union today cannot but be impressed by the general maintenance of historic buildings and the art collections they house. Nevertheless, after Lenin's death in 1924, the policy regarding the preservation of all of the Imperial trappings changed. The country required foreign exchange for trade. What better source than to sell the precious objets d'art of the Imperial Family, the nobility and great landowners. This was a decision that the present authorities perhaps now regret.

The new regime realised that items of quality were worth more than the intrinsic value of their stones or metal content. From 1925 the Soviet government made contact with art dealers in the West. Not all were responsive to such approaches. For example, Germain Seligman, the Paris art dealer, declined to do business with the Soviet government for fear of offending the Russian emigres in France with whom he was presumably dealing. Many of the aristocracy who escaped from Russia after 1917, would only have been able to take small items of value − jewels. In five months of 1919, precious stones to the value of US$75 million were exported from London to the United States. Europe was awash with the finery of Russia's Imperial past.

Seligman may have declined to do business with the Soviets, but there were others who were more than willing to accept their offer. Three Imperial Eggs appeared in Paris at that time (1925) − officially sales did not take place until 1927. Others were more adventurous and journeyed to deal with the authorities on their own territory. One of the world's leading dealers in Fabergé objects today is Wartski of London, The business was founded by Kenneth Snowman's maternal grandfather, Morris Wartski in 1865. Sixty years later, Kenneth Snowman's father Emanuel made his first visit to Russia and in this and subsequent trips over a 14 year period, he was able to purchase many jewels and objets d'art. Mr. Snowman senior also made purchases outside Russia.

However, it was from Russia itself that Emanuel Snowman made his best 'hauls'. As a result of skilful negotiations, he managed to secure nine Imperial Eggs:

Rosebud
Coronation
Lilies-of-the-Valley
Cuckoo Clock
Collonade
Swan
Peacock
Orange Tree
Winter

The *Collonade Egg* was purchased by Queen Mary, wife of King George V of England, on 12 October 1929. Her Majesty paid £500 for this Imperial Egg, which is still in the Royal Collection. Mr. Snowman was by no means alone in buying Russian art within the Soviet Union. Dr. Armand Hammer went to

Russian in 1921, initially to establish a field hospital to help fight the typhus epidemic that was raging in the country. He soon realised that famine was a greater killer than typhus and he became the first American to trade with Russia after the Revolution. The funds generated from the Hammer pharmaceutical company allowed him to arrange a barter arrangement between the USSR and the US. In exchange, for furs, hides and other commodities, the Soviets received one million tons of American grain. In recognition of his help, Lenin, who became a friend of Dr. Hammer, granted him mining and trading concessions.

During their period of residence in Moscow, Armand and his brother Victor Hammer formed a fabulous collection of Russian art. The story of their acquisitions is told in *The Quest of the Romanoff Treasure*. As well as textiles, old masters, icons, jewels and ceramics from the Imperial Porcelain Factory, the brothers also secured Imperial Eggs. They also purchased Eggs which were sent by the Soviets for sale in Berlin and presumably one, the *Swan Egg*, from Mr. Snowman. From all sources the Hammers secured the following Eggs:

The First Imperial
Caucasus
Renaissance
Danish Palaces and Residences
Revolving Miniatures
Pelican
Pansy
Pine Cone
Swan
Tsarevitch
Napoleonic
Grisaille
Red Cross with Portraits

With the advent of the Stalin era, the Hammers decided to liquidate their Soviet investments. The astute Dr. Hammer negotiated as part of the agreement, that their entire Russian art collection would be allowed to leave Russia. These treasures were sold over a number of years, initially at a number of department stores throughout the United States and later via Hammer Galleries in New York. The *New York Times* of 2 January 1933, reports:

'Jewelrey of Czar on View This Week.Gift Easter Eggs Encrusted with Gems Among Pieces Bought in Russia By Dr. Hammer.

Memories of the splendor that surrounded the Russian royal family before its members were killed in July 1918, are to be revived on Fifth Avenue tomorrow, when a $1,000,000 collection of jewels and objects of art from the Russian royal palaces will be placed on view at Lord & Taylor.

Collected by Dr. Armand Hammer, who purchased the items out of his profits from concessions held under the Soviet Government, including one which for a time gave him a monopoly in Russia on lead pencils and stationery, the gems and other items of the collection are to be shown tomorrow at a preview to which admission is by invitation only. On Wednesday, the exhibit will be opened to the public, and will remain on display for three weeks. Chief among the jewels illustrating the generosity of the Czar are two Easter Eggs. One, presented by the Czar to the Czarina on Easter morning 1912, is fashioned from lapis lazuli, heavily ornamented with gold. Inside the egg, which opens like a jewel case, is a replica of the Russian eagle fashioned from large diamonds. The second egg, of gold and enamel, set with diamonds

and emeralds, was presented by Nicholas on Easter 1895, to the Queen Dowager Marie Feodorovna. It serves as a case for a gold screen with ten mother-of-pearl panels, on which are miniatures of the eight castles she occupied during her girlhood in Denmark, and of her two yachts.'

The Imperial Easter Eggs consequently found their way out of Russia in the 1920s. Of course, the House did not restrict the making of Eggs to commissions from the Imperial Family. It will be recalled that the Duke and Duchess of Marlborough commissioned an Egg during their visit to Leningrad in 1901/2. Now known as the *Duchess of Marlborough Egg* it is now part of the Forbes Magazine Collection. The Duchess was born Consuelo Vanderbilt, daughter of W.K. Vanderbilt and the piece is unique in the sense that it was made for an American citizen. It is very similar to the *Imperial Serpent Egg*, but is in pink as opposed to blue enamel.

A series of eggs was also made for Alexander Kelch, the Siberian gold magnate and millionaire for presentation to his wife, Barbara. The Kelch series of pieces include:

Name of Egg	*Present Whereabouts*
Hen	*Forbes Magazine Collection, New York, USA (Forbes)*
Twelve-Panel	*Collection of H.M. Queen Elizabeth II, England*
Rocaille	*Private Collection, USA*
Bonbonnière	*Private Collection, USA*
Pine Cone	*Private Collection, USA*
Apple Blossom	*Private Collection, USA*
Chanticleer	*Forbes, USA*

The House also made an Egg for Dr. Emanuel Nobel to present to a friend. Known as the *Ice Egg*, the exterior is enamelled opalescent white upon silver engraved with frost patterns. It contains a surprise in the form of a watch. However, it is no usual timepiece. It is set in a piece of rock-crystal which takes the form of a diamond-shaped piece of ice. The crystal is decorated with frost patterns made from platinum and rose diamonds. Dr. Nobel was very partial to snowflake and frost patterns. Indeed, at one dinner party he gave each lady present a Fabergé 'icicle', which was either a brooch or pendant in rock-crystal set with diamonds and platinum in a frost pattern. Prince Felix Youssoupov commissioned a gold and raspberry enamel table clock in the form of an egg to present to his wife on the occasion of their Silver Wedding.

In addition to elaborate and costly Eggs, the House also made thousands of small Eggs in gold or silver, with enamel decoration from hardstones porcelain or even wood. Ladies would wear these as a single pendant or even string dozens of them together on a neck chain. The more elaborate pieces are set with diamonds or other precious stones. The variety is amazing. Although so diverse, there is one common theme − quality. Simple examples sold for as little as ten shillings, or half a pound sterling, up to one pound. The more elaborate examples sold in the £3 − £10 range.

Old Russia may have been an 'orgy of eggs', but Carl Fabergé managed to adopt the simple egg form into an artistic style that was admired by many during his own lifetime and at which millions have since marvelled. It is little wonder that the Dowager Empress remarked, *'Vous êtes un génie incomparable'.*

Chapter 6

THEO FABERGÉ –
THE GRANDSON

The Russian Revolution marked the end of the House of Fabergé, jewellers to the Tsars of Russia and all European royalty as well as to the King of Siam. It may be surprising to some that the House did not rise like a phoenix from the ashes. The firm had an international reputation and a host of wealthy customers who could have financed the resurrection of the House.

Initially the family anticipated that the Soviet regime would founder and their business would be restored to its rightful owners. Such hopes soon faded and what little money that had been brought from St. Petersburg quickly dwindled. During 1924, Carl's first and third eldest sons formed Fabergé et Cie in Paris. Both were craftsmen, though Alexander was also a modeller and Eugene a painter. They were joined by Andrea Marchetti, an employee of the Moscow branch of the House of Fabergé and Guilio Guerrieri from the Moscow jewellers Loriè. For a brief period, Theodore, a grandson of Carl, worked with his uncles. The business still continues, but there is no longer any direct Fabergé family involvement. Perfumes sold under the Fabergé brand name also have no connection with the Fabergé family. These were originally marketed in the United States during the 1930s by Samuel Rubin.

Although the first wife of Agathon, Carl's second son, settled in Switzerland, Agathon remained in Russia, though it is possible that he resided in Finland for a while immediately after the Revolution. Agathon was employed at the House as a gemologist. After being imprisoned by the Soviet Authorities for 18 months, he was released so he could catalogue the Imperial Jewels. He settled in Finland with his second wife during the 1920s and became an expert in philately. Oleg, the son by his second marriage, now lives in Helsinki.

The Fabergés who settled in Switzerland initially had a guest house and later a chicken farm at Versoix near Geneva. As will be seen from the family tree, two of Agathon's sons by his first marriage settled in Brazil. Theodore, who worked for his uncles in Paris, returned to Geneva and designed and made jewellery for Lombarde the jewellers. Igor, another of Agathon's sons also worked as a jeweller and also designed limited edition pieces for the Franklin Mint. Rurik, who was only nine when the Revolution occurred, helped look after the family chicken farm.

Alexander's son, Alexander (known as Alexis), studied in England at Imperial College. He is one of Carl's grandson's who inherited the Fabergé business accumen and made a fortune on the stock markets. His expert field was genetics. However he was an academic and later became a Professor of Genetics. Alas, he died in 1988, the year that this book was started, so it was not possible to discuss with him the subject of inherent skills.

The preceeding paragraphs briefly outline the activities in which three of Carl Fabergé's sons and their families became engaged after the Revolution. With the death of Igor Fabergé in 1982, it was considered that the Fabergé family's artistic talent had been lost, as no surviving descendents of Carl Fabergé were known to be involved in any way in the creation of objets d'art or design in general. However, it will be recalled that there were four Fabergé sons, all of whom worked in some capacity for the House. The forgotten son is Nicholas, (in Russian, Nikolai), who managed the London branch with Henry Bainbridge.

Strangely, only a passing mention is made of Nicholas Fabergé in either Mr. Bainbridge's *Twice Seven* or *Peter Carl Fabergé*. Both references relate to Carl Fabergé's refusal to visit Queen Alexandra during a visit to London. Mr. Bainbridge quotes Fabergé as saying, 'But I am *en voyage* and I have no clothes. Look at me, I cannot go like this! There is my son Nicholas and yourself.' It is decidedly odd that his co-manager should appear but once in two books that contain so much material relating to Fabergé's London branch. Bainbridge refers to Eugene, Agathon and Alexander, but never directly to Carl's youngest son. The impression is given that Henry Bainbridge ran the entire branch single-handed. Perhaps the two men had a disagreement which was never resolved. We shall probably never know what did happen but, one thing is certain: Nicholas Fabergé had a son who was born in England on 26 September 1922. He was named Theo and England has been his home ever since.

This man is Theo Fabergé, grandson of Carl Fabergé and the designer of The St. Petersburg Collection. Theo's story is a remarkable one. It begins quite ordinarily, but there is a certain development which although perfectly true, is more characteristic of a fairy tale than of a real situation. Life has its twists and turns, but for Theo Fabergé there was an event which totally changed the course of his life.

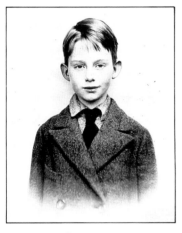

A portrait of Theo in 1932 at the age of 10 years.

For as long as he can remember, Theo loved to make things. At the tender age of four, he attempted to make a model boat. During his school days he excelled at handicrafts. At the age of nine, he was given a fretwork set for Christmas. Young Theo was delighted with the gift and he made ornate cigarette boxes and calendar holders as well as other items. When he was at senior school, he took well to carpentry and metalwork. In one of his early woodwork classes, he made an oak stool fully morticed and tennoned which has stood the test of time, for he still has it in his possession. Such was Theo's enterprise and initiative that he not only created accurate models, especially those that satisfied his penchant for boats, but frequently manufactured the tools with which he would make the models. While making a model galleon he manufactured a lathe too, to turn the barrels of the ship's cannons. He entered the completed model into a competition held by his local Scout Troop and, much to his delight, was awarded a Very Highly Commended certificate. His pastime during his early teens was model-making and waited anxiously for every copy of *Hobbies Weekly*. The young Theo would enthusiastically read its contents and set about experimenting on some project inspired by its pages. The family garden shed was Theo's workshop. There he made his models and experimented with his steam engines, progressing from boats to model aircraft.

His preference gradually became firmly established for the aeronautical as opposed to the nautical. His reasoning was simple — he preferred the shapes of aircraft to boats. At about the same time. D.H. de Havilland introduced a new Comet. Jean Batten flew non-stop to South Africa. Theo's mind was made up — he wanted his career to be centred around aircraft, a form of transport he found romantic.

So determined was the 14 year-old Theo to undertake work connected with aircraft, that he went to evening classes while still at school, to learn technical

drawing, draughtsmanship and engineering science. Five interviews later, he obtained a post at General Aircraft at London Air Park, Feltham. After a brief spell in various parts of the factory he was transferred to the Tool Room and joined what was considered the elite band of men in the process of aircraft production. Here he received a very strict training in high precision work which stood him in excellent stead for the future. By now his love of lathes was firmly established. At work, he was involved with aircraft manufacture; at home, on his own lathe, he was making model aircraft.

However, it was design that most appealed to Theo. When he was 15 years old, a chance of further involvement with design came his way − or rather, Theo seized an opportunity to make an opening happen. The Chief Jig and Tool Draughtsman made a visit to the Tool Room, presumably to see how some particular piece of work was progressing. After he had finished his conversation with Theo's peers, the Tool Room junior plucked up courage and asked if there was a vacancy in the Drawing Office. Anxious to secure the position, he outlined his evening class studies. Examples of his work duly impressed the Draughtsman and a vacancy was found in the Drawing Office. He remained there for one year.

At 16 he was accepted to serve a five-year apprenticeship and started a rigourous training programme, subsequently learning the skills involved aircraft manufacturing, foundry work, machining, making fittings by hand, instrument making and the general maintenance and repair of machinery. Working in aircraft manufacture was not enough for Theo. He joined the Air Defence Cadet Corp and experienced his first flight. With the outbreak of war, his natural desire was to join the Royal Air Force. However, apprentices in the aircraft industry were too valuable to be released for the services. When he was called up, his superiors would not allow it. At this stage he was working at various aerodromes. Initially, he was in charge of inspection reports on Hamiliar Gliders which were being prepared in readiness for the invasion. Later he was engaged with airborne crew who were becoming conversant with the glider. Then in 1944, he and his superiors received an ultimatum − if Theo did not report for active service within 48 hours, he would be arrested as a deserter. Theo did not stop to question the logic of asking how a non-member of the forces could be a deserter, but proceeded poste-haste to report for duty.

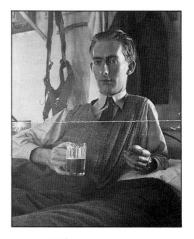

Taken off duty in the Canal Zone, Egypt, 1947.

Early in January 1945, he was posted to the Middle East. It is not the object of this work to dwell upon aspects of his active service. However, at one stage he was in charge of prisoners-of-war in some machine workshops. This gave Theo the opportunity to devote some of his spare time to model making.

He arrived back in Britain in the autumn of 1947 and returned to the aircraft industry. However, he could not envisage the demand for planes to be buoyant after the War, so he decided to look for a career elsewhere. It so happened that there was a shortage of instrument-makers. Theo had received a rigorous training in this field during his apprenticeship in the aircraft industry. Furthermore, he enjoyed such work − his love of model making is evidence of this fact. He took a position at EMI at Hayes in Middlesex and remained there for two years. It proved to be very good experience and a good foundation upon which to draw in the future.

His parents decided to move to the south coast of England, though for Theo the move was constricting for he discovered that there were few career openings for someone of his calibre at a small English seaside resort and looked further afield for employment. After a gruelling interview he was accepted for a post as an instrument-maker at Wallace Heaton, the Royal photographers in Bond Street. He stayed in London during the week and visited his parents on the coast each weekend. City life possibly was not to his liking, for after four to five months he left and took a position with a photographic firm near his parents'

home. Needless to say, there was neither the volume nor the variety of work to which Theo had become accustomed, and within six months he was on the move again.

In 1950, a small advertisement in the local newspaper caught his eye and shortly after, he started work as a production engineer at a small electro-mechanical firm. The work involved making intricate coil wiring for transformers and radios and, later, high quality parts in the field of telecommunications. Theo's rôle in the business grew as the company expanded, and he became responsible for staff training, production planning and all aspects of production. By 1962, there was a staff of 65. Theo's mind and skills were certainly being stretched but by now he wanted a change from intricate coil wiring and the general administration involved with managing a manufacturing business.

His objective was to find a position that required artistic skills as well as technical. In 1962, he returned to the photographic business and became the works manager at a cinematographic factory that made cine equipment and audio instruments. Apart from design work, production planning and training staff, Theo was also involved with placing sound strips on 8mm home movie films. Although a long way from the film studios of Hollywood, the work did allow him to combine technical knowlege with a degree of artistic freedom.

Until that time, Theo had always been employed as opposed to being an 'entrepreneur'. In 1967, he decided to take the plunge and establish his own business. Naturally, he turned to an area that he knew best. Theobar Engineering (the name was derived from Theo's name and that of his partner, Barney), was involved in coil-winding, making electro-mechanical equipment, instruments, jigs and press tools. Though the company progressed well, Theo still did not feel he had found his true vocation in life. Theo was a man in his forties with a leaning towards artistic craftsmanship running an engineering business. Probably he would still be there had not an aunt, on an afternoon in January 1969, triggered events that not only changed the course of Theo's life, but resulted in him finding more of his real self.

It was a death in the family that resulted in Theo eventually discovering his new life. While motoring back from a family funeral on a cold and damp afternoon, the conversation with his aunt inevitably turned to family matters. The middle-aged lady seemed to want to impart some revelation to Theo, but would not directly address herself to the matter. Eventually, she hesitantly advised him to obtain a copy of his birth certificate. He was not unduly surprised, because for some time he had been pondering why his 'brother' was dark haired while Theo had fair hair. However, his parents had treated both of their 'sons' with equal love and affection and so as not to embarrass them, he had never broached the subject. Strange though it may seem, he had never seen his birth certificate, as when it was required for some official purpose, Theo's 'father' had always handled the matter. Nothing appeared suspicious at the time for the situations were always treated as if parents always dealt with cases where birth certificates were required to be presented to the authorities. As Theo had led a busy life, he had been grateful to be relieved from the burden of dealing with official bureaucracy.

'You should have been told earlier', muttered the aunt as Theo escorted her to her home. He could not have agreed more when a copy of his birth certificate arrived from Somerset House, London (the registration archives for births, deaths and marriages in the UK). In a state of shock he read on the certificate:

MOTHER: Dorise Cladish of 6 Wellington Square, Chelsea, London

FATHER: Nicholas Leopold Fabergé, artist, of Avenue Studios, 76 Fulham Road, Fulham, London.

CERTIFIED COPY OF AN ENTRY OF BIRTH

GIVEN AT THE GENERAL REGISTER OFFICE, SOMERSET HOUSE, LONDON.

Application Number 7888

REGISTRATION DISTRICT Kensington

1922. BIRTH in the Sub-district of Kensington South in the County of London

No.	When and where born	Name, if any	Sex	Name, and surname of father	Name, surname, and maiden surname of mother	Occupation of father	Signature, description, and residence of informant	When registered	Signature of registrar	Name entered after registration
416	Twenty sixth September 1922 122 Fulham Road	Theodore	Boy	Nicholas Leopold Fabergé	Dorise Cladish of no occupation	of 11 avenue studios 76 Fulham Road artist Painter	N. Fabergé Father 11 avenue studios 76 Fulham Road D. Cladish mother 6 Wellington Square Chelsea	Twelfth December 1922	A·W·D Holtham Deputy Registrar	—

CERTIFIED to be a true copy of an entry in the certified copy of a Register of Births in the District above mentioned.
Given at the GENERAL REGISTER OFFICE, SOMERSET HOUSE, LONDON, under the Seal of the said Office, the 9th day of October 1972.

BC 784829

*See note overleaf.

This certificate is issued in pursuance of the Births and Deaths Registration Act 1953. Section 34 provides that any certified copy of an entry purporting to be sealed or stamped with the seal of the General Register Office shall be received as evidence of the birth or death to which it relates without any further or other proof of the entry, and no certified copy purporting to have been given in the said Office shall be of any force or effect unless it is sealed or stamped as aforesaid.
CAUTION:—Any person who (1) falsifies any of the particulars on this certificate, or (2) uses a falsified certificate as true, knowing it to be false, is liable to prosecution.

Theo Fabergé's Birth Certificate.

For 47 years Theo had been known as Theo Woodall, Woodall being the family name of his supposed parents. It turned out that Philip and Linda Woodall, who had brought him up as their own son, were not his mother and father, but his Aunt Linda and Uncle Philip. The dark-haired Digby Woodall was not his brother, but his cousin. His Aunt Dorise was in fact his mother and Theo was the grandson of Carl Fabergé, Goldsmith and Jeweller to the Russian Imperial Court and the man whose work impressed royalty, the aristocracy and connoisseurs the world over. After he had unravelled the tangled web of his identity, Theo was left deep in thought.

For all his working life, Theo had been involved with precision engineering, yet he had always had a strong leaning towards the arts. The search for perfection had also been his goal in his technical craftsmanship and also in his earlier model-making. Can an artistic talent have been inherited? Whatever the case, Theo's artistic work is evidence of his gift. Although much of his life had been spent in the world of industry, making tools and instruments, the technical skills he acquired are invaluable for a craftsman-designer of objets d'art. However, Theo had no time to contemplate the theory of genetics; he had a business to run, as well as coming to terms with his 'new identity'.

Theo telephoned his real mother and gently broke the news that he knew his name was Fabergé and not Woodall. After a long silence the old lady responded, 'Why do you want to drag all that up?'. As Theo has discovered over the years, it is far easier to obtain information about his grandfather than about his father. He did not want to press the issue with his mother, who was not in good health. The Woodalls were also not prepared to discuss the past and, as both of them were unwell, Theo did not try to discover anything of his father from that source. He wrote to Kenneth Snowman of Warkski's, but apart from learning that Mrs. Snowman's mother was sketched by Nicholas, no more information was available. The sketch was lost many years ago. In the early 1970s, Theo did meet an old gentleman in London's Clerkenwell, where craftsmen still have their workshops, who claims that he knew his father. Nicholas had taken certain pieces of his own Fabergé items to be repaired or restored from time to time. Unfortunately, Theo did not persue the matter and became resigned to the fact that he would never discover anything about his father.

The greater proportion of Theo's time in the early 1970s was spent running Theobar, his engineering business. However, the metamorphosis from Woodall to Fabergé was having a profound and unsettling affect. It was as if

Theo's artistic gifts, which had been suppressed for so long, could no longer be restrained. However, there was also the realisation that he could not immediately give up his livelihood and transfer to an occupation that would yield far more personal satisfaction than coil-winding and making jigs and press tools. A medium had to be found for his other talents.

In 1970, Theo began a part-time course in silversmithing. His tutor was Leslie John Medhurst. Theo quickly grasped the basic fundamentals of this craft and it was not long before he was undertaking experimental work with enamels and silver. In Britain, articles may not legally be described as gold, silver or platinum in the course of trade until they have been sent to an Assay Office, assayed and hallmarked. The assay is an accurate chemical analysis which is carried out on samples scraped from the articles submitted and is the responsibility of The Worshipful Company of Goldsmiths. The articles are stamped with symbols signifying the standard of the metal, the place and the year of assay and the maker's mark. Before anyone can call themselves a goldsmith in Britain, the hallmarking authorities must be satisfied not only of an applicant's technical ability but also that they are suitable individuals to be 'allowed' to have Assay and Touche within Goldsmiths' Hall. Theo's mark T.F. was entered at the London Assay Office in 1979 and at Birmingham in 1987. His work assayed at London bears a leopard's head and items hallmarked at Birmingham, an anchor.

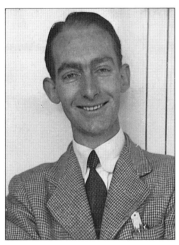

Theo in 1960 as a works manager.

However, although Theo is now a registered silversmith, his penchant had a different direction in the early 1970s. Through a passing interest in non-precious stones, Theo discovered a craft that not only gave him an artistic outlet, but also satisfied his love of matters connected with engineering. There is no doubting that polished common stones have a natural beauty. They do not have the brilliance of their semi-precious or precious counterparts, but they nevertheless have an irresistible appeal. Theo wanted to discover the wonders of lapidary. In 1971 he visited a local dealer to ask about parts for a stone polishing machine he wished to make. Part of the joy to Theo was to make his own equipment as opposed to purchasing something standard. During the conversation, Theo revealed that he had an engineering business. A little later two gentlemen arrived at Theobar. One was Fred Howe, a founding member of the Society of Ornamental Turners. However, it was nothing to do with turning that caused Fred Howe to visit Theo. In a feature published in the December 1973 edition of *Do-it-yourself,* a magazine for DIY enthusiasts, Fred had been described as a 'master turner, wood carver and lapidary craftsman'. Fred simply wanted some stands on which to display geodes, or mineral specimens. His visit was to ask Theo if he could supply items to a certain specification.

At their first meeting a rapport developed between Theo and Fred. It was the foundation of a firm friendship. During their conversation, Theo revealed that two years previously he had discovered that he was the grandson of Carl Fabergé. A true craftsman, Fred Howe had always marvelled at Carl Fabergé's work. Indeed, one item of his own work of which he was justly proud is a carved ivory plaque of Fabergé, set in an oval turned frame made from purple heart wood. It is believed that Fred used a medal designed by Alfred Pocock as a model for this work.

One can imagine the meeting of these two men: Fred Howe, recognised as a leading turner, coming face to face with the grandson of the craftsman whom he held in the highest regard. It was through Fred Howe that Theo found his niche in the artistic world. It was Fred's ornamental turning undertaken on a highly specialised antique Holtzapffel lathe that fascinated Theo, for as an engineer he appreciated the beauty of the machine. As a craftsman it was the vehicle which would allow him to express himself artistically. England is not the home of ornamental turning, but because the Holtzapffel family settled in London in the 18th century, the craft had become well-established. It reached a peak of popularity

during the second half of the 19th century when William Morris the designer, craftsman, poet and early socialist, revolutionised Victorian taste with his designs in the field of decorative arts. William Morris, together with John Ruskin, founded the Arts and Crafts movement. Their objective was to bring quality handmade items back into everyday life; they disliked the mass-produced furniture, drapes, wall-coverings and ornaments made for the home and attempted to produce well-designed hand-crafted items at affordable prices. Ornamental turning benefited as the craft became a popular pursuit of the wealthy amateurs of mechanical engineering. By the end of the century, it was no longer the vogue.

From the 18th century to the First World War, it is believed that the Holtzapffel's made 2,500 lathes. They are the Rolls Royces of the lathe world. Fred Howe was captivated by them after the Second World War. He realised that with such a complicated piece of machinery, it would take a lifetime to discover all its functions. He also was very much aware that many of the lathes had been scrapped for the value of their brass, whilst others lay in varying degrees of disrepair around the country. However, he also felt that somewhere there must be devotees of these, the ultimate in lathes. Fred advertised asking other enthusiasts of the Holtzapffel lathe to contact him and in 1948, the inaugural meeting of the Society of Turners was held. Fred Howe passed away in 1982. In 1984, 'The Art of the Master Turner', an exhibition in memory of Fred Howe, was held at the Science Museum in London. Theo assisted throughout its preparation.

HRH The Duke of Gloucester being shown some of the exhibits by Theo Fabergé at 'The Art of the Master Turner' exhibition held at the Science Musuem, London in October 1984.

Needless to say, it was not long after meeting Fred Howe that Theo became a member of the Society of Ornamental Turners. He attended his first meeting in 1972 and started to experiment with turning while also undertaking his course in silver-smithing. As already mentioned, Theo was familiar with lathes both in his model-making and engineering work. However, other than a pair of candlesticks (See page 75) which he made in 1953, he had done nothing of an ornamental nature since childhood. The candlesticks, which are still used by Theo, were carved by hand, from two rolling-pins he purchased at Woolworths for half-a-crown (12½ pence).

Theo began to make objects to exhibit at the Society's quarterly meetings. With typical modesty he recalls, 'I only turned simple items to begin with'. One of his early works was a Chinese Ball with a 152mm diameter comprising four concentric spheres within each other. His medium was a resin with the consistency of ivory. It caused considerable interest at the Society for no member had made one for many years. Within two years, he had progressed to Chinese Balls in box wood comprising 13 concentric spheres. When people express surprise at the feat, Theo shrugs his shoulders and merely says, 'The theory behind them is easy'. The theory may be, but a considerable degree of expertise is required.

Britain's Winter of Discontent was a significant one for Theo. The miners were on strike, electrical power rationed and the Heath government had introduced the three-day working week. Such conditions were not good for industry. Theo anticipated that there would be a recession and decided to sell his business. It was sold as a going concern in September 1974. However, it was not just fears about the economy that prompted Theo to make this move. He explains, 'I had always been more interested in shapes than in technology. For example, when I was in the aircraft industry, the form of aeroplanes was far more appealing to me than their technical specifications. I had just spent a fortnight making a complicated press tool. Goodness, what a dreary, uninteresting shape it was too. That decided me — I wanted to spend my time making beautiful objects, not items for the industrial world.'

The transition from an instrument-maker/engineer to an artist-craftsman is relatively unusual. At this time Theo was 52 years old. Many men would have chosen to retire at 60 and spend their retirement pursuing a craft as a hobby. However, Theo is not the average man. Undoubtedly for many years, he had

had a subconscious desire to create objets d'art, but, it had been constrained by a career path. After he had discovered his true identity, Theo found it increasingly difficult to restrain his desire to create objects artistically as opposed to industrially.

Age was against him and he did not want to trade on his family name. He wanted to become accepted because of his own talents, not because his grandfather was Carl Fabergé, one of the world's legendary jewellers. Although he uses his rightful surname, he vowed never to trade on the international reputation of the House of Fabergé. He has kept his vow.

In 1974, Theo Fabergé rented a workshop. Although he did not know it at the time, he was adopting his grandfather's business stance. When Carl had taken over his father's business in 1870, he waited a number of years before he broke away from the traditional rôle of provider of conventional jewels. Indeed, there was nothing remarkable about the output from the House of Fabergé during the first decade or so that it was under Carl's control. Theo was in a different situation. Unlike his grandfather he was not taking over a going concern, but was starting a completely new venture. Theo realised that he could not immediately start a new business creating objet d'art and survive. After all, each year art colleges throughout the land were decamping qualified art students into the commercial world who struggled to earn a living.

Rather than launch himself as a creator-craftsman producing objets d'art, Theo started his business as a general craftsman. He drew upon his inherent skills and within reason he would turn nothing away. He started by repairing clocks, 'I had been interested in timepieces since my teens', Theo now muses. It was not the average clock that was his penchant, but quality pieces made by master clockmakers of previous generations. He would turn his hand to restoring anything, from an 18th-century snuff shoe or to providing a replacement leg for a table. There were almost no bounds to what he would tackle. He even undertook the restoration of Boullé furniture, which is a marquetry of tortoiseshell and brass.

This work was only a means towards an end. It provided him with his daily bread and a degree of satisfaction. However, it did not quell his creative needs. So, while restoring objects from a past age to their original glory he was also creating original objects to his own designs.

In 1975, Theo entered the tri-annual competition of the Worshipful Company of Turners of London, the successor to the Guild of Turners which can be traced back to the 12th century. He submitted a matching pair of egg-shaped salt and pepper mills, worked in red cam wood, a variety of paduak. The pieces are lined with boxwood, and have a ribbed pattern (See page 77). Theo won second prize for his work. Considering that he had only begun ornamental turning three years before, this was no mean achievement.

It was not until 1975 that he managed to secure his own Holtzapffel lathe. Although Fred Howe had allowed Theo to use his machine for practice, Theo had mainly used an ordinary lathe for his work. Theo's Hotzapffel came from the north of England and was sold, through an advertisement, by the son of its previous owner. The lathe was duly transported to Theo's workshop. It was in a sorry state of repair, and it took Theo two to three years to restore it to full working order. Originally made in 1861, it is now as good as the day it was made.

In 1976, Theo started to sell the objects he was making, ranging from candlesticks to paper knives mainly through craft fairs in the south of England. However, there was one item missing from his stock − eggs. He vowed never to make decorative eggs as he regarded his grandfather's to be the ultimate in craftsmanship. When Pinkney Near, Curator of the Virginia Museum of Fine

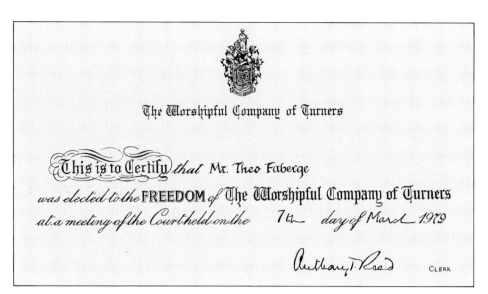

Theo Fabergé was elected a Freeman Prizeman of the Worshipful Company of Turners on the 7th March 1979.

Arts, Richmond, Virginia, sent Theo a catalogue of the fabulous Fabergé pieces in the Lillian Thomas Pratt Collection, Theo did not send an egg in return. Instead he made a snuff shoe from black buffalo horn. The gift was well received and is now in the museum's collection.

H.M. Queen Elizabeth II celebrated the Silver Jubilee of her accession to the throne in 1977. Theo decided to make a commemorative casket to mark the event. The piece is made in ivory and is embellished with rubies and silver. It is 128mm in height and diameter and has 25 Burmese cabachon rubies set in silver and mounted on ivory spheres placed round its base. The body of the casket is decorated with 25 flutes. The crown-shaped cover is set with 25 silver beads and has an engine-turned silver centre. The base is engraved inside and out with engine-turned patterns. After it was completed, Theo was satisfied with the result, and still considers it to be his finest work to date (See pages 78 and 79).

He entered his Silver Jubilee Ivory Casket in the 1978 competition at the Worshipful Company of Turners. He was awarded the Lady Gertrude Crawford Medal, which is the highest award for ornamental turning, and was also granted the ultimate honour for an ornamental turner − to be elected a Freeman Prizeman of the Worshipful Company of Turners. The latter had not been conferred upon any individual since 1956, when Fred Howe received the honour. Fred was awarded the Lady Gertrude Crawford Medal in 1969. Naturally, Theo was delighted. It is remarkable that within seven years of being introduced to ornamental turning, and without any formal training, Theo had been awarded the highest honours that could be conferred by the Worshipful Company of Turners.

Theo has not worked in ivory for a number of years. He is totally opposed to the slaughter of animals for their tusks and abhors the action of poachers. All the ivory he has turned was inherited from members of the Society of Ornamental Turners. Most of the pieces he acquired in this way were 100 years of age, whilst other were decades old.

The Lady Gertrude Crawford Medal — awarded for the Silver Jubilee Ivory Casket.

In 1979, Theo's work was accepted for inclusion in an exhibition organised by the Worshipful Company of Goldsmiths at Goldsmiths' Hall in the City of London. There were in fact two exhibitions, *Loot* and *Super-Loot*. Both were part of the Worshipful Company's programme to encourage good craftsmen. The introduction to the catalogue states, 'The aim is to give a smart shop window to some of the best small British workshops, so that they can achieve a powerful group impact.' Objects in *Loot* retailed at £100 or less, while *Super-Loot* was for more expensive items. Theo had two items accepted for *Loot*. His entry in the catalogue reads:

'T. Fabergé

b. 1922 Five year apprenticeship − instrument making −toolmaking. Studied at various technical and art colleges. Grandson of Carl Fabergé. Speciality − ornamental turning. Won prizes at Worshipful Company of Turners − Freeman Prizeman.

Ivory letter opener/book marker.

7″ tazza with gallery.'

The Silver Jubilee Ivory Casket featured in *Super-Loot.* It was also exhibited at Asprey's, the Bond Street jewellers.

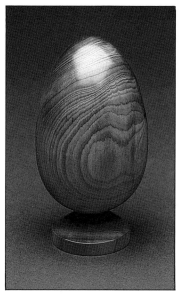

*Peter's Egg −
1979.*

Loot was the first major public exposure of Theo's work. The ivory letter opener/book marker was secured by a Fabergé collector in the United States. The piece terminated with an egg set with a ruby. Slowly the orders and commissions began to arrive. However, Theo still refused to make a decorative egg. Nevertheless, he did finally relent. In 1979, he was making lace bobbins for a lady in Suffolk. It was her 12-year-old son Peter who persuaded Theo to break his vow. Peter asked Theo to make him an egg. 'He asked so nicely that I could not refuse', Theo reflects. Like so many people, the young Peter had become fascinated with the story of Fabergé eggs and the Tsars of Russia. However, there was to be no surprise in the one made for him by Theo. It was a plain piece turned from Yew wood, but it more than satisfied the schoolboy.

The piece was seen by a customer for whom Theo had undertaken some important antique restoration. 'Oh you are making eggs', she exclaimed when she spotted the item in the workshop. Theo dismissed the object as being of no importance. He continued, 'It is a mere triviality not worthy of bearing the name of Fabergé. My grandfather's eggs are amongst the finest items made by man. He employed Europe's best craftsmen and the result is absolute perfection. That is a mere nothing.' Theo emphasised that he had no intention of making decorative eggs. The lady admitted that the egg in question was a mere trifle. Indeed, she likened it to a door knob, but added that she knew he could do better. Theo also knew that he could create something more satisfying to himself as well as for others. He agreed to make a decorative egg for the lady to present to a friend as a gift. Made from rosewood, the piece stands on a brass rimmed base, is set with brass rings and mounted with a gilt finial set with a birthstone. It was not long before others wanted, 'One of Theo Fabergé's eggs.'

Theo's business did not turn into an orgy of eggs, however. He was making other objects as well. For example in 1980, when Felix L. Levy, a past Master of the Worshipful Company of Turners, wanted an item in memory of Edward H. Pinto, who had been a valued member of the Company's Court of Assistance and an expert on treen, he approached Theo. A Chinese Ball was commissioned. Made from ivory as opposed to wood, it is made up of six concentric spheres, the largest having a diameter of 85mm (See page 85). Felix L. Levy wrote to Theo after it was delivered, 'Your Chinese Ball is superb in both execution and design . . . it was very greatly admired.'

Nevertheless, Theo himself was now fascinated by the egg as an art form. The awards he had received for the Silver Jubilee Ivory Casket were sufficient to allay any fears that he could be accused of trading on the name of Fabergé. He had now established a reputation in his own right, firmly based on his skills as a craftsman. In 1981, he made his first 'surprise' egg as a gift for a friend in Cornwall. When the top was removed a platform slowly emerged from the body of the piece. The platform houses a ring. The egg was turned from yew wood and in Theo's words, is, 'very plain'. Shortly afterwards he made another along the same lines.

*The earliest
photo of Theo
at the age of
7 months.*

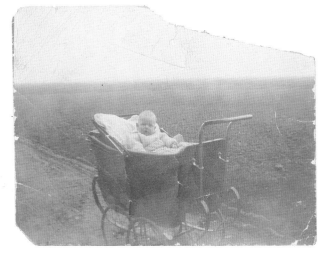

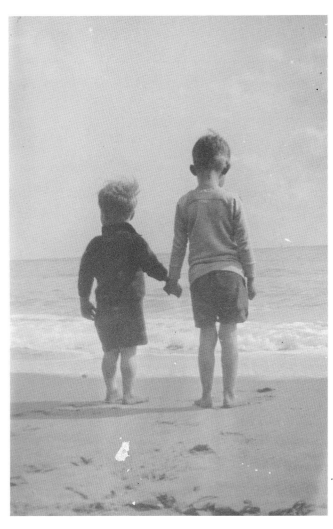

*An enchanting
photograph of
Theo with
John Scott
(cousin) taken
during the
summer of
1927.*

*A family outing to Ramsgate in 1925. Digby, May Payne
(an aunt), Doris Cladish, Linda Woodall with Theo in the pram.*

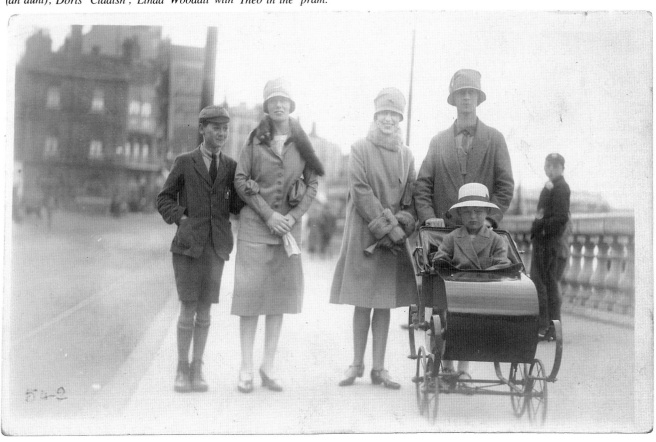

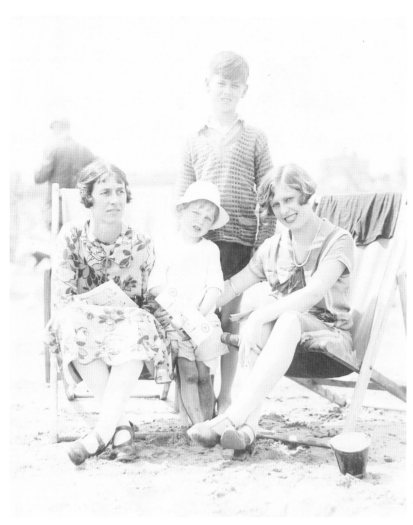

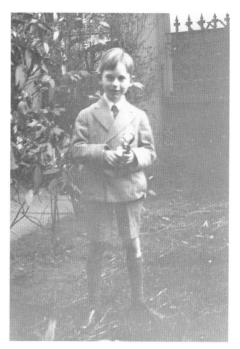

Theo taken in
1929 at the age
of 7 years.

Theo between his Aunt Linda Woodall (who
brought him up as a son) and his natural mother
Doris Cladish. Digby Woodall (who Theo
was lead to believe was his brother) is standing.

Doris Windess
(née Cladish)
Theo's natural
mother, taken
on her 80th
birthday in 1983.

In October 1981, Theo exhibited again at *Loot*, and proved to be the turning point in his career as a craftsman. John Andrew, a banker and writer, attended it's private preview. He had previously visited the 1979 *Loot* and had been fascinated by Theo's ivory letter opener/book marker, but had not placed an order. At that time he was writing features for airline magazines and articles for several publications in the UK and overseas. He had noted that Theo was a grandson of Carl Fabergé and had placed details 'on file' for a possible feature. Theo only had one item on display at *Loot*, a 'standing egg in yew and brass'. John secured it, insisting that he was to receive the actual piece on display as he liked the graining of the wood. To quote John, 'Its simplistic shape, gilt brass finial and gilt rings set in its body, more than appealed'. A couple of weeks after the exhibition closed, the egg duly arrived, together with the invoice, which was more like a letter than a bill. Theo apologised for the delay in forwarding the piece, but explained that the heat of the lighting in the display case at Goldsmiths' Hall had expanded the wood and dislodged the gilt brass rim around the base. He repolished the piece. The invoice concluded, 'I also make anniversary eggs and more elaborate eggs. Yours faithfully, T. Fabergé.'

John's parents were to celebrate their Ruby Wedding Anniversary, on 28 February, 1982. He was at a complete loss as to what to give them to mark the occasion, he realised that one of Theo's 'Anniversary Eggs' would suit the occasion. He rang Theo to enquire what form an 'Anniversary Egg' took. The response was typical of Theo, 'Whatever you like. The choice is yours.' During their conversation, *The Owl Ruby Anniversary Egg* was conceived. At that time John did not realise that it was only Theo's third such Egg and that both parties were experimenting with a new field.

Over several telephone conversations, the design was agreed. John now reflects, 'It was quite remarkable, I never saw a sketch, but I knew that the end result would be exactly what I wanted. Needless to say, they were delighted with the gift.' It was decided that the piece should be made from purpleheart, a rare and exotic wood from South America. Theo managed to obtain the necessary piece quite by chance. One of the suppliers whom he visited advised that they could not provide him with even a chip of this particular wood − that is until Theo pointed out that a chunk of it was propping open their warehouse door. When a piece of wood is being turned, no craftsman knows how the graining will appear in the final piece. As luck would have it, the graining of *The Owl Ruby Anniversary Egg* is heart-shaped. John was delighted, especially as it was so appropriate for the occasion (See page 92).

The finished piece stands 155mm in height. The top is surmounted by an ivory finial mounted with a cabochon ruby set in silver and the body of the egg is inlaid with 20 ivory rings. The base is edged by an ivory ring comprising forth flutes. Like Carl Fabergé's Eggs, the piece does contain a surprise. This was the last element of the commission agreed by Theo and John. Owls were John's family symbol. His parents were also dealers in antique sliver so it was appropriate that the surprise was in this metal. A firm of silversmiths in the City of London produced an owl as part of its standard product range of an 'Owl and Pussy Cat in a Boat'. They kindly agreed to cast the owl separately. The firm had no objections to its work being an integral part of the egg and Theo did not mind another craftperson's creation being included in his work. John's idea was that the owl should freely stand on the platform that Theo had devised and should emerge from the body of the egg when the top was removed. Although Theo had no objections to such plans, John felt that Theo considered the 'surprise' would not have a suitable element of the unexpected. A couple of days later Theo suggested an ingenious modification. 'Why not place the owl in a hole carved in a tree trunk?,' Theo queried. John agreed, but knowing the constraints of space, was not convinced that it was possible. Needless to say, what appeared impossible

was achieved. Furthermore, the trunk was taken from a yew tree, reputed to have been at least 800 years old, near the site where the Battle of Hastings was fought in 1066. The origin of the wood added a depth of historical feeling to the piece. Those who remove the top of the egg are surprised to see a 25mm high tree trunk − inside which a small guitar-playing owl is perched − emerge as if from nowhere.

This was not the only item by Theo Fabergé that John's parents received for their Ruby Wedding Anniversary. John's Aunt and Uncle were also at a loss as to what would be a suitable gift to mark the occasion. They were intrigued by the Egg and decided to commission Theo to make a table cigarette box. This is also made in purple heart. The top features an ivory and ebony box with a silver plaque at its centre set with four cabochon rubies. The sides are inlaid with a band of alternating black and white wood and the feet are ivory. The style has an art deco influence. This is the only example of Theo's flirtation with the art form of the 1920s (See page 81).

The following year, John visited Theo at his workshop to interview him for a magazine feature. At that time Theo was working on two models of the William Herschel Telescope. One was for the Royal Greenwich Observatory, the other for Jodrell Bank. It may appear at this juncture that Theo's creative life had turned full cycle, from the youth who liked to make models of galleons, through a penchant for aircraft to an instrument-maker, and then the release from the world of the technical to the artistic and back to models. This was not the case. In 1980, Theo had successfully completed commissioned models of the Isaac Newton telescope, the one-meter Cassigrain and the William Herschel telescopes for the Royal Greenwich Observatory. Not surprisingly, when more detailed models were required, Theo, with his unusual combination of the technical and artistic, was the obvious choice.

Sarah's 25th Birthday Egg − a view of the engraved base beside the removed 'surprise' pen.

Nevertheless, scale models were now a thing of the past, for Theo was developing a range of functional objets d'art. His *penholder paperweights* had just been launched. They are made of turned elongated exotic wood, set with gilt brass rings; the gilt brass finial is lifted to reveal a ball-point pen. The penholder is mounted on an engine-turned gilt brass base. A more elaborate version has the penholder emerging from a fluted ivory mount, with each of the 20 flutes set with a carbochon ruby. The finial of these penholders, of which only a few were made is turned from ivory and is mounted with a cabochon ruby set in silver (See page 95). Theo was of course receiving commissions for Eggs. He was also working on a silver chess set.

John's feature, *Fabergé − Back in Business*, appeared in *Executive World*, a British Airways in-flight magazine. The piece generated considerable interest from around the world, including one enquiry from a member of the British royal family. A catalogue was hastily prepared and despatched to those who wanted to learn more of Theo's work. Philip Birkenstein, who lives near London, read the feature while travelling to South Africa. He was so fascinated by the story that he could not wait to return to the United Kingdom. As soon as he arrived back, he contacted Theo and arranged to meet him at his workshop.

A visit to Theo's place of work proved to be no ordinary experience for Philip. I remember the old workshop well. It was spacious and thanks to large windows running the entire length of two sides, it was blessed with good natural light. There were racks of tools, carefully stacked wood, completed objects, others that had been advanced to a certain stage and then left to be finished when inspiration was at hand. In brief, it was an Aladdin's cave of creative ideas. It may have been a mere workshop, but it generated so much atmosphere that it was easy to forget that it was a place of work. Theo's character was implanted within the environs of those four walls that it felt like a lived in home. The smell

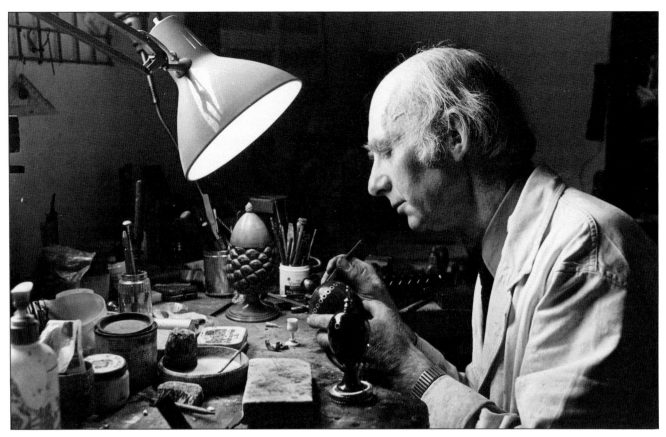

of exotic wood tickled the sense of smell whilst ones visual feelings were satisfied by pleasing shapes.

Theo at work in his studio in 1984.

I remember my first visit to that workshop. Like a gleeful schoolboy. I darted from one object to the next. 'What is this?,' I would ask. Theo would give some explanation. It may have been a prototype for an idea that had not yet been fully developed, or a special piece of wood that had been transported from some distant part of the world to be transformed into an object that would eventually bear Theo's mark of design. Something would have fascinated me. It may have captured my imagination, but Theo, in his quite dismissive style may have simply imparted the words, 'It is a mere nothing.' However, he would enthusiastically caress a piece of wood and talk of graining and texture, or perhaps demonstrate his Holtzapffel lathe and speak of its capabilities as one would describe an infant prodigy that had to be nurtured so as to reveal its full potential. I felt that I was in the presence of a master craftsman whose motto was, 'Always express modesty.' Philip attempted to describe his first visit to Theo's to me. After some hesitation he muttered, 'I was hooked from the first moment.' It was not a drug he was describing, but, the presence of Theo's creativity.

I can quite appreciate Philip feeling captivated by the 'magic' of all that he saw. He was extremely impressed with Theo's workmanship and ideas. Not only did he make some purchases, but he had a proposition to put to Theo. He wanted Theo's creativity to be obtainable not only by the few who knew Theo Fabergé, but by people everywhere. In other words that the work should receive a wider audience. After much discussion over several months, The St. Petersburg Collection was formed. However, two years elapsed before the Collection was launched. During this period Theo was busy designing objects, crafting pieces for the range, selecting quality craftsmen to join his team and generally supervising The St. Petersburg Collection.

From the outset a policy was agreed, to limit each design to a maximum of 750 pieces worldwide. While a smaller quantity of a particular object could, and indeed has been crafted, the policy decision was taken to never exceed this

figure. The rationale of such a course is simple. Editions of 750 objects allow Theo's work to be relatively widely enjoyed without detracting from the exclusiveness of his creations. Some designs are limited to as few as 125 pieces worldwide.

It is not surprising that Theo chose wood for his first two pieces for the Collection. He has a deep love and understanding of this natural material. Indeed, on occasions when Theo has described to me the colour and graining of a particular block of wood upon which he is working, his words are more poetic than clinically descriptive. His enthusiasm is no less for wood in its raw state than after he has carved and polished it to further enhance its natural beauty. The first piece Theo created for The St. Petersburg Collection was *The Scribe Egg* (See page 115). This is a variation of his earlier *penholder paperweights*, but instead of having an elongated body, the theme is naturally an egg. He chose specially selected cocobolo, a rich and well-grained exotic wood from Central America. The base is ornamental turned brass gilded with 24-carat gold. Carved from a single block of cocobolo, the pedestal and egg-shaped body emerges from the base. The line is perfect and the piece is equally suitable for practical or decorative use. The secret does not lie with the brass rings expertly set into the wood, but is connected with the elegant gilded 24-carat gold finial surmounting the piece. Lift this and a ballpoint pen is revealed, also gilded with 24-carat gold.

A full catalogue of The St. Petersburg Collection appears later in the book, together with the date that each piece was launched. The styles of the Eggs designed for The St. Petersburg Collection by Theo Fabergé are diverse. *The Four Seasons Egg* (See page 119) is totally different from *The Spring Egg* (See page 121), although the underlying theme of both is nature. *The Dragon Egg* (See page 123) is clearly influenced by the mysterious East whilst *The Devil Egg* (See page 127) draws upon the story of Adam and Eve from the Old Testament. Despite the diversity of Theo's designs, there are nevertheless things which are common to all his creations. Like his grandfather's, Theo's standards are of the highest. No item bears the personal mark of Theo Fabergé, unless he is satisfied that the piece has been crafted in the most precise, skilled and intricate way possible. Each object sold by The St. Petersburg Collection is numbered. When the pre-determined number of objects for each issue have been made, the patterns are destroyed. All the Eggs have a story and most contain a hidden suprise. Needless to say, Theo's desire for perfection does not cease with the objects he creates. They have to be presented in a befitting manner. As much care is taken in the design and manufacture of the presentation cases as of the objects they contain. For example, each Egg is housed in an elegant six-sided brass-mounted carrying and display case covered in a golden material made specially in Switzerland for The St. Petersburg Collection.

A question that Theo is frequently asked is, 'Do you make everything yourself?' While he does not make everything, he does the ornamental turning and most of the engraving. At its peak, the House of Fabergé could have employed up to 700 craftsmen, workers and administrative staff. Under normal circumstances the number was 500. No item is known to exist which is the exclusive work of Carl Fabergé. In fact to our knowledge, Carl never worked on objects which bear his name. However, Theo does. In addition, he designs every piece, whereas his grandfather's company employed a team of designers. Like his grandfather, everything has to receive Theo's approval before it is sold. Theo has surrounded himself with a dedicated team of craftsmen specially selected for their fine skills. These crystal cutters, artists, enamellers, silversmiths, gem setters, engine turners and box makers are based at several workshops throughout England, and, like his grandfather, Theo is a perfectionist: only the very best will suffice.

Theo has travelled extensively to attend exhibitions of The St. Petersburg Collection. His first visit to the USA was to Chicago where the Collection was being displayed at the department store Marshall Field's. This choice was no accident. Dr. Armand Hammer had exhibited a group of Carl Fabergé's Eggs there 53 years earlier. All of Theo's visits to North America have been memorable, but he will always treasure the recollections of his first visit in November 1986.

It so happens that it coincided with a record cold spell. Theo recalls waking in his room at the University Club and switching on the radio. 'They were warning all old people not to go outdoors, so, I nearly turned over and went to sleep again.' He is pleased that he did not. Whilst breakfasting in the Cathedral Hall with its views over Lake Michigan, he was fascinated by the mist that hung 'like white candy floss' over the frozen water. The day may have begun peacefully, but the pace was to quicken. After a brisk walk, which froze him to the marrow and confirmed the wisdom of the radio announcer's advice to the elderly, Theo entered the traditional world of Marshall Field's. The St. Petersburg Collection was beautifully displayed and a three piece orchestra added to the graceful atmosphere. Theo instantly took to the American people and from all accounts, they to him. Theo's workshop in England may have seemed a million miles away, but he felt at home amongst friends.

As well as chatting to the customers who came to view The St. Petersburg Collection, Theo was interviewed by the press. He has of course since appeared on many radio and TV shows and has been the subject of numerous newspaper and magazine features worldwide. It was at Marshall Field's that Theo gave his first talk about his life and The St. Petersburg Collection. The venue was the Great Room where the store's gigantic Christmas tree had just been erected. Theo unfolded aspects of his life and work to the assembled audience. However, this was not to be Theo's only talk of the trip. He felt very priveleged to be invited by the students and staff of the Art Institute to share his experiences in crafting and designing objets d'art. The theme of his lecture was to give sound practical advice. It took the form of, 'persevere with your own designs, do what you think is right and do not give up.' Theo was flattered to be asked so many questions by his young audience.

Details of the exhibitions or functions which Theo has attended in person are given in Appendix IV. Although his travels have taken him to cities of considerable contrast, there is one common theme − the hospitality of the people he has met. For example, arriving late one evening at the Mayflower at Washington DC, Theo found upon entering his suite that the dining table had been set for supper. A small card simply read, 'I thought you may arrive late for an evening meal'. Theo more than appreciated the kind thought when he saw the delicious cold supper. Not surprisingly his penchant is for the older hotels which express the grace of earlier years.

Theo loves to meet those who come to view his Collection. Always dressed in an evening suit, he wears a diamond stick pin in his lapel from the range of jewellery in The St. Petersburg Collection. It is in the form of his mark, which appropriately incorporates an egg. The questions Theo is asked on these occasions do not always centre around the Collection or his life. The inquisitive may want to know, when they learn that Theo is a Freeman of the City of London, what this in fact means. The response generally results in puzzled looks followed by chuckles of laughter when Theo explains that he is entitled to drive his sheep across London Bridge and through the streets of the City of London 'without heed or hinderance'. The customs of old England are certainly quaint, if impractical in today's world. The last Freeman who attempted this, at four o'clock in the morning so as to avoid traffic chaos as well as providing safety for the animals, suffered the embarassment of three sheep bolting. They took seven hours to round up! Theo has no intention of taking up his rights. Designing and crafting

Scroll for The Freedom of the City of London granted to Theo Fabergé in 1979.

Theo and his daughter. Sarah.

objets d'art is more Theo's line. Inevitably the conversation returns to Theo's work and to his Eggs in particular.

Naturally, The St. Petersburg Collection by Theo Fabergé is not just restricted to Eggs. As shown in the catalogue later in this volume, it extends to jewellery, boxes, items for the desk and picture frames. Theo's favourite is *The Scribe Egg*, while his daughter favours *The Devil's Egg*. Sarah married in June 1988. One of her wedding gifts, which is one of her prized possessions, is *The Devil's Egg*. Sarah takes a keen interest in her father's work and discusses concepts and designs with him.

The most important item in The St. Petersburg Collection may be considered to be the Vladimir Egg which was unveiled in August 1987. It was commissioned by the Russian Orthodox Church outside Russia with the blessing of its Primate, His Eminence Metropolitan Vitaly to commemorate the Millenium Celebration of the Baptism of Russia. The edition is limited to 500 pieces worldwide and it is the first piece that a member of the Fabergé Family has made for the Russian Orthodox Church since the Russian Revolution (See pages 130 and 131).

The St. Petersburg Collection by Theo Fabergé and Theo's fascinating story have simultaneously impressed and captured the imagination of many people throughout the world. His story is not yet complete, for Theo has many more exciting designs to unveil. We also hope that more information about his father will come to light. However, to date, all that is available to be told in these pages has been revealed. Undoubtedly, Theo's work has had a considerable impact upon a world where it appears that high technology rules supreme over gradually disappearing traditional skills and craftsmanship. The St. Petersburg Collection by Theo Fabergé is proof that the old skills are being kept alive. All can be summed up by a lady who spoke with deep emotion and sobbed, 'Thank you Mr. Fabergé for maintaining the tradition.' I can add no more to this, the ultimate of accolades. When you view The St. Petersburg Collection by Theo Fabergé, reach your own conclusions.

Nicholas Fabergé's visiting card. Although Theo's father adopted the name Nicolas, the Anglicised spelling Nicholas is used in the text.

Nicholas Fabergé — Paintbrush in hand, probably taken in his late twenties whilst he was running the London branch of Fabergé.

Postscript

NICHOLAS FABERGÉ

The information that we have been able to gather about Theo's father is extremely sketchy. He came to England and with Henry Bainbridge was the joint manager of the only overseas branch of the House of Fabergé. As Bainbridge only makes a fleeting reference to Nicholas in his books, it is reasonable to conclude that the men were not on good terms. One of the reasons for opening the London branch was for trade with the East and Bangkok, in particular. The Thai Royal Archives reveal that Nicholas Fabergé had an audience with King Chulalongkorn on 27 November 1908. He also appears to have seen the king three days earlier, for a copy invoice exists in the archives. It is written in Nicholas' hand and reads:

<div align="center">

C. Fabergé
Joaillier de la Cour St. Petersburg

Oriental Hotel, Bangkok
November 25th 1908.

</div>

Your Royal Highness

Enclosed I have the honour to send you my account for the eight articles of enamels his Majesty so kindly bought from me yesterday.

<div align="center">

I am your Royal Highness
Obediently Yours,
(signed) N. Fabergé

</div>

To H.R.H. Prince Sommot
 Private Secretary to the King
 Bangkok

The eight items comprised one locket, five links and two cigarette cases. The total bill came to £571:

	£
Locket	*110*
Links	*135*
Links	*78*
Links	*13*
Links	*28*
Cigarette Case	*175*
Cigarette Case	*12*
	£571

The Oriental Hotel archives reveal that Carl Fabergé stayed at the establishment in 1911 and 1912 Rooms 3 and 4 were the venue for a 'lavish exhibition of his objets d'art in the finest Russian enamels and Siberian precious stones'. It is seriously doubted however, that Carl himself ventured to Bangkok. The firm is more likely to have been represented by Nicholas. It is believed that the exhibition was staged during the period of celebrations to mark the coronation of King Vajiravudh.

In the mid 1980s, Theo was contacted by Barbara German, the great niece of Nicholas' wife Marion. She had learnt of Theo's existence through a newspaper article and wanted to meet him. Although she could not furnish a great deal of information she did have a small article about her aunt which possibly came from a London evening newspaper in 1958:

BELLE OF THE 1912 BALL

I put the clock back 46 years yesterday and went to see the belle of the 1912 Chelsea Arts Ball, 74 year-old Mrs. Marion Macrae.

In those days Marion, red headed daughter of a Civil Servant, was the most beautiful woman in London.

King Edward VII paid £1,760 for a painting of her by Sir Laurence Alma-Tadema. More than 30 paintings of her were hung in the Royal Academy. Nicholas Fabergé, son of Carl Fabergé, the fabulously rich, fabulously successful Russian jewellery designer, wooed and won her.

Now she lives in the basement of a tiny house in an unfashionable Chelsea street.

"I met Nicholas - I called him Coco - at a dance." she said. "He was just back from delivering jewels worth £1,500,000 to the King of Siam."

"He said, 'A pang went through me the moment I saw you', And I married him."

Now Coco is dead. The Fabergé fortunes are gone, victims of the Russian revolution. The elegant house in Pelham Crescent is sold.

And Marion, although she still used the title Baroness Fabergé, has married Commander Roderick Macrae, R.N.V.R.

Some of the information in this piece is undoubtedly economical with regard to historical fact. Nicholas was never a baron and although the value of items taken to Siam was sizeable, it is stretching the bounds of credibility to suggest that the figure was £1,500,000 at 1912 prices. However, it does confirm Nicholas was in Bangkok that year.

Theo's mother Doris and her sisters also attended the Chelsea Arts Balls and he believes that Nicholas met her at one in 1920/21. Doris would then have been 16-17 years old and Nicholas 36-37 years. At the time Nicholas had a photographic studio in the Fulham Road, West London. Doris, or Dorise as she later adopted, was a beautiful young lady. Until recently the only items that Theo had of his father were some photographs of his mother simply signed N. Fabergé. One of Theo's earliest memories was the family excitement when Aunt Doris was to fly back from Paris. It is believed that Nicholas also had a studio in Paris, but this has not been confirmed. One of the photographs in Theo's possession is marked 'Paris'. From the limited conversations Theo had with his

mother on the subject, Doris and Nicholas were very much in love and it was not a 'flighty romance'. We shall probably never know what did happen, but Nicholas returned to Marion. Family tradition is that he was forgiven and he and Marion led a 'jet set' life. Nicholas was not without money, for it is believed that he had a portfolio of residential property in Greater London. Marion and Nicholas travelled extensively and attended parties given by the British elite; it is said that they were part of the Windsor set.

One of the strangest facts that has come to light during research emanates from Bangkok. A manager of The Oriental advised, 'Please note that his (Carl Fabergé's) son Nicholas came to The Oriental in 1921 with a dozen steamer trunks, one filled with his Easter Eggs'. Subsequent enquiries have revealed no more. It has always been believed that when trading ceased in London during 1917, the entire remaining stock of 200 items was sold to Lacloche of Paris. It is strange that the final stock was so low, and items could have been sold elsewhere, but, could this have been as late as 1921?

It is sad that Theo cannot discover more about his father. Possibly further information will come to light in due course. We know of at least one individual who knew Nicholas Fabergé, but their lips remain sealed. Tragically the Fabergé family destroyed a series of photographs of Nicholas. His son, Theo, had never seen a likeness of his father until this book was virtually on the press. Miraculously pictures came to light for inclusion in this volume just in time. Theo received a telephone call to advise that after much searching photographs of Nicholas had been found in an old album belonging to Marion's family. Next day Theo anxiously awaited for the past to arrive. The Royal Mail duly obliged. Yet another jigsaw piece had been found. Possibly the future will bring equally kind surprises.

THEO FABERGÉ
THE EARLY CREATIONS

The following represent a selection of commissions completed between 1952 and 1989.

The sizes and weights are approximate.

All the diamonds used are 'brilliant cut' (57 facets).

All measurements in millimetres (mm), unless otherwise stated.

THE BEECH CANDLESTICKS 1952

Masquerading beneath the turned spiral design of the two candlesticks is the wood from two quite ordinary beechwood rolling pins. The candlesticks are inlaid with balsa wood stringing.

These are an example of Theo Fabergé's early work and show the skills of his wood craftsmanship.

Height 220mm Diameter 95mm

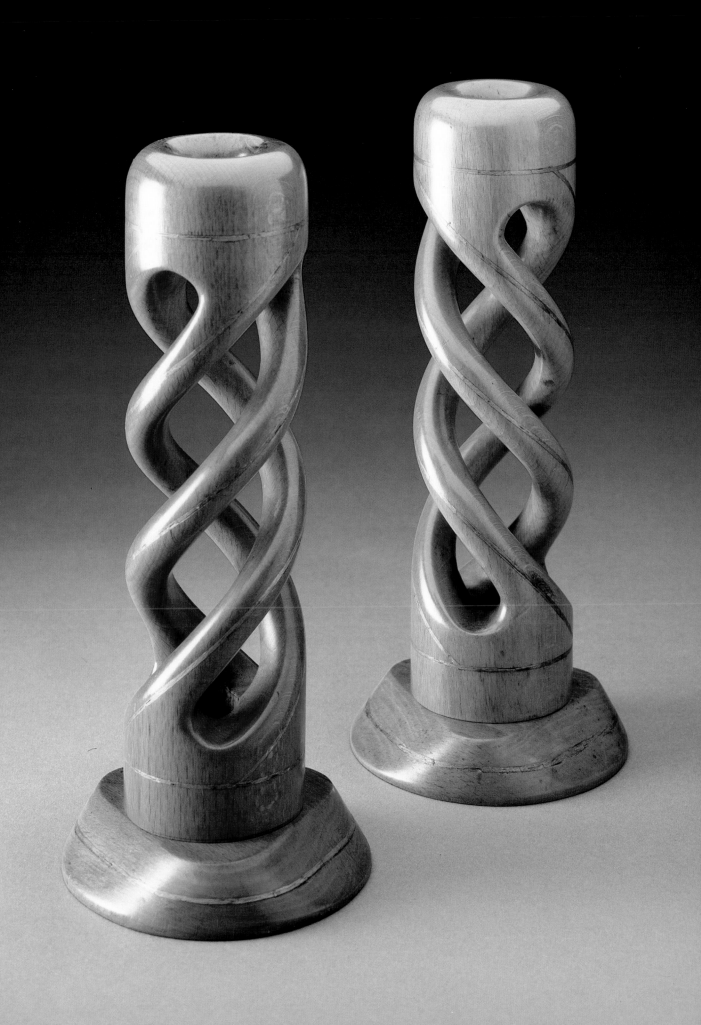

Overleaf
THE SILVER JUBILEE IVORY CASKET 1977

A special commission made to commemorate the 1977 Silver Jubliee of Her Majesty Queen Elizabeth II.

The casket is ornamentally turned from ivory and lavishly embellished with Burmese cabachon rubies and sterling silver.

The base, with an engraved interior and exterior is decorated with 25 rubies, set in silver and mounted on ivory spheres. Fluting, 25 in number, encircles the body of the casket, whilst the crown-shaped cover is set with 25 silver beads.

Height 105mm Diameter 115mm

THE RIBBED SALT AND PEPPER MILLS
—A MATCHED PAIR 1975

Meticulously turned from cam wood and lined with boxwood, the salt and pepper mills represents the fervour with which Theo Fabergé applies his craft.

The mills are complimentary; symmetrical in design but not identical. The pepper mill is identifiable by a blackwood crown and the salt mill crown turned from white ivory.

Height 200mm Diameter 90mm

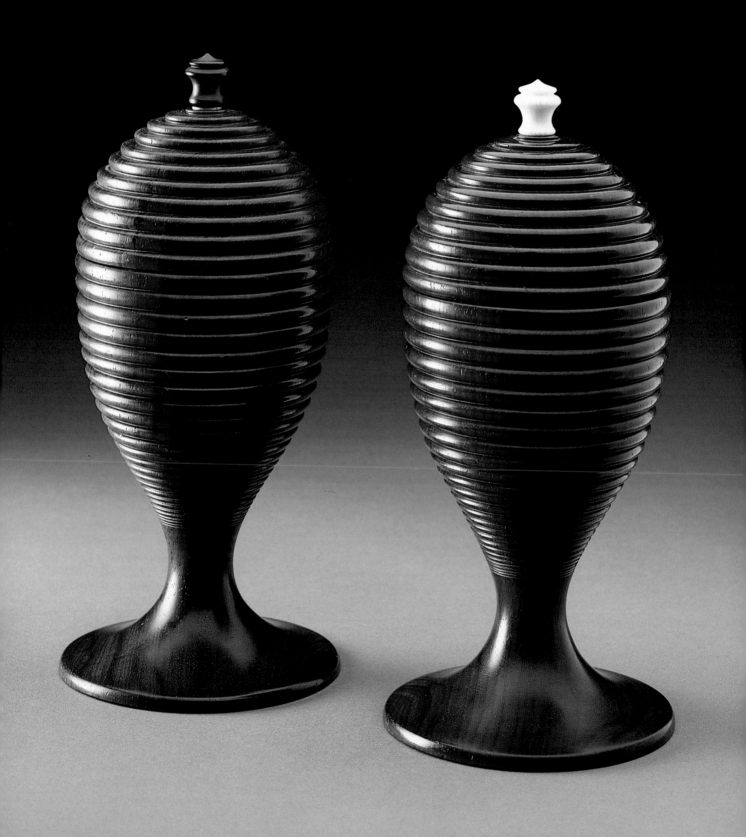

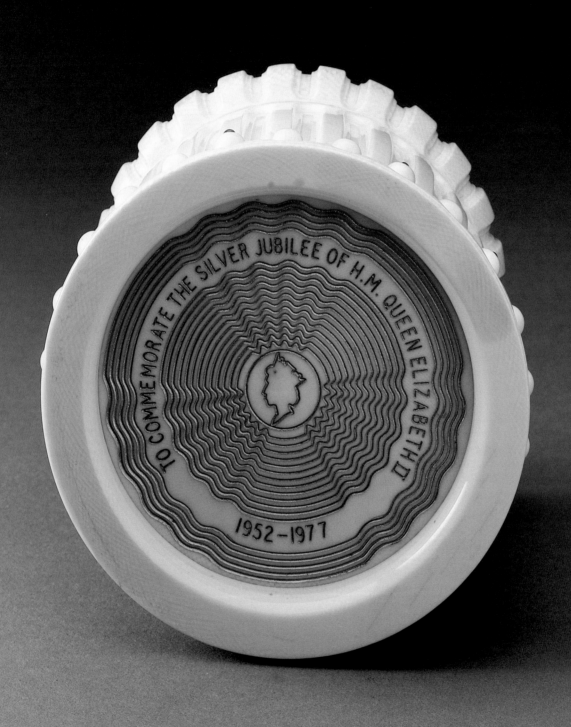

TO COMMEMORATE THE SILVER JUBILEE OF H.M. QUEEN ELIZABETH II

1952 – 1977

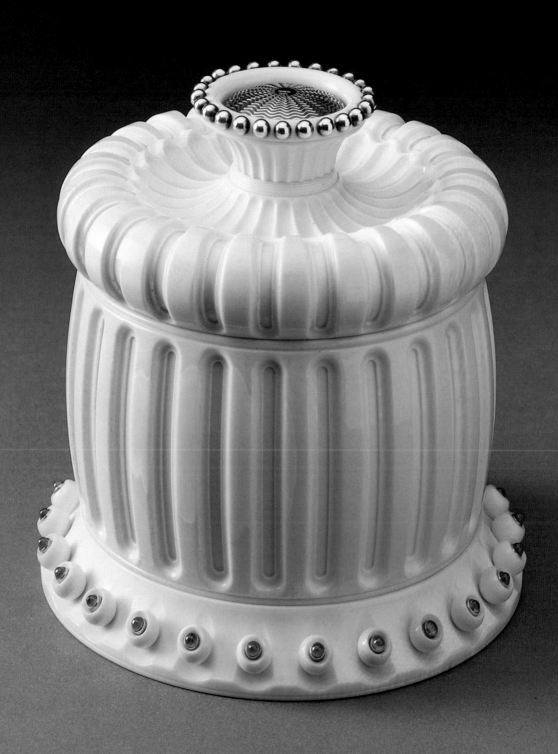

LACE BOBBINS 1979-1984

*Utilizing a selction of native and exotic woods Theo Fabergé has created
these aesthetically pleasing yet functional lace bobbins.
The woods used include rosewood, pernamduco and African blackwood,
and decorated with non-precious beads.*

Length 110mm

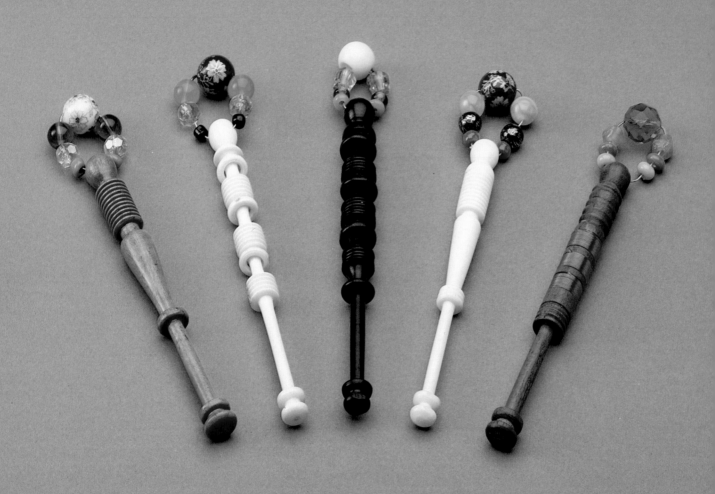

LETTER OPENER AND BOOKMARK PRESENTED
IN A TURNED CASE 1980

*A rich yew wood case with a burgundy velvet inlay
endorses the clean lines of the hand carved ivory
design. The item has been engraved with
the T.F. (Theo Fabergé) mark.*

*It is only upon close inspection that the dual function of
the item is revealed.*

Length 160mm Width 25mm

THE CANDLELIGHT MIRROR 1980

*A combination of native and exotic wood has
produced a unique creation.*

*Lathe turned, The Candlelight Mirror has been made from the
combination of ash, mahogany, ramin and sapele.*

Height 390mm Width 250mm

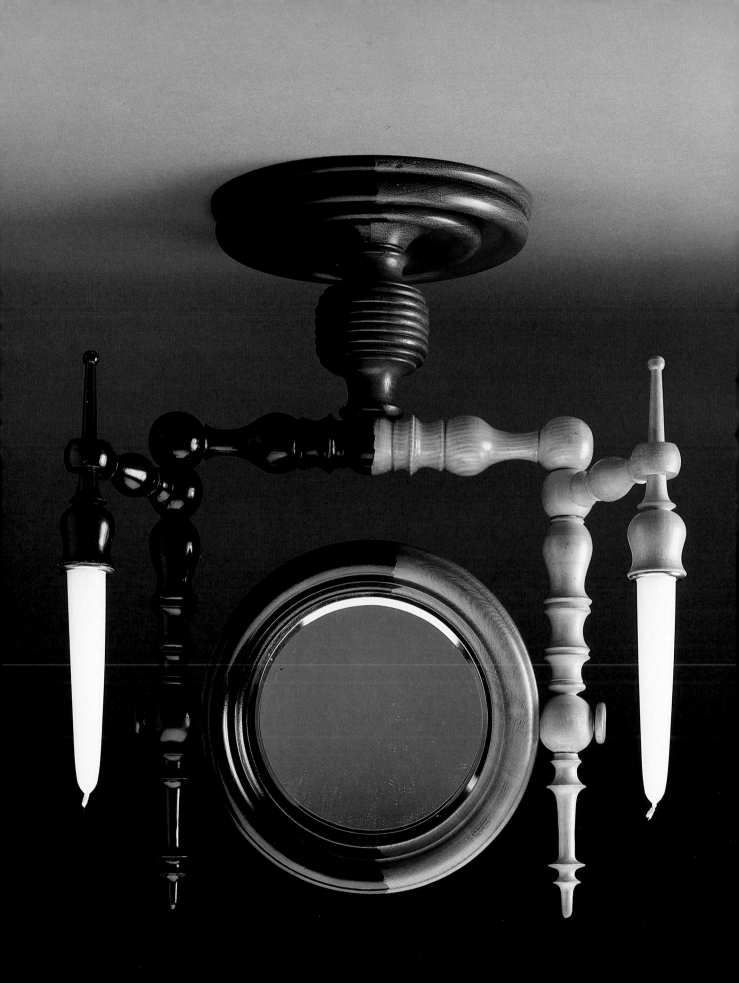

THE CHINESE MYSTERY TURNED SPHERES 1980

*Based upon an earlier design by Theo Fabergé, The 1980 Chinese
Mystery Turned Sphere consists of six concentric spheres
within each other.*

*Turned from a solid piece of white ivory, and set upon
a complimentary rosewood base, the puzzle intrigues
the ardent observer.*

Height 105mm Diameter 85mm

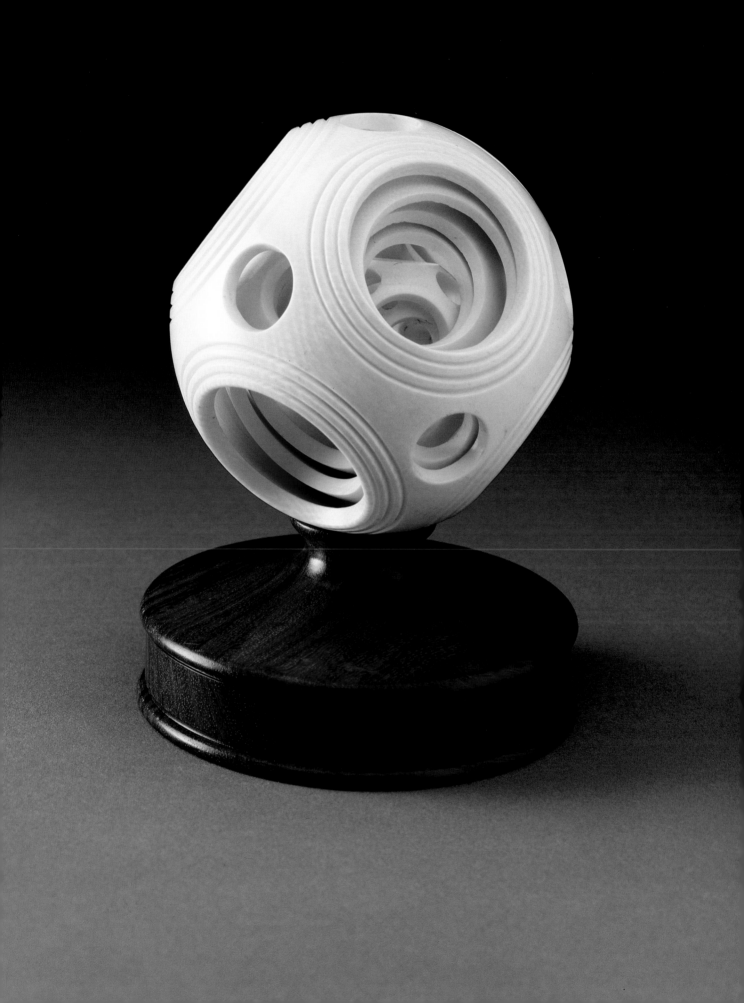

Overleaf Left

TEARS OF THE MOON EGG 1982

*Turned from purple heart wood, the design is accentuated by
ten sterling silver rings and a finial.*

*The Tears of The Moon Egg, which opens to reveal a surprise,
is trimmed with sterling silver at the base,
and completed with a beechwood stand.*

Height 95mm Diameter 90mm (measured on base stand)

Overleaf Right

PURPLE HEART CIGARETTE BOX 1982

*This opulent Cigarette Box is crafted in rich purple heart wood,
decorated with inlaid bandings and is crowned with a
sterling silver boss inset with four cabachon rubies and
then set upon contrasting mounts of ebony and ivory.*

Length 178mm Width 105mm Height 68mm

ST. CATHERINE CANDLESTICKS – *A MATCHED PAIR* 1981

*Created by Theo Fabergé as a competition and exhibition piece
for The Worshipful Company of Turners. The St. Catherine
Candlesticks represent the elements of the
Company's Coat Of Arms in three-dimensions.*

*Crafted in lignum vitae wood with additional brass fittings,
the piece presents the woodman's axe and St. Catherine's sword
and wheel, which are featured in the Coat of Arms.*

Height 280mm Diameter 140mm

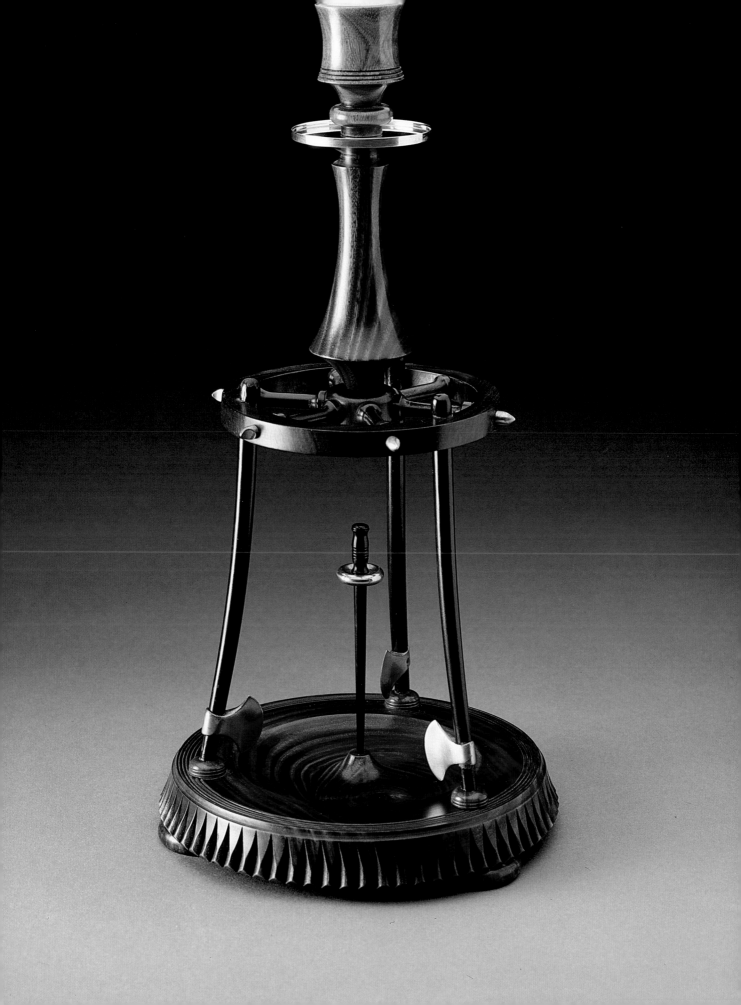

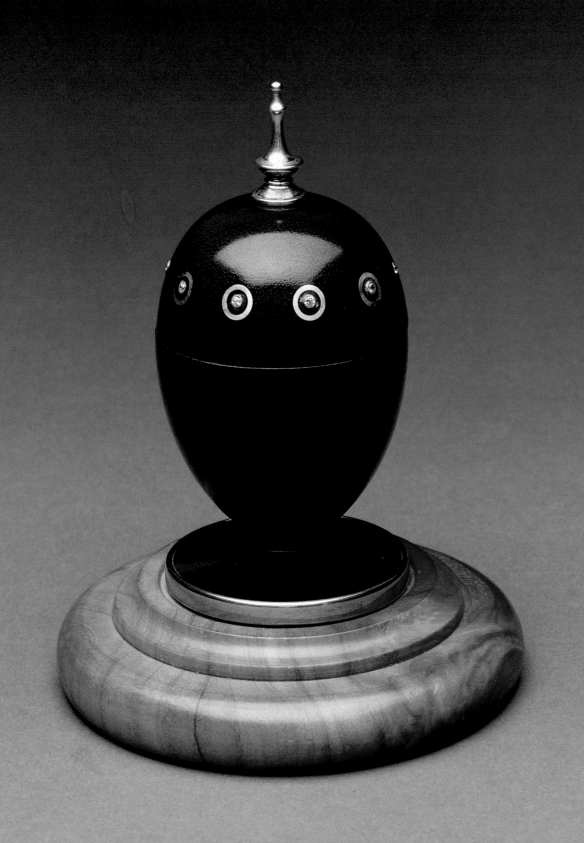

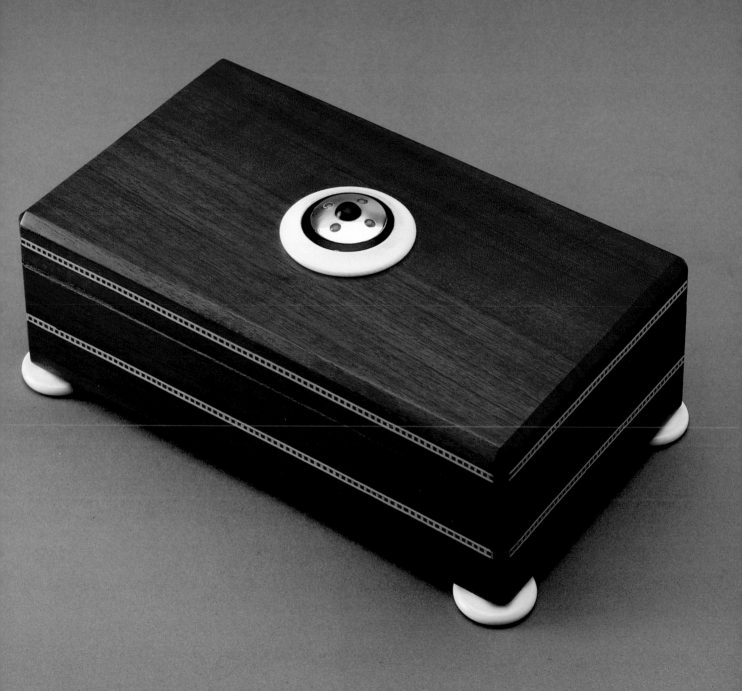

Overleaf Left

THE OWL RUBY ANNIVERSARY EGG 1982

*The Owl Ruby Anniversary Egg combine Theo Fabergé's skills of
both wood craftsmanship and technical engineering.*

*The Egg is turned from purple heart wood and designed
with an integral base trimmed with ivory. The body of the
Egg is inset with sterling silver rings, and the lid crowned
with an ivory finial and set with a cabachon ruby.*

*On lifting the lid the surprise — a sterling silver owl, playing a guitar,
set in a yew wood tree trunk — rises pneumatically from the Egg.*

Height 140mm Diameter 75mm

Overleaf Right

THE 30TH ANNIVERSARY PEARL EGG 1983

*Exquisitely turned from rich Brazillian rosewood, the body of
the Egg is adorned with 30 pearls inset in silver rings.
A sterling silver rim around the base forms a complimentary
adornment to the silver finial, set with a 4mm opal and 4mm
emerald, which crowns the lid.*

*The surprise pneumatically rises to reveal a three faced
pyramid, displaying the initials D. and A. on two sides, and a
butterfly set in gold trimmed heart on the third.*

Height 136mm Diameter 72mm

THE SUMMER FLOWER TARZZA 1982

*The spectacular two-tier tarzza interprets a summer
bloom in yew and rosewood.*

*Ornamentally turned, the flower, like many of Theo's work has
an integral surprise — the flower's stamens can be removed and
are cocktail sticks.*

Height 250mm Diameter 170mm

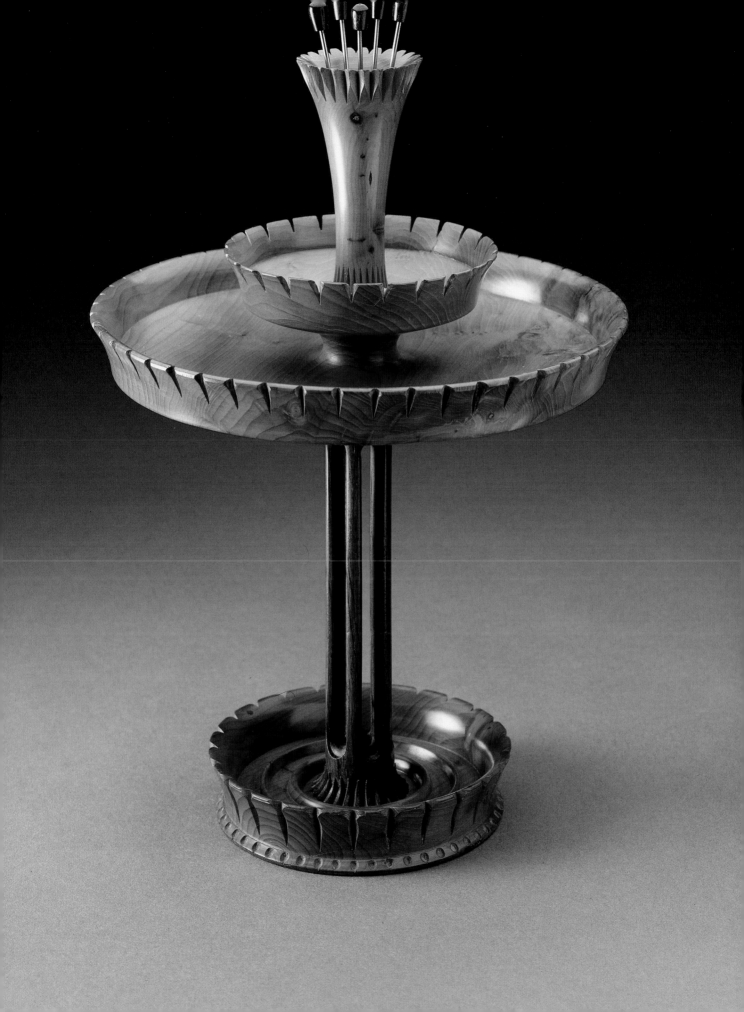

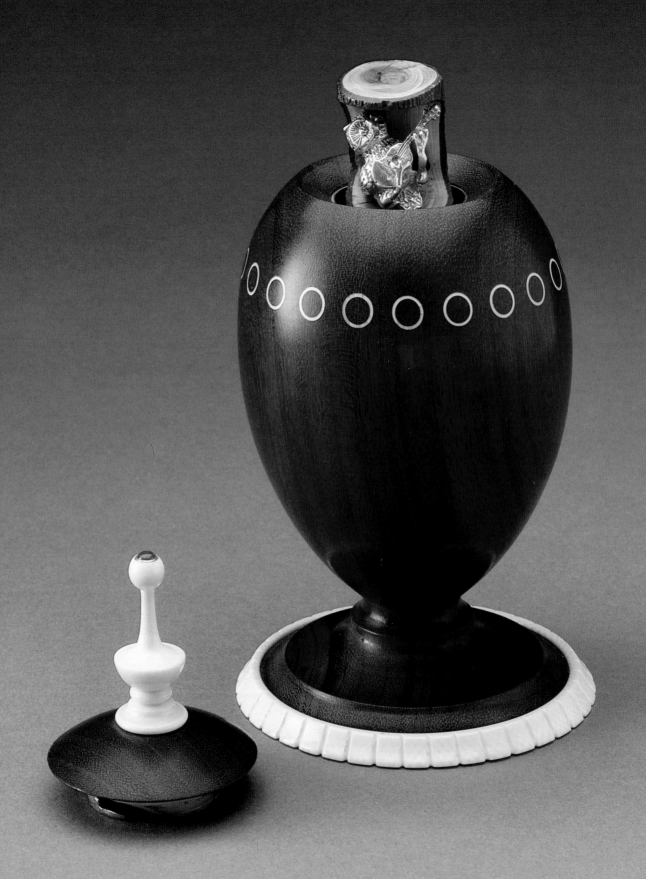

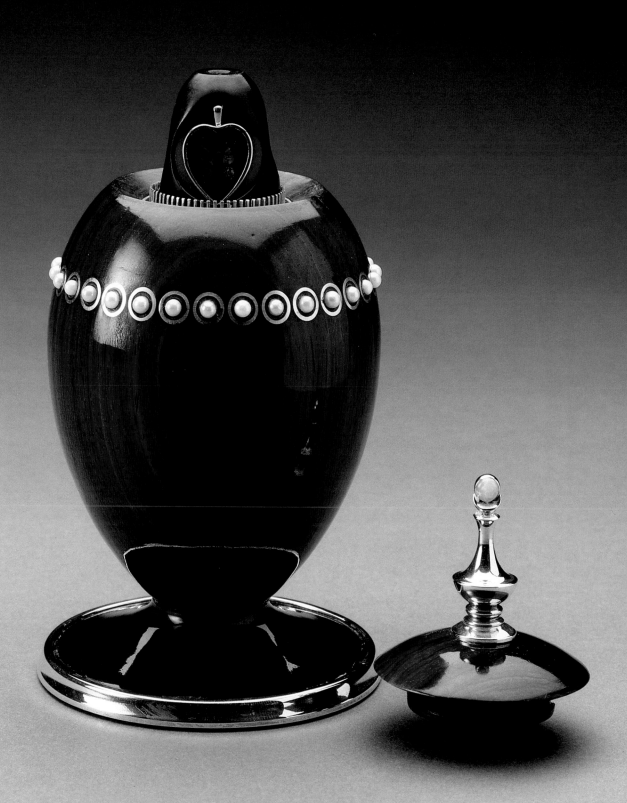

SARAH'S 25TH BIRTHDAY EGG 1983

*In celebration of his daughter's 25th. birthday Theo Fabergé
created a surprise Egg, set upon an ornamentally turned base.*

*Turned from purple heart wood, inset with gold rings, it resting on
an ivory plinth adorned with 25 cabachon rubies.*

*The suprise is the ivory finial, set with a single cabachon
ruby, which once lifted reveals a pen.*

Height 125mm Diameter 50mm

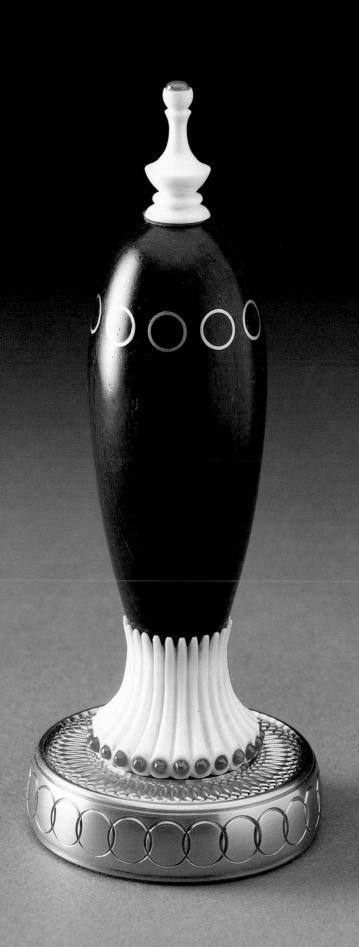

THE NOUVEAU CANDLESTICKS 1983

Turned from native laburnum and sycamore, inlaid
with a banding of rosewood, Theo Fabergé has crafted a finely
balanced pair of nouveau-style candlesticks.

Height 270mm Diameter 110mm

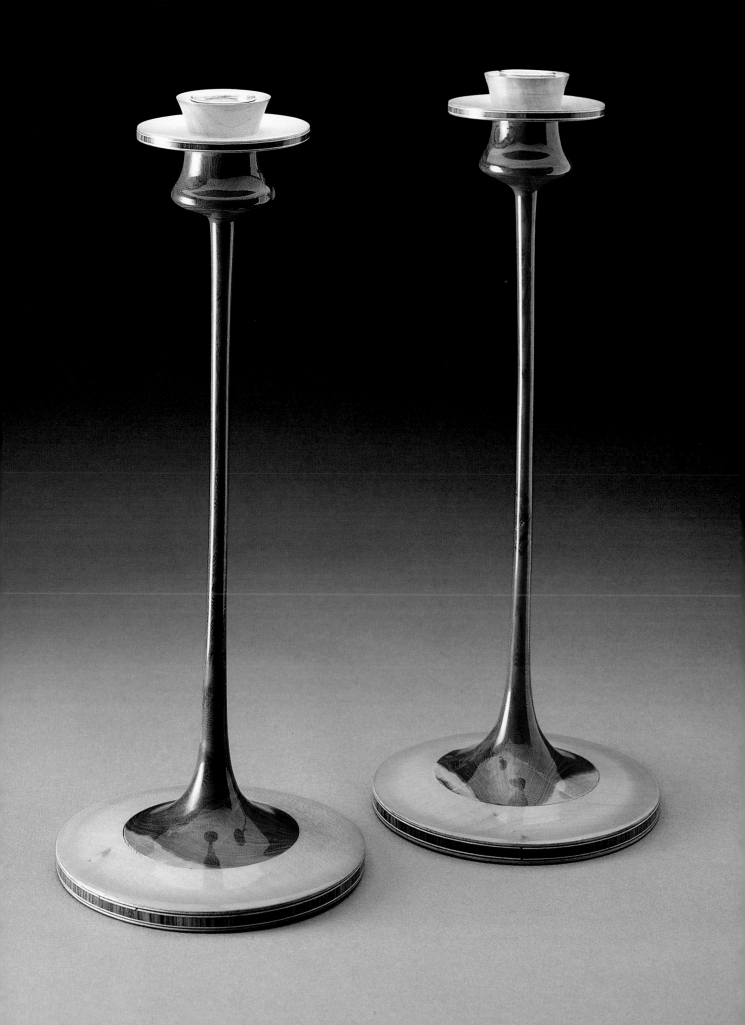

Overleaf Left

SWAN LAKE FANTASY 1984

*A hand carved ivory swan, acting as a ring holder, majestically
floats upon a gilded brass cover. Once lifted, it reveals a ballerina,
standing on one point, delicately carved from ivory and surmounted
upon a contrasting green malachite base.*

Height 55mm Diameter 27mm

Overleaf Right

HELEN'S 70TH BIRTHDAY FANTASY 1984

*A fantasy ring holder made from white ivory, complete with
a finely crafted finial, is complimented by the delicate grain
of the green malachite.*

*The ivory base is ornately decorated with 70 turned beads that
correspond to the 70 birthday years.*

Height 140mm Diameter 70mm

THE PROCESSIONAL CROSS 1984

*Theo Fabergé was commissioned to recreate the Processional Cross
for the Hastings Grammar School in 1984.*

*The ebonised wood staff is crowned with a cross
set with a central monogram — IHS — in Champleve enamel, encompassed
with four sterling silver cast emblems: (Clockwise from top) The Paschal
Lamb, Saint Michael (Patron Saint of the County Borough of Hastings),
The Hastings Grammar School badge and Sign of the
Borough Church of Saint Clement.*

Height 2.1 metres

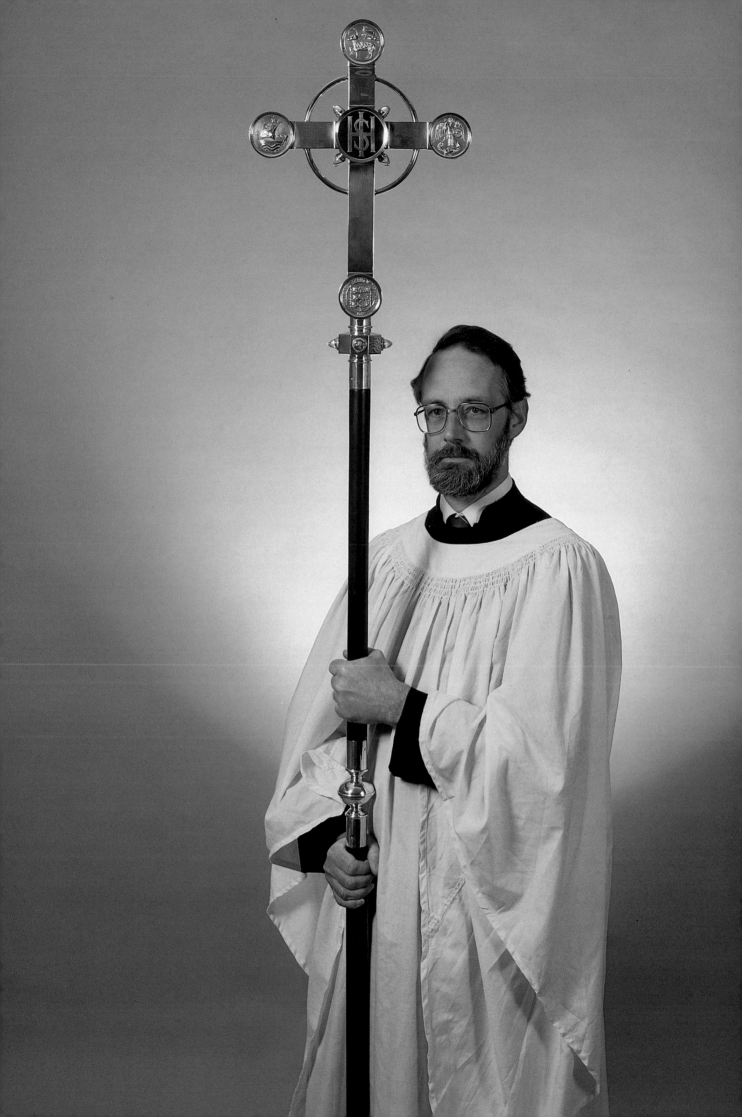

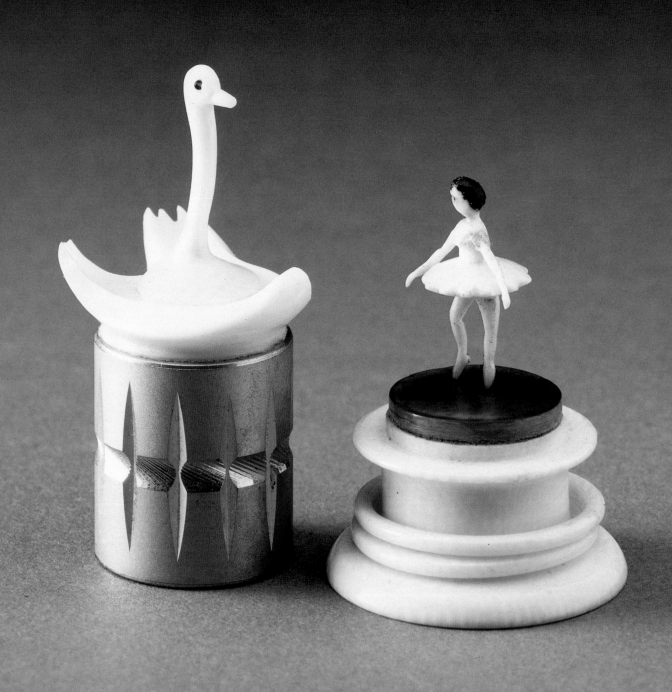

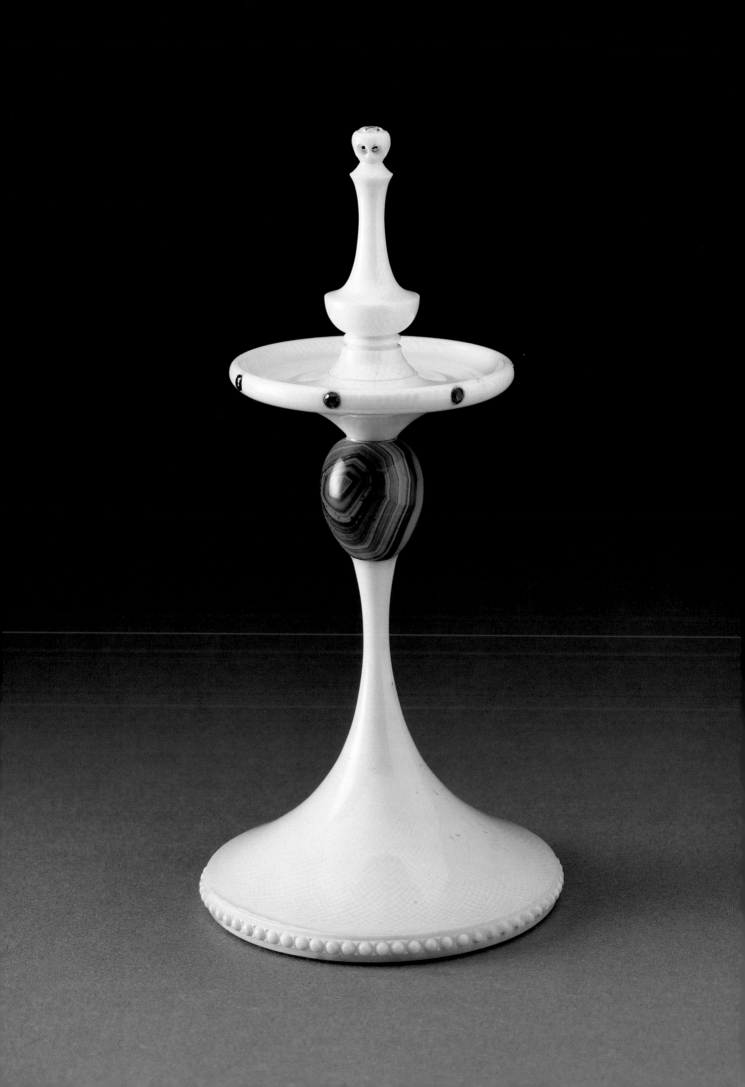

THE TWO-TIER TARZZA 1984

The Two-Tier Tarzza is crafted from
a combination of rosewood, laburnum with elements of brass.

The deep rosewood base highlights the 50 gilt beads, whilst the
50 gilded brass supports create a stunning two-tiered balustrade.
The brass finial is capped with a fire opal.

Height 235mm Diameter 190mm

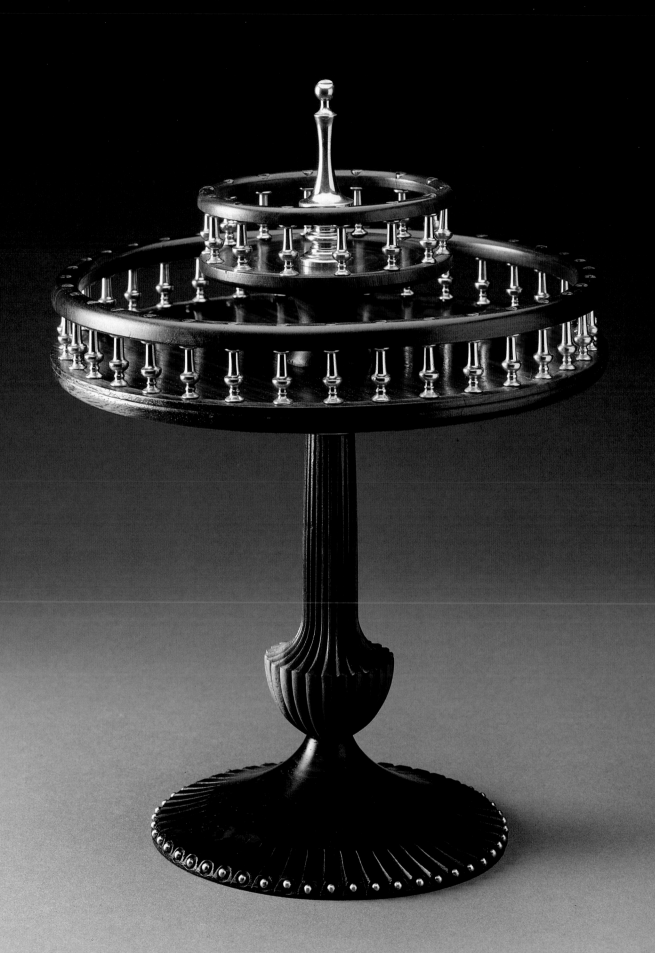

Overleaf Left
THE DIAMOND BIRTHDAY EGG 1985

A stunning design turned from Brazillian rosewood and adorned with a glittering selection of coloured and clear diamonds.

On lifting the finial the humourous surprise − a golden dog standing beside an ivory lampost lit with a sparkling blue marquise diamond − rises pneumatically from the Egg.

The Egg is set with Fancy yellow, light pink, blue-grey and lime green 'brilliant diamonds' with a total weight of 7.5 carats.

Height 270mm Diameter 75mm

Overleaf Right
THE 40TH RUBY ANNIVERSARY EGG 1985

Made from Brazillian rosewood complimented with a sterling silver base trim, set with 40 cabachon rubies delicately set in silver roundels which encircle the Egg. Crowned with a sterling silver finial inset with a single cabachon ruby.

Its hidden surprise rises pneumatically to reveal a four-sided crown; mounted with the badges of the Royal Dutch Air Force and the British Women's Auxiliary Air Force adjacent with photographs of husband and wife taken during wartime.

Height 135mm Diameter 75mm

THE OLD WORLD SUGAR SHAKERS − *A PAIR* 1984

The Old World Sugar Shakers combine functionalism with an intricately turned decoration.

The richness of the rosewood's colour and its grain design are enhanced by the finely balanced silver tops.

Height 160mm Diameter 75mm

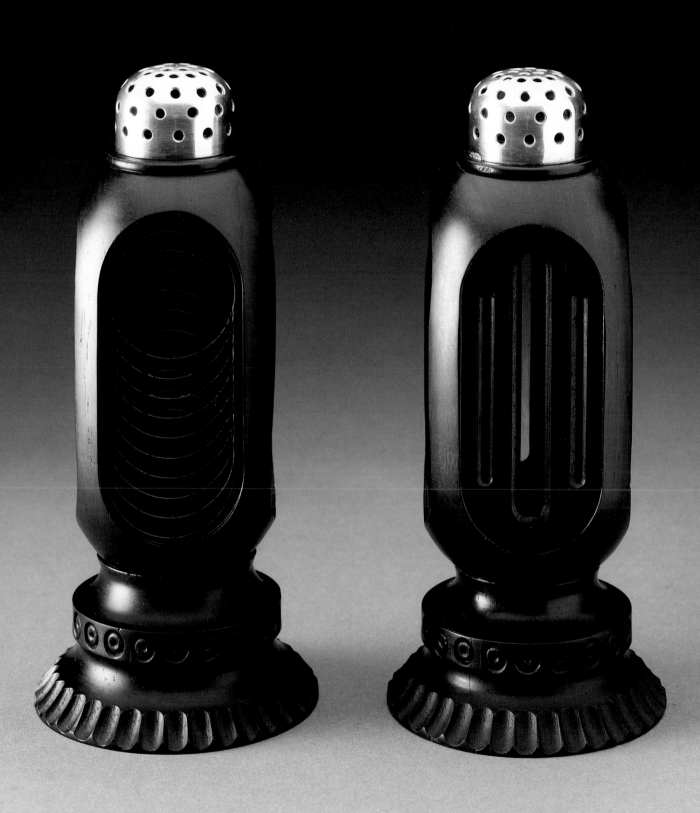

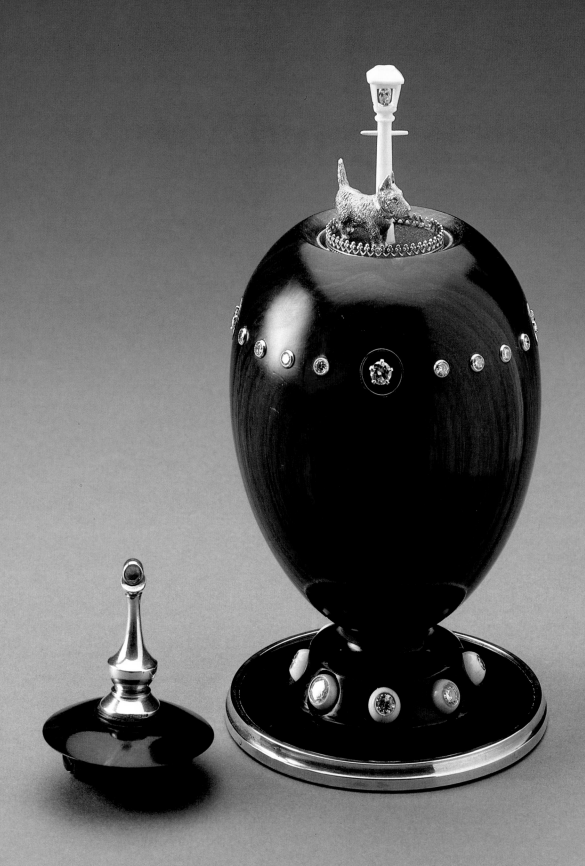

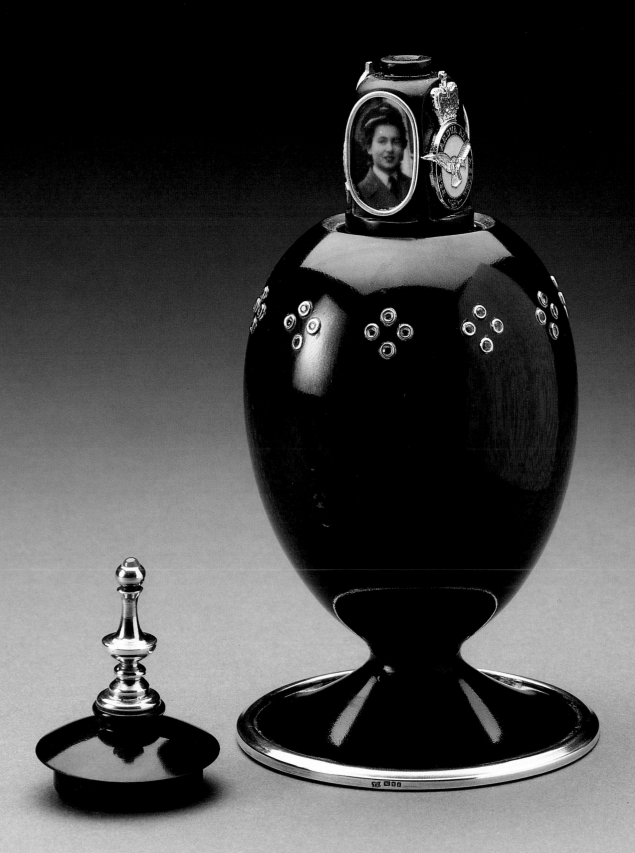

THE MARINE FANTASY EARRINGS – *A PAIR* 1986

*The simplicity of the fish shape is faithfully recreated in
Theo Fabergé's Marine Fantasy Earrings.*

*The 'scaled-body' of hand carved ivory is set with two faceted
ruby eyes.*

Length 40mm Diameter 10mm

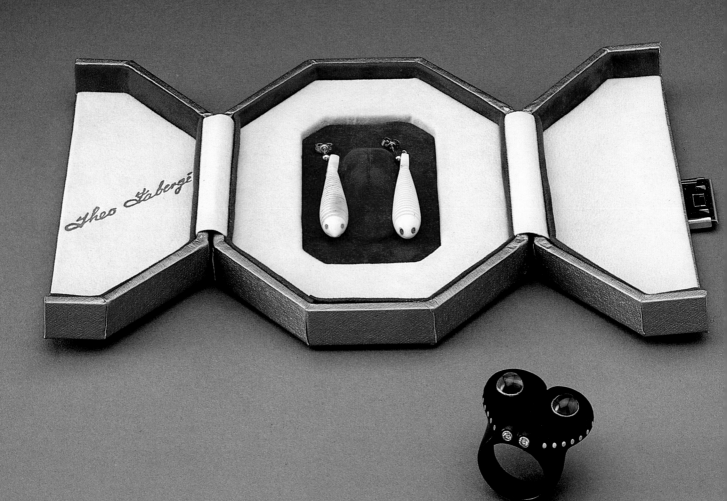

THE JUNGLE RING 1980

*Crafted in African blackwood the Jungle Ring is as
inspiring as it is exotic.*

*Its heart-shaped centre is set with two amethysts, encircled
with sterling silver rings.*

Length 37mm Diameter 37mm

THE FREEDOM OF HASTINGS CASKET 1986

*The intricate craftsmanship of the mahogany casket,
surmounted with four engine turned
ivory pillars and finials, surpasses its formal civic function.*

*The sterling silver, enamelled Hastings Coat of Arms
denotes the dignity of the occassion.
Inscribed: "Presented to Cllr. V.J. Pain on the confirment of the
Freedom of the Borough of Hastings on May 14th. 1986."*

Length 420mm Width 220mm Height 270mm

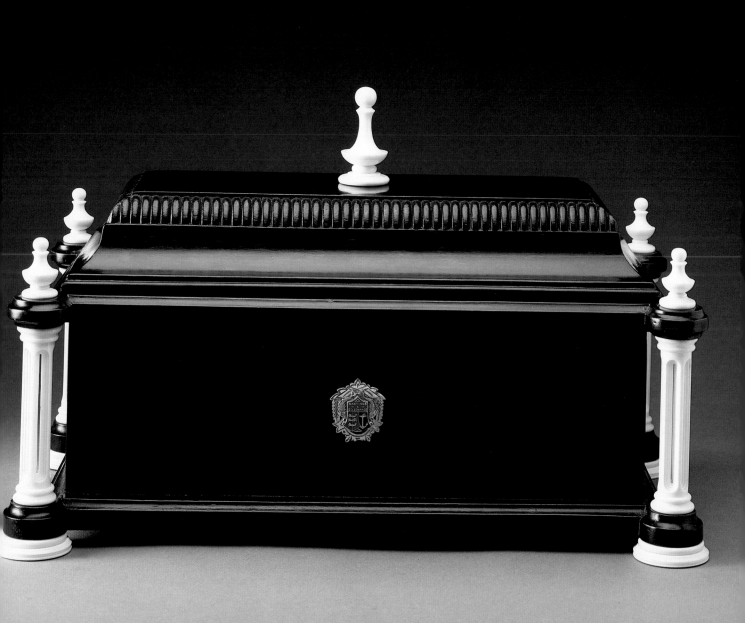

THE 37TH BIRTHDAY MENORAH 1987

*Turned from rare pink ivory wood, with a gilded based of 37
cuts, the menorah becomes a statement of skill and ingenuity.*

*As with many of Theo Fabergé's creations hidden amongst its
construction is a surprise. Close inspection reveals the candles are
made from ivory with gilt candle wicks. However,
the artistry of deception is furthered as the centre candle
can be removed and is a pen.*

Height 245mm Width 195mm

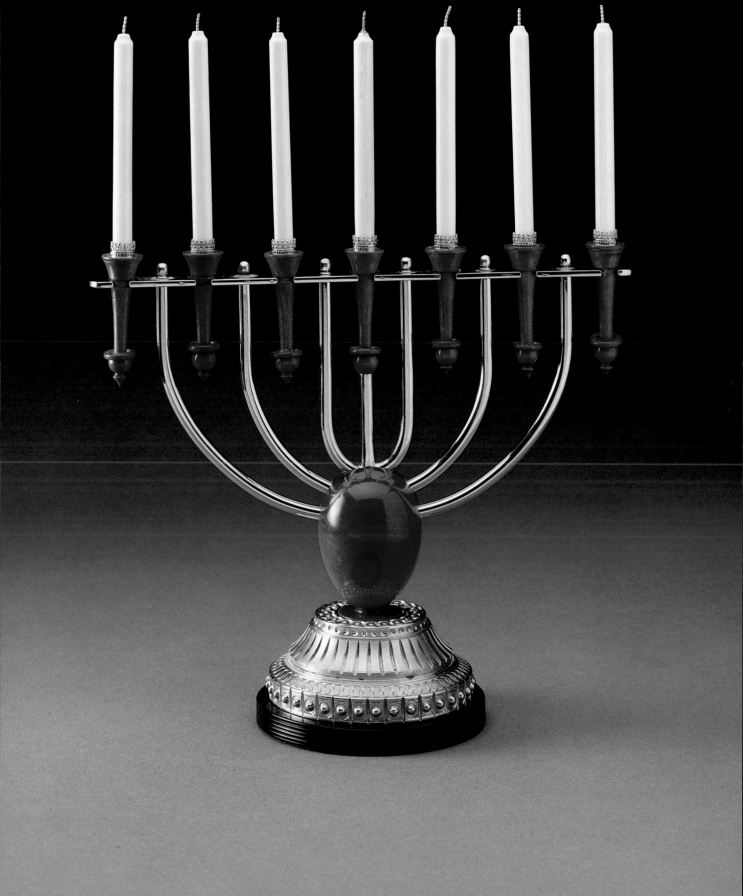

ETAK TARZZA 1989

*The design of the Etak Tarzza not only highlights the wood's grain,
but also the simplicity of form that demonstrates
the craftsmanship of Theo Fabergé.*

*The choice of a variety of light cedar, known as wellingtonia,
is aesthetically pleasing.*

Height 140mm Diameter 120mm

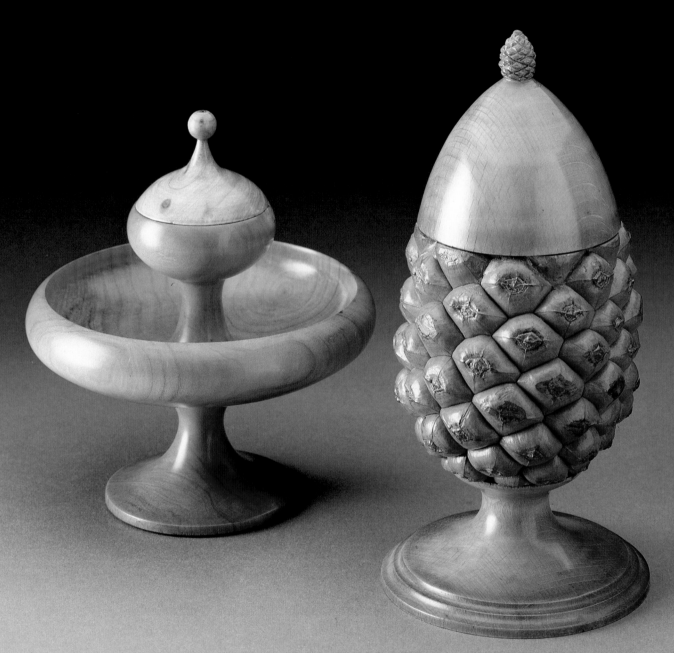

THE PINE CONE EGG 1979

*The utilisation of an umbrella pine cone (pinus pinea),
together with beechwood, has allowed Theo Fabergé
to capture the rich flavour of Autumn,
within the Egg-shape.*

Height 170mm Diameter 90mm

THE 50TH ANNIVERSARY SHIPS BOWL 1989

*Oak seasoned by both the tides of time and of the ocean
has been turned on Theo Fabergé's own Holtzapffel Lathe,
and adorned with 50 golden beads in a celebration of a golden
wedding anniversary.*

*The bowl stands upon a gilt
base, enhanced with finely turned 50 gilt beads.*

Height 70mm Diameter 200mm

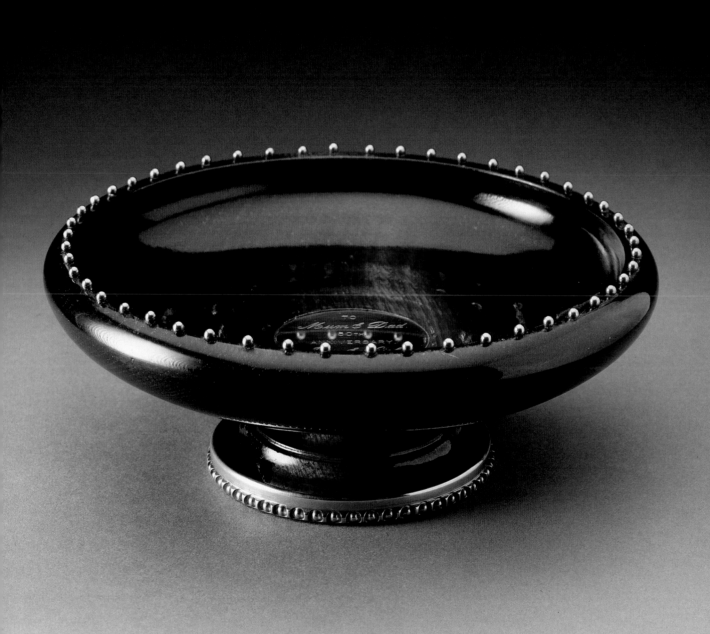

THEO FABERGÉ
AND THE

THE SCRIBE EGG 1985

*The Scribe Egg was the first of Theo Fabergé's creations for
The St. Petersburg Collection.*

*It is made from cocobolo wood, a rare and exotic wood from
Central America. The Egg is inset with rings, whilst the base
and the 24 carat gold finial are ornamentally turned on
Theo Fabergé's own Holtzapffel Lathe.*

*The surprise within is the Scribe's pen, 24 carat gold plated
and embellished with a single cabachon ruby.*

Height 125mm

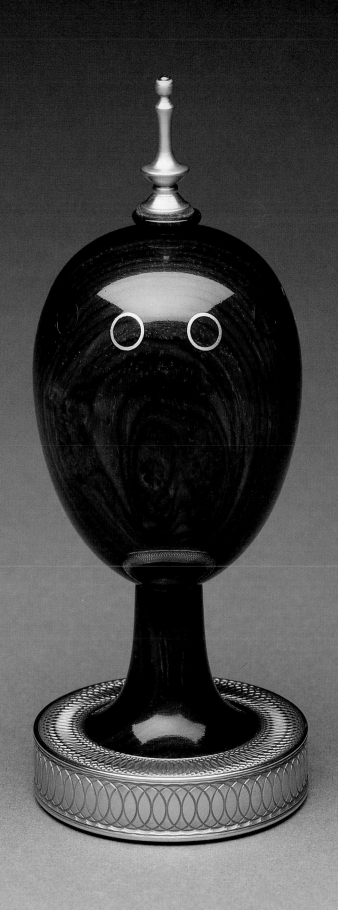

THE SWAG EGG 1985

*The Swag Egg present Theo Fabergé's skill with both
wood and lathe.*

*It is made of cocobolo wood encircled with swags and mounted
with the Russian Imperial Crown, all of vermeil.
The Crown is set with a fine cabachon ruby.*

Height 150mm

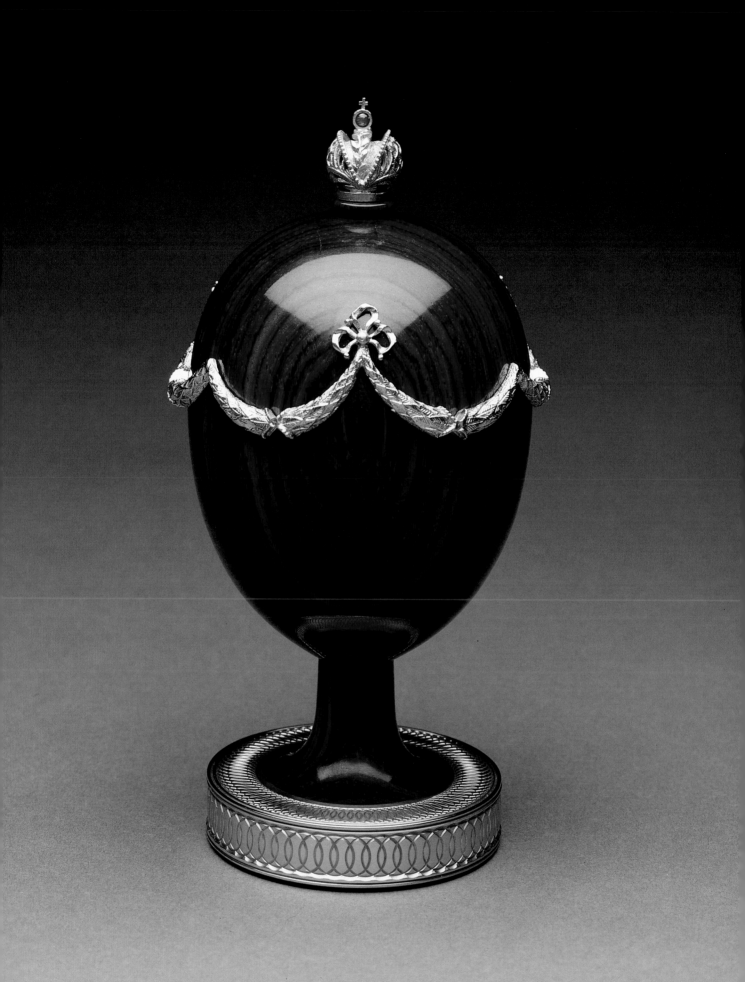

FOUR SEASONS EGG 1985

*As its name suggests, The Four Seasons Egg portrays the
individual character of the year's seasons.*

*Spring, Summer, Autumn and Winter represented in rich hand
painted enamels, each in an elegant oval panel. Spectacular in
24% handcut lead crystal and adorned with hand painted
23 carat gold. The Imperial Crown, in vermeil, is set with
a fine cabachon ruby.*

Height 114mm

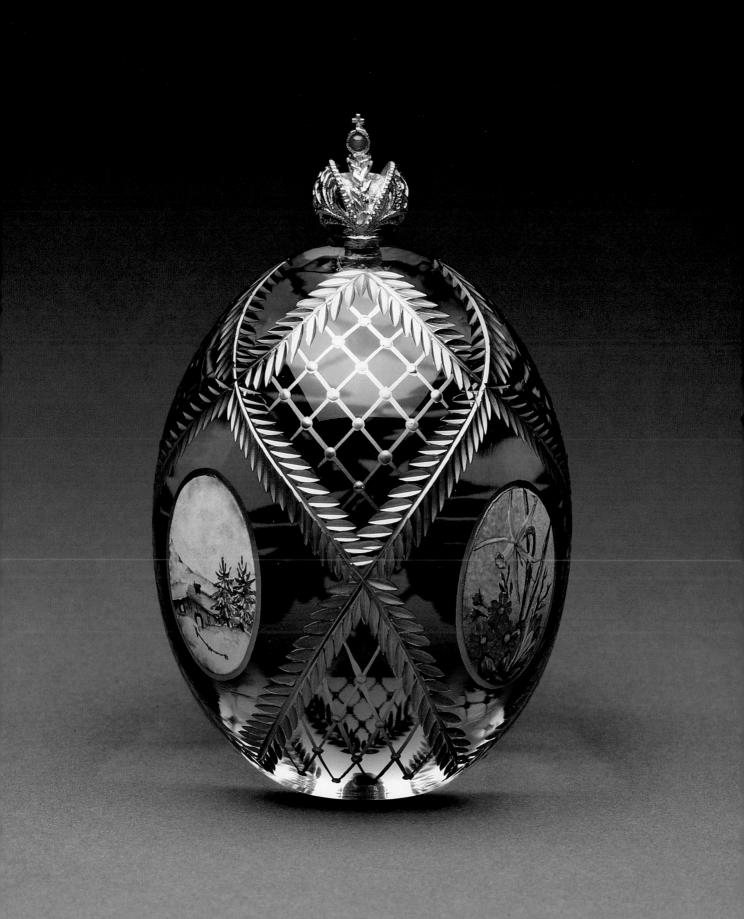

THE SPRING EGG 1985

*Seeks to unravel the mystery of the egg and its symbolism
of life and rebirth. The delicate, hand painted enamelled
Spring flowers raised from the crystal surface
express the regeneration of nature after Winter, when the land
will once again blossom and bear fruit.*

*The surprise is a golden yolk upon which is set the
Imperial Crown in sterling silver which reveals a
hidden compartment.*

Height 114mm

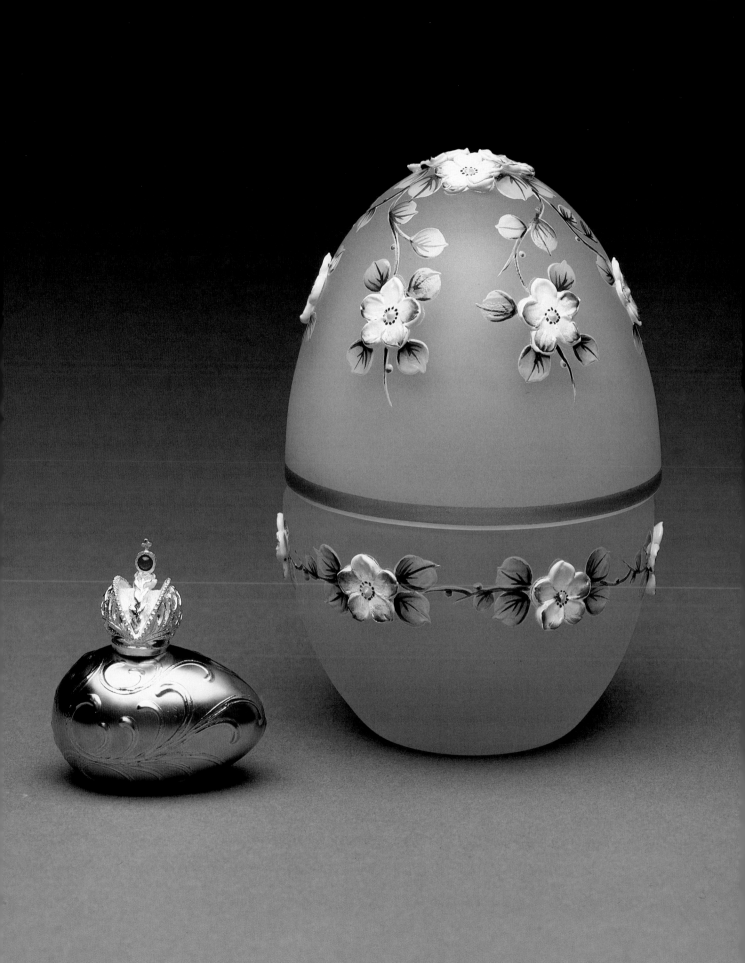

THE DRAGON EGG 1986

*The Theo Fabergé creation in tribute to his grandfather
Carl Fabergé who was one of the first to interpret
oriental influence onto jewellery.*

*Thus the Egg is made from jet black crystal and hand painted
with raised 23 carat gold. A design inspired by the delicate
work of ancient oriental craftsmen.*

Finally, the fiery eye of the dragon is a glittering faceted ruby.

Width 110mm

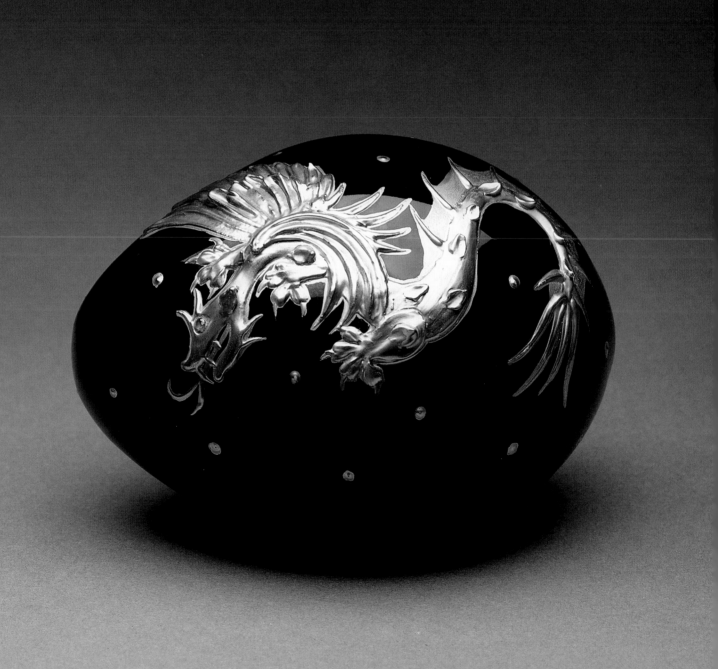

THE ETERNITY EGG 1986

If love is forever, what better expression of it, than this
beautifully created Egg.

It is made of Burbinga wood from Central Asia and The Imperial
Crown of Russia is of vermeil with a cabachon ruby.
The base is 24 carat gold plated and ornamentally turned.

The body of the Egg is finely inlaid, and concealed in its
heart is a specially designed compartment of African blackwood
that will safely hold a precious ring.

Height 125mm

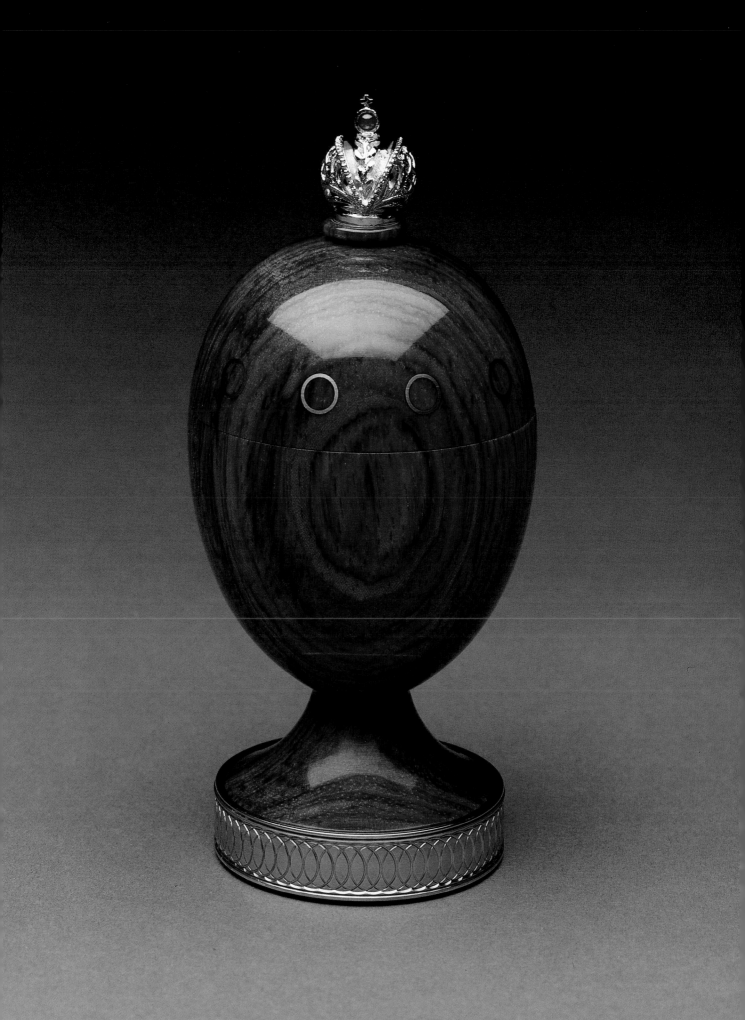

THE DEVIL'S EGG 1986

A stunning interpretation of Temptation and Original Sin.

*An Egg of Paradise Green crystal entwinned with a 23 carat
golden serpent, set with a rich enticing ruby eye
that dares the Egg to be opened.*

*Its hidden surprise is the Golden Apple of Knowledge from the
Tree of Life. In 23 carat gold on crystal, the Apple sits on a
sterling silver tray concealing a secret compartment beneath.*

Height 127mm

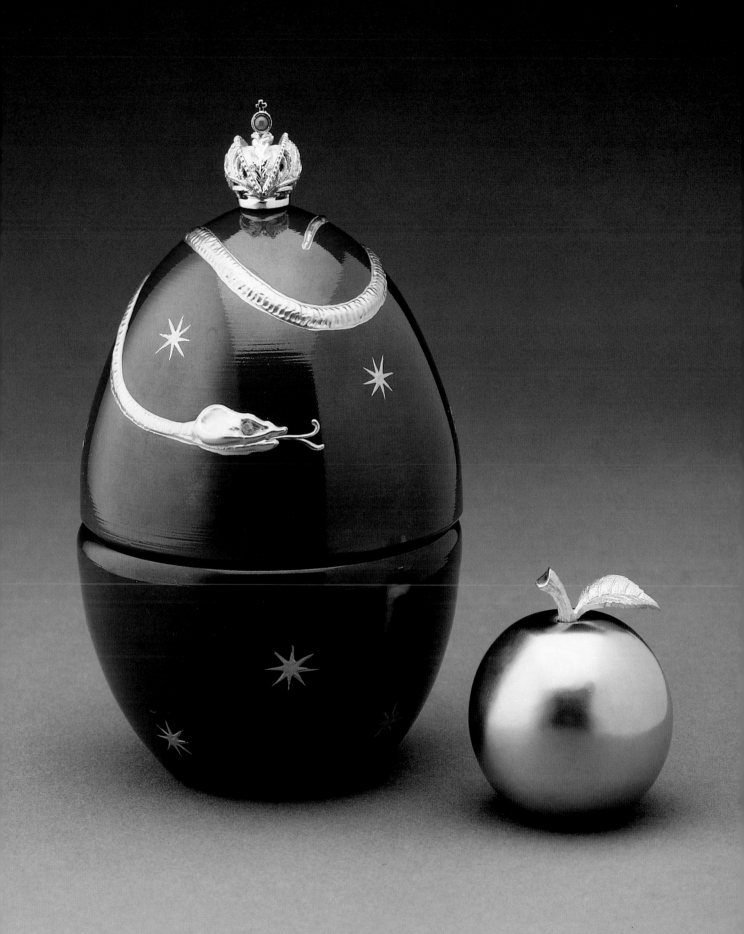

Overleaf

THE ST. VLADIMIR EGG 1987

In celebration of the millennium anniversary of Russian Orthodox Christianity Theo Fabergé was commissioned to create The St. Vladimir Egg.

Evoking the splendor of Russia, the hand cut crystal egg is decorated in rich burgundy enamel complimented by intricate silver designs. Crowned with a vermeil dome from which the sterling silver Russian Orthodox cross rises, the Egg opens to reveal a sterling silver scaled recreation of St. Vladimir's Cathedral, which stands on the site where the first baptism took place in the year 988, in Kiev.

The sterling silver disc is inscribed in Church Slavonic "988...Tysyacheletie Kreshcheniya Rus'...1988" Translated: "988...One Thousand Years of Baptismal of Rus'...1988".

Height 136mm

THE WINTER EGG 1986

A fusion of Winter ice and festive cheer, The Winter Egg is a celebration of Christmas and the Winter Season.

Made of cobalt blue and clear crystal, it is set with the Imperial Crown of Russia. Decorated with delicate bows and green holly, the Egg, resting upon a sterling silver base, opens to reveal a music box that plays 'Silent Night'.

The vermeil Crown inside winds-up the mechanism and revolves with the music. A cabachon ruby operates the miniature mechanism.

Height 152mm

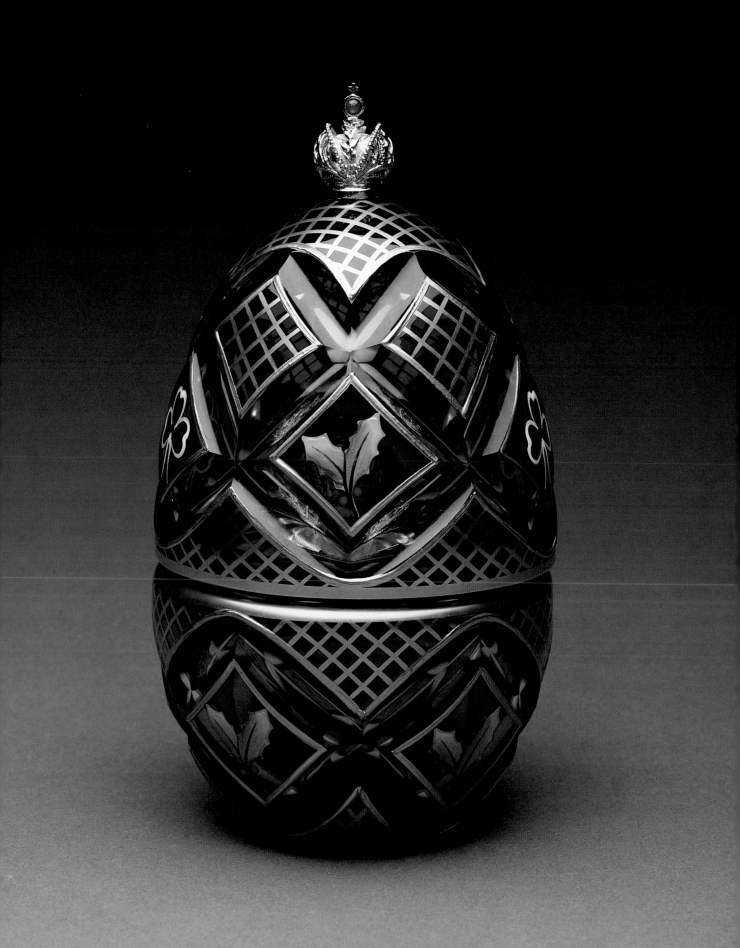

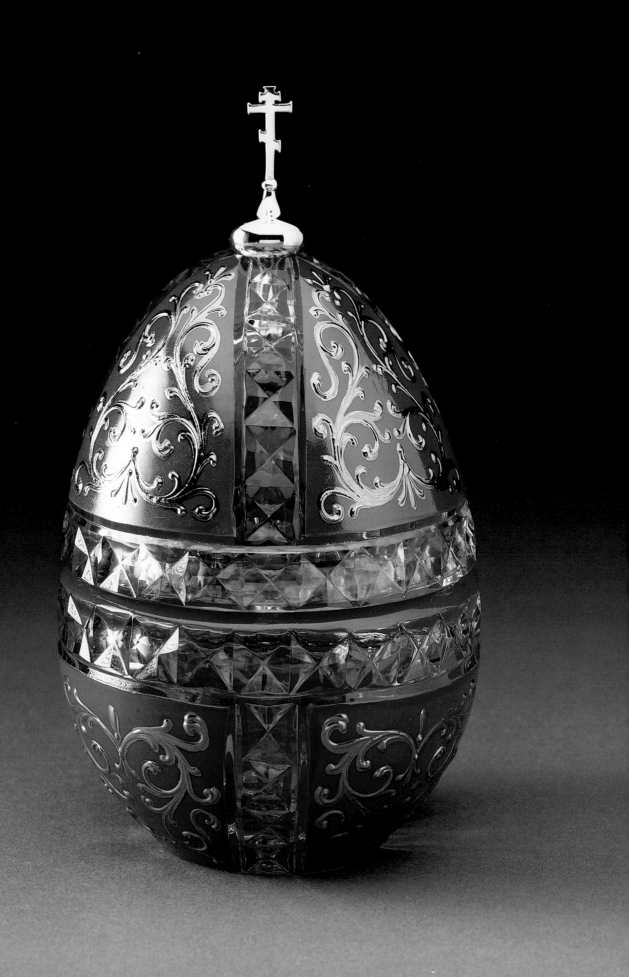

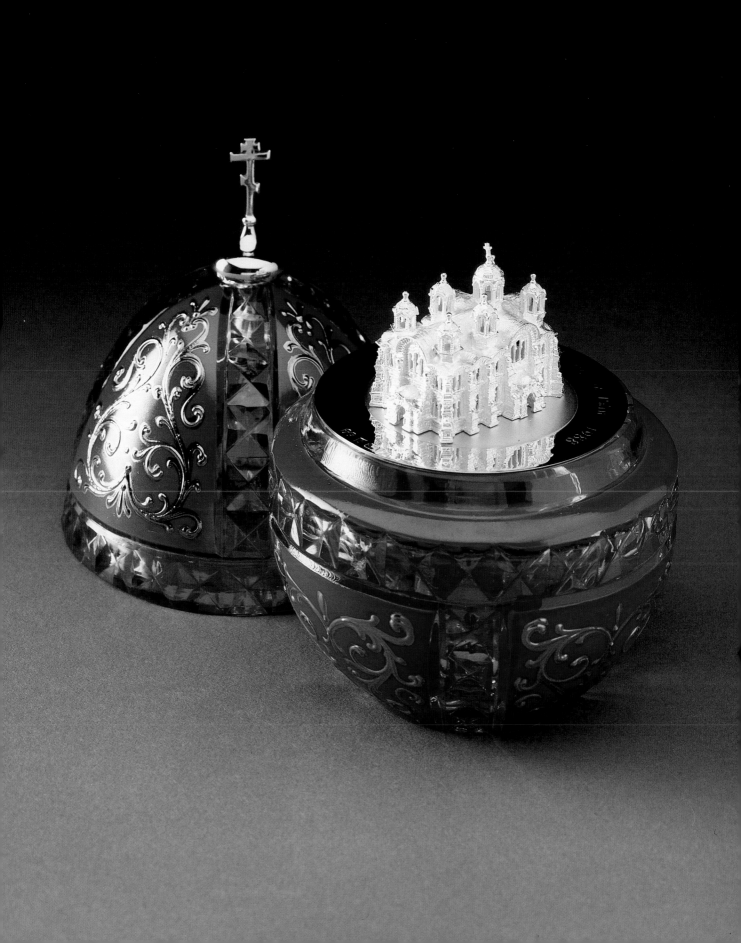

THE WASSAIL BOWL 1987

*The 'Wassail Bowl' was a 16th. century forerunner of the cocktail
mixer, when the drink, probably Mead, was seasoned with spices,
which were contained in the knob of the cover.*

*Theo Fabergé's creation is made from 30% hand cut and hand
painted lead crystal and, naturally, contains a surprise
element—Lift the vermeil Imperial Crown to reveal an engine
turned champagne swizzle stick.*

*The Wassail Bowl is signed by Theo Fabergé and is exclusive and
one of only 125 pieces worldwide.*

Height 460mm

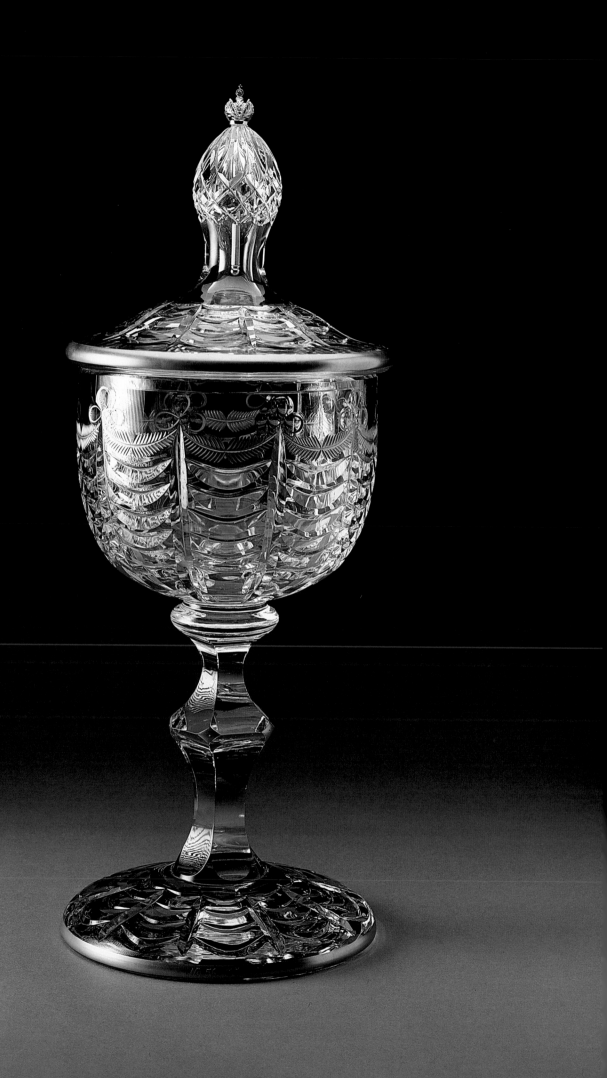

THE CORAL EGG 1988

*This 24% lead crystal Egg, offset by an Imperial Crown of vermeil,
represents the swirling motion of marine life on the ocean.*

*Amid the 'sea bed' of sterling silver coral lay miniature
vermeil shells and starfish, completed with tropical fish
carved from natural carnelian and in grey agate. Beneath the
coral – A secret resting place for some treasure of your own.*

Height 135mm

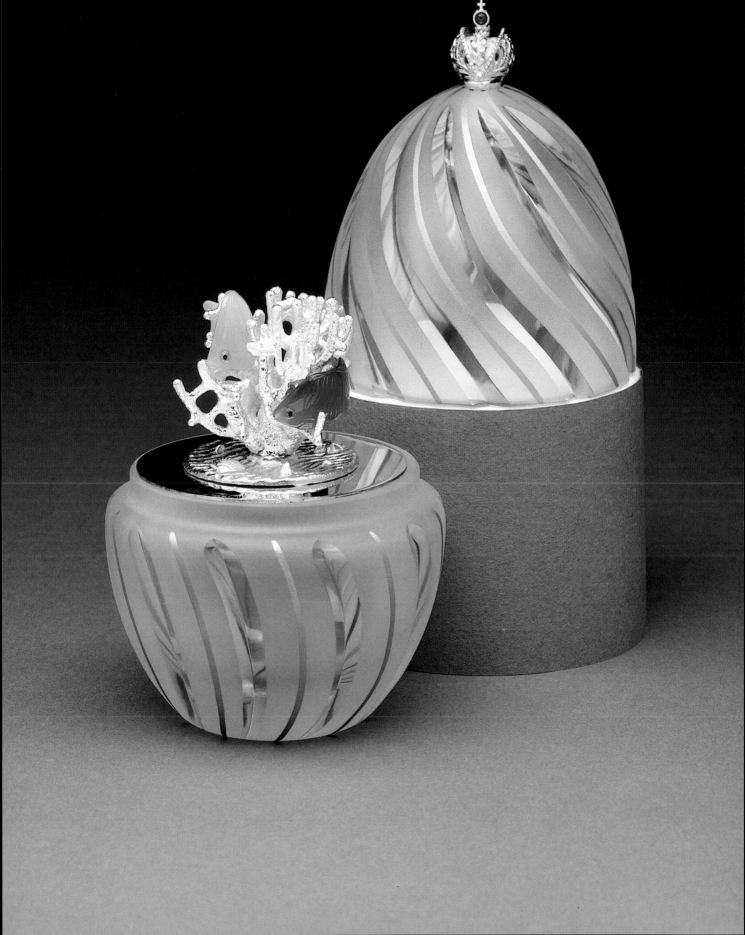

THE CLOVER EGG 1988

*A low relief of clover leaves in deep green enamel adorn the
surface of the Egg which is made of 24% lead crystal and hand
painted with glass enamel and 23 carat gold. The quartz crystal
clock face compliments the classic lines of the whole, which is
surmounted by the Imperial Crown in vermeil.*

*The base, ornamentally engine turned, is guilded with 24 carat
gold. This Egg would not be complete without a surprise —
to bring good fortune, The Clover Egg has a single
four-leaf clover somewhere upon it.*

Height 130mm

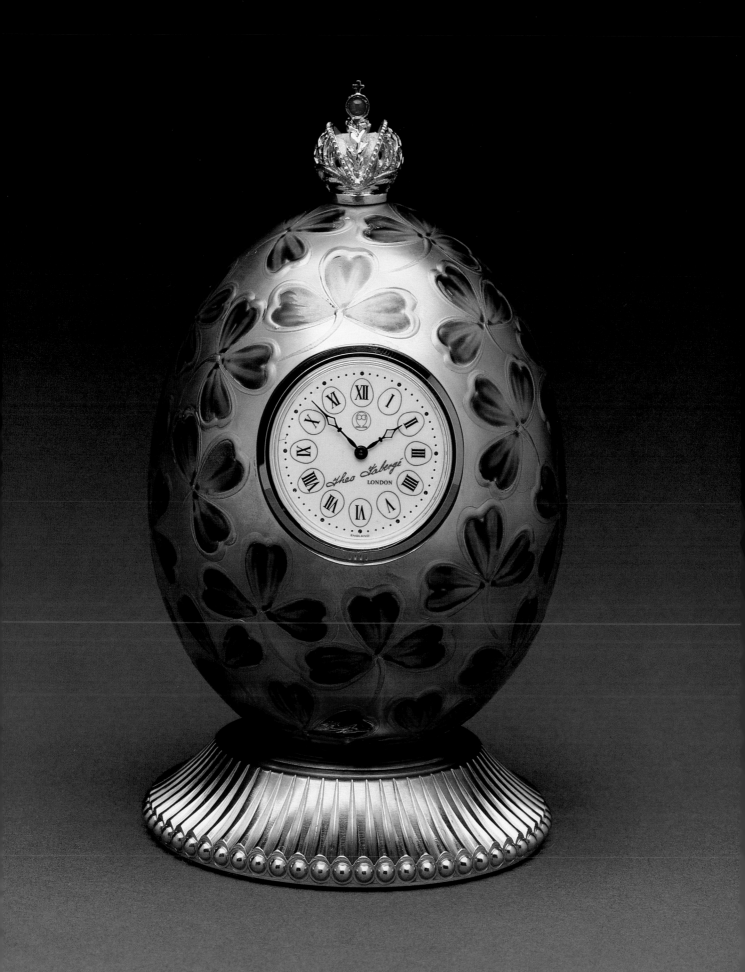

THE DIAMOND EGG JEWELS 1988

The Diamong Egg Jewels represent Theo Fabergé's first collection of jewellery for The St. Petersburg Collection.

Inspired by Theo's special trademark the collection is crafted in 18 carat white and yellow gold, with 'brilliant cut' diamonds and sapphires. A collection of Cufflinks, Money Clip, Stick Pin, Tie Slide and Dress Buttons.

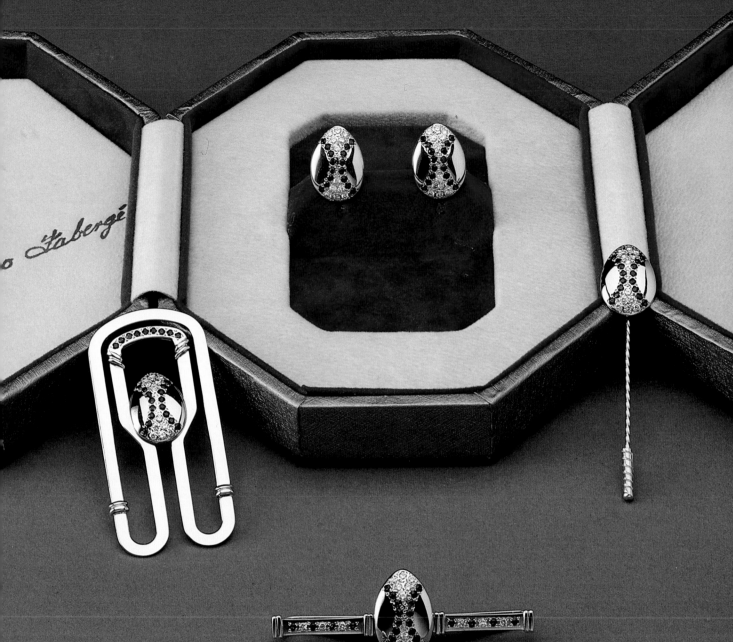

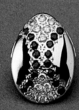
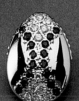
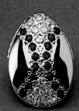

THE TRILOGY BOX 1989

The sterling silver framed 'en cage' box, inset with handpainted porcelain panels, encapsulates the story of opportunity and life.

The lizard becomes an opportunist taking an egg from the unattended Thrush's nest, whilst she is feeding from a half peach. Meanwhile the mouse hoards fruits from the tablesetting.

The box is lined with burgundy velvet and adorned with a ribbon finger plate of vermeil and set with a faceted ruby.

Length 120mm Width 80mm Height 48mm

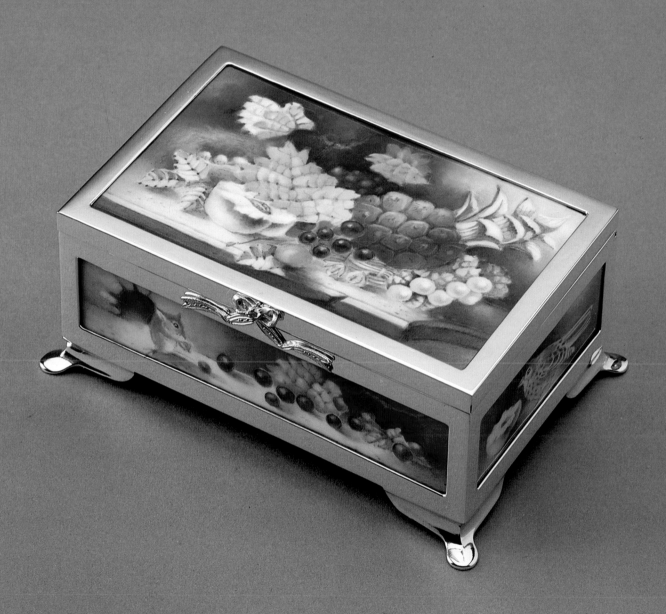

THE SUMMER EGG 1989

*As the days draw longer, The Summer Egg recreates the
sweet smelling meadows of the countryside.*

*Adorned with delicately hand painted enamel wildflowers,
softfruits and brightly coloured butterflies. The scene is set
in a 23 carat gold basket cut into an opaque 24% lead crystal
egg, and crowned by the vermeil Imperial Crown
inset with a cabachon ruby.*

Height 110mm

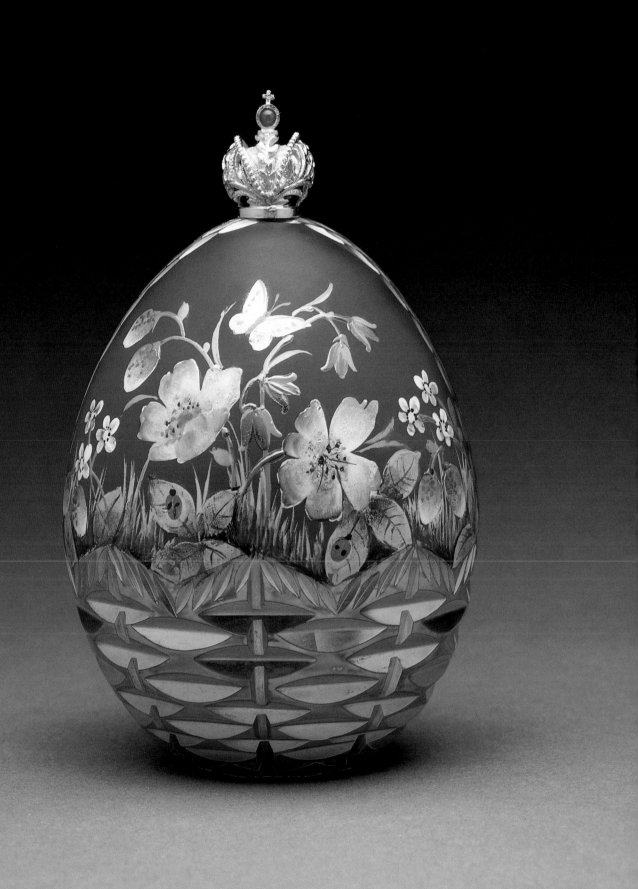

THE DESK CLOCK 1989

A time piece befitting a noble desk.

*Decorated with a design of vermeil swags and bows, set with
faceted rubies and pearls, The Desk Clock eloquently combines a
functional quality with Theo Fabergé's aesthetic craftsmanship.*

*The hand turned cocobolo spiral pillars, crowned with sterling
silver finials encompass the clock. The clock features the Theo Fabergé
hallmark and sterling silver mark, as well as a secret compartment.*

Length 90mm Width 90mm Height 60mm

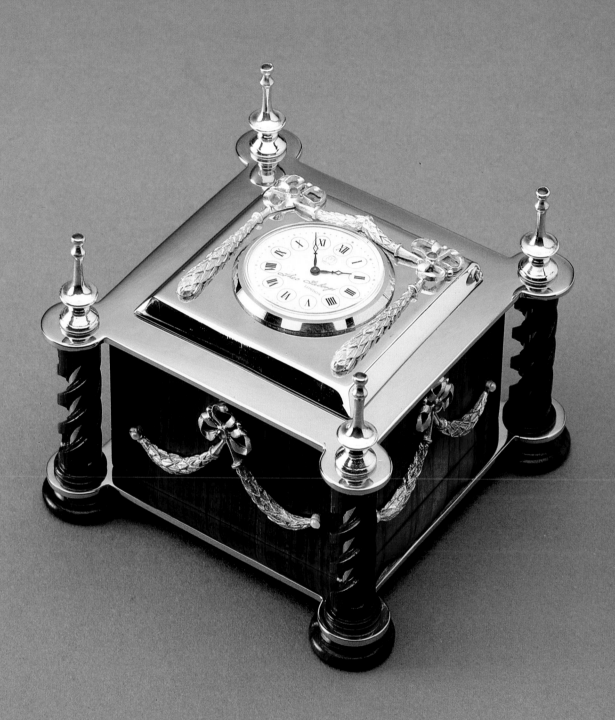

THE PICTURE FRAMES (Left to right)

ALEXIS AND ANASTASIA 1987

OLGA, MARIA AND TATIANA 1989

Named after the 5 children of Tsar Nicholas II, the guillochéd enamelled picture frames are lavishly decorated with sterling silver, 24 carat gold, pearls and faceted rubies.

The surprise is that the frames open from the front to take a photograph.

Alexis (Sky Blue)
Anastasia (Pink)
Olga (Turquoise)
Maria (Ivory)
Tatiana (Burgundy)

Height 120mm

THE DESK KNIFE 1989

A complimentary piece to The Desk Clock.

The cocobolo wood handle, turned on a Holtzapffel lathe is inset with a sterling silver blade, gilded with 24 carat gold.

The vermeil Imperial Crown can be turned to reveal a hidden surprise of a seal bearing the Theo Fabergé mark.

Length 257mm

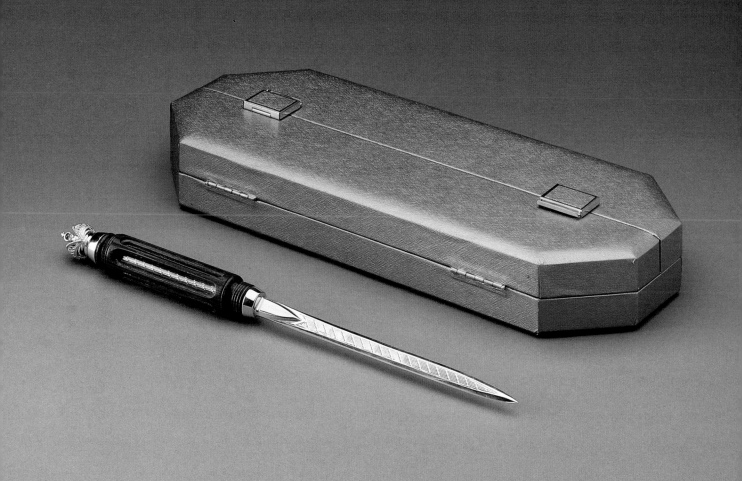

Overleaf
THE PHOENIX EGG 1990

The Phoenix Egg is inspired by Greek Mythology which tells of a bird of beauty reborn from the flames of destruction, thus becoming a symbol of hope, immortality and spiritual rebirth.

The story, hand painted on fine English bone china, is depicted through four panels consisting of anxiety, tranquility, hope and fulfillment.

The Egg opens to reveal the sterling silver Phoenix, set with sapphire eyes rising defiantly from the vermeil flames.

Height 150mm

THE ALEXANDRITE PENDANT 1989

Theo Fabergé has created The Alexandrite Pendant from a unique combination of gemstones.

The Phoenix with a Mother-of-Pearl breast, set with an Alexandrite heart, sapphire eyes all against 18 carat gold are complimented by 50 'brilliant cut' diamonds and 18 carat white gold of the wings. It is detailled with a branch of eight faceted cabachon rubies. (The Alexandrite gemstones are named after Alexander II of Russia whilst heir to the throne).

Length 45mm Width 50mm

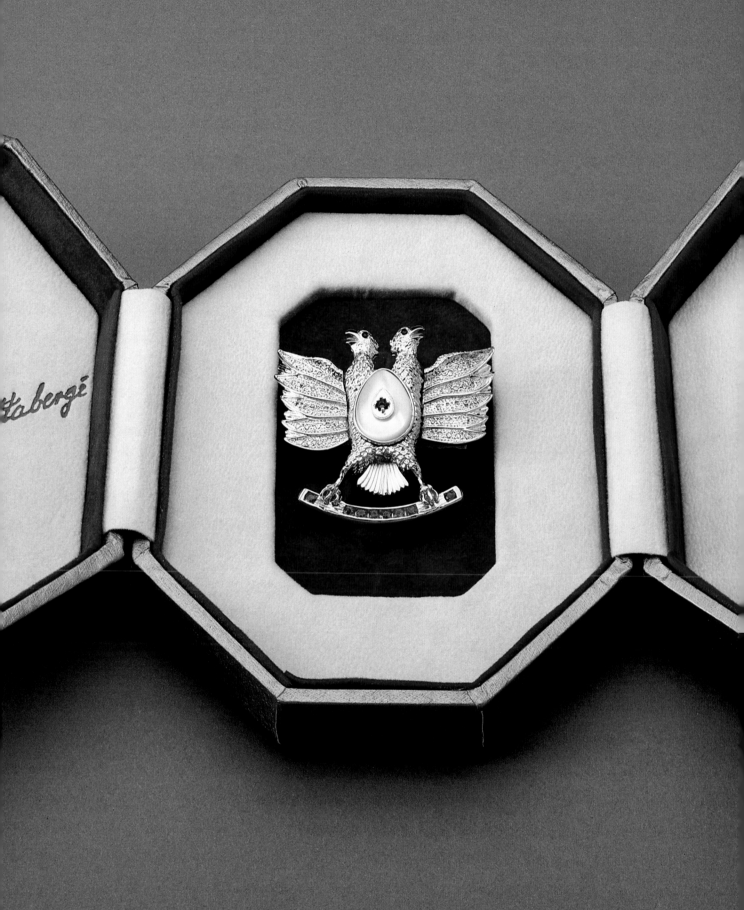

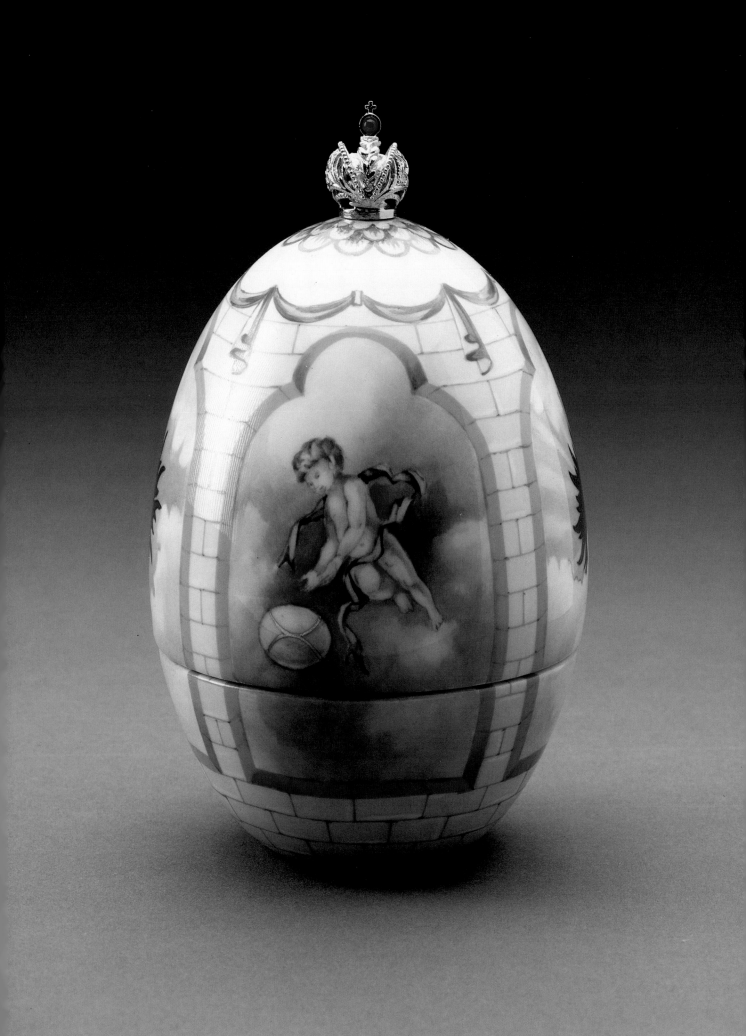

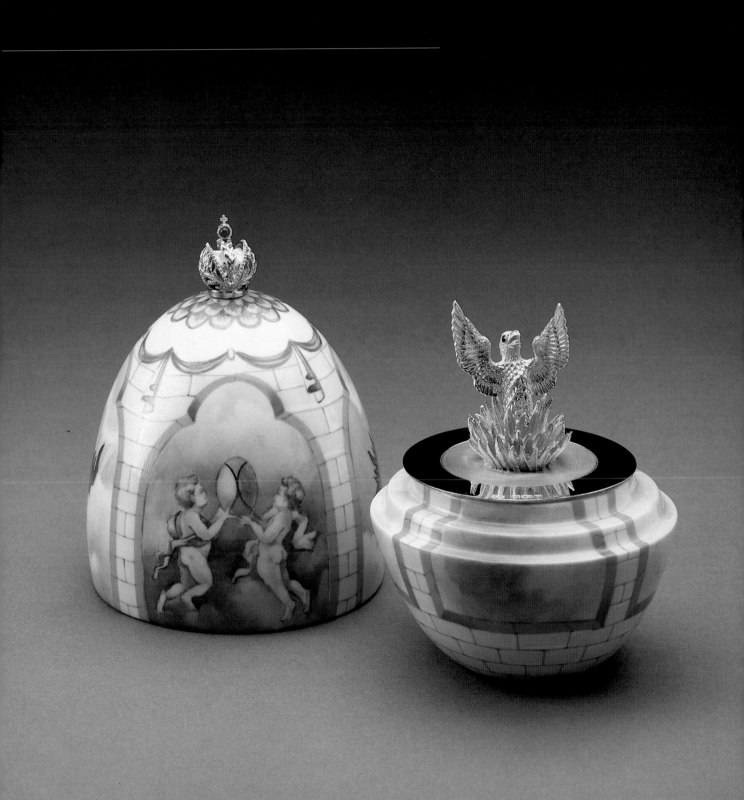

CARL FABERGÉ – THE IMPERIAL EASTER EGGS

NAME OF EGG	PRESENT WHEREABOUTS (IF KNOWN)
First Imperial	Forbes Magazine Collection, New York. (Forbes)
Hen and Wicker Basket	**Lost** – Reference is made to this piece in a list dated 1889 made by N. Petrov, Assistant Manager of His Majesty's Cabinet in charge of the Imperial Family's property, listing all the Imperial Eggs to that date (1889 Cabinet List).
Serpent Clock	Swiss Private Collection
Angel Clock	**Lost** – Reference is made to this piece in the 1889 Cabinet List.
Angel Chariot	**Lost** – Reference is made to this piece in the 1889 Cabinet List
Pearl	**Lost** – Reference is made to ordering this piece in a document dated 22 February 1889 which is now contained in the Central State Historical Archives at Leningrad.
Emerald	**Lost** – Reference is made in an 1890 document in the Central State Historical Archives at Leningrad to 'an egg with an emerald'
Blue Emerald Ribbed	Starvos S. Niarchos Collection, Paris (Niarchos)
Azova	Armoury Museum of the Kremlin, Moscow (Kremlin)
Twelve Monograms	Hillwood Museum, Washington D.C. (Hillwood)
Danish Jubilee	**Lost** – Photograph survives
Resurrection	Forbes
Caucasus	Matilda Geddings Gray Foundation Collection, New Orelans (New Orleans)
Renaissance	Forbes
Danish Palaces and Residences	New Orelans
Rosebud	Forbes
Revolving Miniatures	Museum of Fine Arts, USA (Richmond)
Pelican	Richmond
Coronation	Forbes
Lilies-of-the-Valley	Forbes
Pansy	Private Collection, USA
Modonna Lily	Kremlin
Cuckoo Clock	Forbes
Trans - Siberian Railway	Kremlin
Gatchina Palace	Walter Art Gallery, Baltimore (Baltimore)
Clover Leaf	Kremlin

NAME OF EGG	PRESENT WHEREABOUTS (IF KNOWN)
Peter the Great	Richmond
Spring Flowers	Forbes
Upensky Cathedral	Kremlin
Alexander III Commemorative	Kremlin
Colonnade	Collection of H M Queen Elizabeth II, England (Royal Collection)
Swan	Heirs of the late Maurice Sandoz, Switzerland (Sandoz)
Rose Trellis	Baltimore
Alexander Palace	Kremlin
Peacock	Sandoz
Standart	Kremlin
Love Trophy	Private Collection, USA
Alexander III Equestrian	Kremlin
Fifteenth Anniversary	Forbes
Orange Tree	Forbes
Tsarevitch	Richmond
Napoleonic	New Orleans
Romanov Tercentenary	Kremlin
Winter	Formerly in the Collection of the late Bryan Ledbrook. Present whereabouts **Unknown**
Mosaic	Royal Collection
Grisaille	Hillwood
Red Cross with Resurrection Triptych	I E Minshall Collection, Cleveland Museum of Art, Cleveland
Red Cross with Portraits	Richmond
Steel Military	Kremlin
Cross of St. George	Forbes
Twilight	Private Swiss Collection. **Note:** This Egg was never delivered.
Wooden	**Lost**—Source of information, the late Eugene Fabergé. **Note:** This Egg was never delivered.

TITLE	DATE	COLLECTION	PAGE
THE BEECH CANDLESTICKS	1952	*PRIVATE*	75
THE RIBBED SALT AND PEPPER MILLS – A MATCHED PAIR	1975	*THE WORSHIPFUL COMPANY OF TURNERS*	77
THE SILVER JUBILEE IVORY CASKET	1977	*PRIVATE*	78/79
LACE BOBBINS	1979-1984	*PRIVATE*	80
LETTER OPENER AND BOOKMARK PRESENTED IN A TURNED CASE	1980	*PRIVATE*	81
THE CANDLELIGHT MIRROR	1980	*PRIVATE*	83
CHINESE MYSTERY TURNED SPHERES	1980	*THE WORSHIPFUL COMPANY OF TURNERS*	85
ST. CATHERINE CANDLESTICKS – A MATCHED PAIR	1981	*THE WORSHIPFUL COMPANY OF TURNERS*	87
TEARS OF THE MOON EGG	1982	*PRIVATE*	88
PURPLE HEART CIGARETTE BOX	1982	*PRIVATE*	89
THE SUMMER FLOWER TARZZA	1982	*PRIVATE*	91
THE OWL RUBY ANNIVERSARY EGG	1982	*PRIVATE*	92
THE 30TH. ANNIVERSARY PEARL EGG	1983	*PRIVATE*	93
SARAH'S 25TH. BIRTHDAY EGG	1983	*PRIVATE*	95
THE NOUVEAU CANDLESTICKS	1983	*PRIVATE*	97
THE PROCESSIONAL CROSS	1984	*WILLIAM PARKER SCHOOL*	99
SWAN LAKE FANTASY	1984	*PRIVATE*	100
HELEN'S 70TH. BIRTHDAY FANTASY	1984	*PRIVATE*	101
THE TWO-TIER TARZZA	1984	*PRIVATE*	103
THE OLD WORLD SUGAR SHAKERS	1984	*PRIVATE*	105
THE DIAMOND BIRTHDAY EGG	1985	*PRIVATE*	106
THE 40TH RUBY ANNIVERSARY EGG	1985	*PRIVATE*	107
THE MARINE FANTASY EARRINGS	1986	*PRIVATE*	108
THE JUNGLE RING	1980	*PRIVATE*	108
FREEDOM OF HASTINGS CASKET	1986	*PRIVATE*	109
THE 37TH BIRTHDAY MENORAH	1987	*PRIVATE*	111
ETAK TARZZA	1989	*PRIVATE*	112
THE PINE CONE EGG	1979	*PRIVATE*	112
THE 50TH. ANNIVERSARY SHIPS BOWL	1989	*PRIVATE*	113

Appendix III **THEO FABERGÉ AND THE ST. PETERSBURG COLLECTION**

TITLE	LAUNCH DATE		LIMITED EDITION	PAGE
THE SCRIBE EGG	SEPTEMBER	1985	*750*	115
THE SWAN EGG	SEPTEMBER	1985	*750*	117
FOUR SEASONS EGG	SEPTEMBER	1985	*750*	119
THE SPRING EGG	SEPTEMBER	1985	*750*	121
THE DRAGON EGG	SEPTEMBER	1985	*750*	123
THE ETERNITY EGG	OCTOBER	1986	*750*	125
THE DEVIL'S EGG	NOVEMBER	1986	*750*	127
THE WINTER EGG	NOVEMBER	1986	*750*	129
THE PICTURE FRAMES				
ALEXIS	MAY	1987	*250*	148
ANESTASIA	MAY	1987	*250*	148
THE ST. VLADIMIR EGG	AUGUST	1987	*500*	130/131
THE WASSAIL BOWL	NOVEMBER	1987	*125*	133
THE CORAL EGG	OCTOBER	1988	*750*	135
THE CLOVER EGG	OCTOBER	1988	*750*	137
THE DIAMOND EGG JEWELS				
CUFFLINKS	OCTOBER	1988	*125*	139
MONEY CLIP	OCTOBER	1988	*125*	139
STICK PIN	OCTOBER	1988	*125*	139
TIE SLIDE	OCTOBER	1988	*125*	139
DRESS BUTTONS	OCTOBER	1988	*125*	139
THE TRILOGY BOX	FEBRUARY	1989	*125*	141
THE SUMMER EGG	AUGUST	1989	*750*	143
THE DESK CLOCK	SEPTEMBER	1989	*500*	145
THE DESK KNIFE	SEPTEMBER	1989	*500*	147
THE PICTURE FRAMES				
OLGA	SEPTEMBER	1989	*250*	149
MARIA	SEPTEMBER	1989	*250*	149
TATIANA	SEPTEMBER	1989	*250*	149
THE ALEXANDRITE PENDANT	OCTOBER	1989	*125*	151
THE THEO FABERGÉ JEWELLED BOOK	OCTOBER	1989	*250*	
THE PHOENIX EGG	SEPTEMBER	1990	*500*	152/153

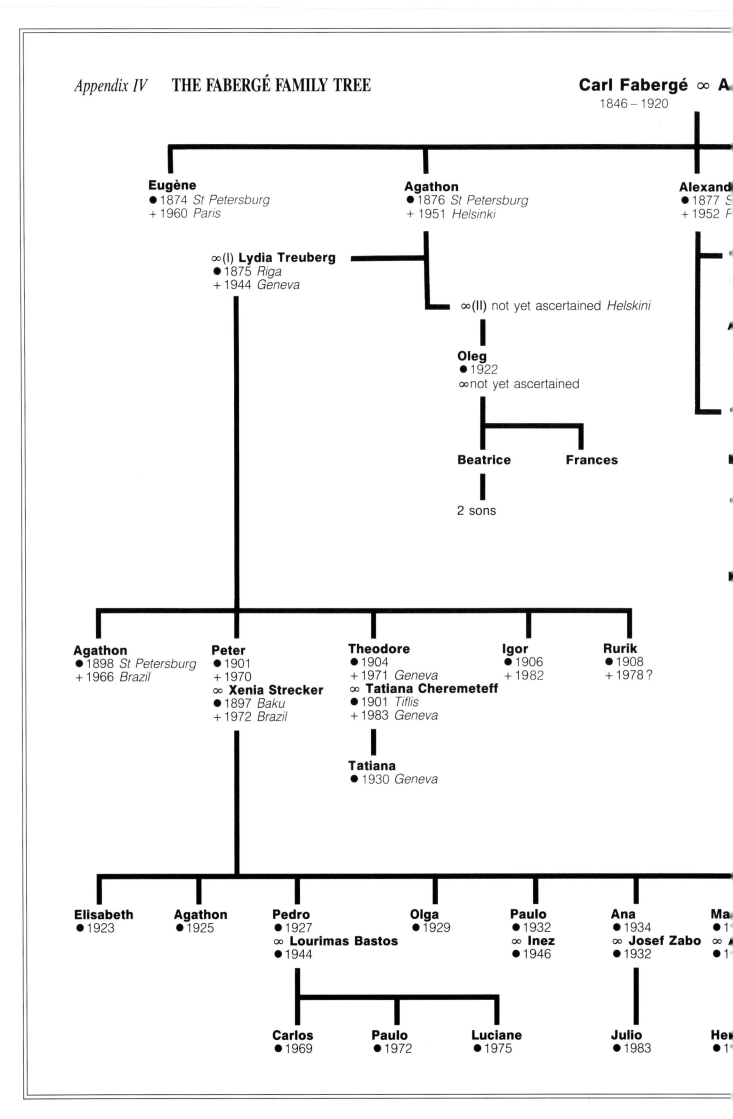

Appendix IV **THE FABERGÉ FAMILY TREE**

Carl Fabergé ∞ A
1846 – 1920

Eugène
● 1874 *St Petersburg*
+ 1960 *Paris*

Agathon
● 1876 *St Petersburg*
+ 1951 *Helsinki*

Alexand
● 1877 *S*
+ 1952 *F*

∞(I) **Lydia Treuberg**
● 1875 *Riga*
+ 1944 *Geneva*

∞(II) not yet ascertained *Helskini*

Oleg
● 1922
∞ not yet ascertained

Beatrice **Frances**

2 sons

Agathon
● 1898 *St Petersburg*
+ 1966 *Brazil*

Peter
● 1901
+ 1970
∞ **Xenia Strecker**
● 1897 *Baku*
+ 1972 *Brazil*

Theodore
● 1904
+ 1971 *Geneva*
∞ **Tatiana Cheremeteff**
● 1901 *Tiflis*
+ 1983 *Geneva*

Igor
● 1906
+ 1982

Rurik
● 1908
+ 1978 ?

Tatiana
● 1930 *Geneva*

Elisabeth
● 1923

Agathon
● 1925

Pedro
● 1927
∞ **Lourimas Bastos**
● 1944

Olga
● 1929

Paulo
● 1932
∞ **Inez**
● 1946

Ana
● 1934
∞ **Josef Zabo**
● 1932

Ma
● 1
∞ *A*
● 1

Carlos
● 1969

Paulo
● 1972

Luciane
● 1975

Julio
● 1983

He
● 1

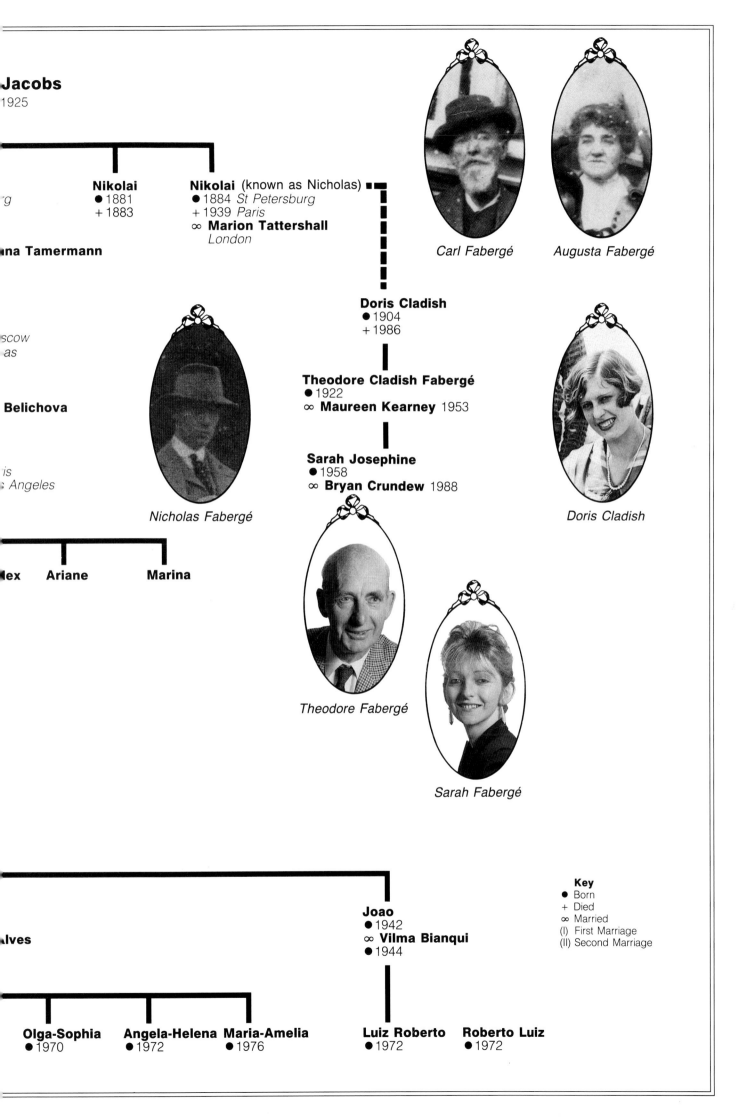

Jacobs
1925

Nikolai
● 1881
+ 1883

Nikolai (known as Nicholas) ■ ■
● 1884 *St Petersburg*
+ 1939 *Paris*
∞ **Marion Tattershall**
London

Carl Fabergé *Augusta Fabergé*

rg

na Tamermann

scow
as

Belichova

is
Angeles

Nicholas Fabergé

Doris Cladish
● 1904
+ 1986

Theodore Cladish Fabergé
● 1922
∞ **Maureen Kearney** 1953

Sarah Josephine
● 1958
∞ **Bryan Crundew** 1988

Doris Cladish

lex **Ariane** **Marina**

Theodore Fabergé

Sarah Fabergé

Joao
● 1942
∞ **Vilma Bianqui**
● 1944

lves

Olga-Sophia **Angela-Helena** **Maria-Amelia** **Luiz Roberto** **Roberto Luiz**
● 1970 ● 1972 ● 1976 ● 1972 ● 1972

1986 November 13th - 15th *Marshal Field's, Chicago, USA*
 November 20th - 22nd *Saks Fifth Avenue, New York, USA*

1987 March 27th - 28th *Camalier and Buckley, Washington DC, USA*
 March 30th - 31st *Saks Fifth Avenue, Atlanta, USA*
 April 2nd - 4th *Linz Jewelers, Dallas, USA*

 November 27th - 28th *Geary's, Los Angeles, USA*
 December 1st - 2nd *Tuverson's, Phoenix, USA*
 December 4th - 5th *Linz Jewelers, Dallas, USA*
 December 6th *The Fabergé Crystal Charity Ball, Dallas, USA*
 December 7th - 8th *Saks Fifth Avenue, San Francisco, USA*
 December 10th - 12th *Jacobsons's, Detroit. Grosse Pointe,*
 Birmingham and Livornia, USA

1988 March 18th - 19th *Schwarzchild Jewelers, Richmond, USA*
 March 22nd - 23rd *J E Caldwell Jewelers, Willmington, USA*
 March 24th - 26th *Shreve Crump and Low, Boston, USA*

 March 30th *Harrods, London, UK*

 November 25th - 26th *Saks Fifth Avenue, New York, USA*
 Nov./Dec. 30th - 1st *Jessop Jewelers, San Diego, USA*
 December 2nd - 3rd *Shreve and Co., San Francisco, USA*
 December 6th *Frederick and Nelson, Seattle, USA*
 December 7th *Henry Birks and Sons, Vancouver, Canada*
 December 9th *Henry Birks and Sons, Toronto, Canada*
 December 10th *Henry Birks and Sons, Montreal, Canada*

1989 March 10th - 11th *Lux Bond and Green, Hartford, USA*
 March 14th *Jacobson's, Livornia and Michigan, USA*
 March 15th *Jacobson's, Indianapolis, USA*
 March 16th *George Watts, Milwaukee, USA*
 March 17th - 18th *J B Hudson Jewelers, Minneapolis, USA*

 September 12th - 13th *Brown Thomas, Dublin, Ireland*

 September 29th - 30th *J E Caldwell Jewelers, Washington DC, USA*
 October 2nd - 3rd *C D Peacock, Chicago, USA*
 October 5th - 7th *Jessop Jewelers, San Diego, USA*

 October 19th - 21st *David Jones, Sydney, Australia*
 October 23rd - 25th *David Jones, Melbourne, Australia*

 December 8th - 9th *Lee Michael Jewelers, Baton Rouge, USA*
 December 11th *Lee Michael Jewelers, Shreveport, USA*
 December 13th *Mayors Jewelers, Fort Lauderdale, USA*
 December 14th *Mayors Jewelers, Palm Beach, USA*
 December 15th *Mayors Jewelers, Miami, USA*
 December 16th *Saks Fifth Avenue, Bal Harbour, USA*

British hallmarks have acted as a safeguard to purchasers of gold and silver for over six centuries. It is generally an offence for any trader in Britain to sell or describe an article as gold or silver unless it has been hallmarked at one of the country's four Assay Offices.

The Theo Fabergé mark was entered at London in 1979 and at Birmingham in 1987.

Reading from left to right, the hallmarks are as follows:

Maker's Mark	In this case T.F. for Theo Fabergé.
Assay Office Mark	London is represented by a forward facing leopard's head and Birmingham by an anchor.
The Standard Mark	Articles in sterling silver (925 parts pure silver to 75 alloy) are marked with a **lion passant**, ie lion portrayed walking.
The Date Letter	This indicates the year in which the object was assayed. The letter is changed each year and the shape of the shield and or the style of the letters are altered each cycle.